IN PREDATORY LIGHT

IN PREDATORY LIGHT
LIONS AND TIGERS AND POLAR BEARS

Cyril Christo
and Marie Wilkinson

Texts by
Elizabeth Marshall Thomas
Sy Montgomery
John Houston

MERRELL
LONDON · NEW YORK

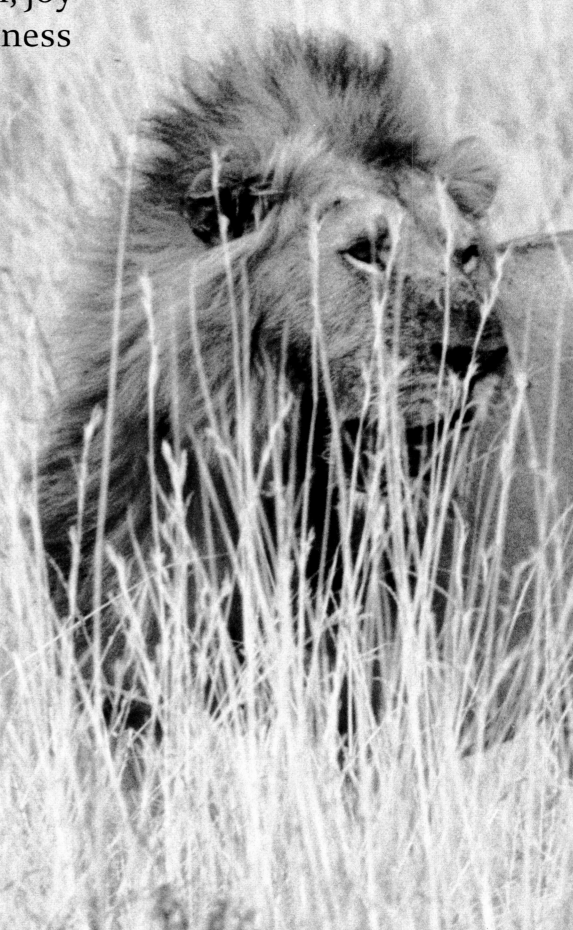

No artificial drama, humour, pathos, suffering, triumph, joy or grief ever held the vividness of Nature's own.

MARTIN JOHNSON,
LION: AFRICAN ADVENTURE WITH THE KING OF BEASTS, 1922

*To Marie, without whose love
and persistence our shared vision would
have remained mute, and to Lysander
and the next generation; may they come
to know and honour the heart,
mind and soul of
'the other'.*

PROLOGUE 12

LIONS 22
Text by Elizabeth Marshall Thomas 62

TIGERS 68
Text by Sy Montgomery 98

POLAR BEARS 100
Text by John Houston 144

CAPTIONS 152

ACKNOWLEDGEMENTS 159

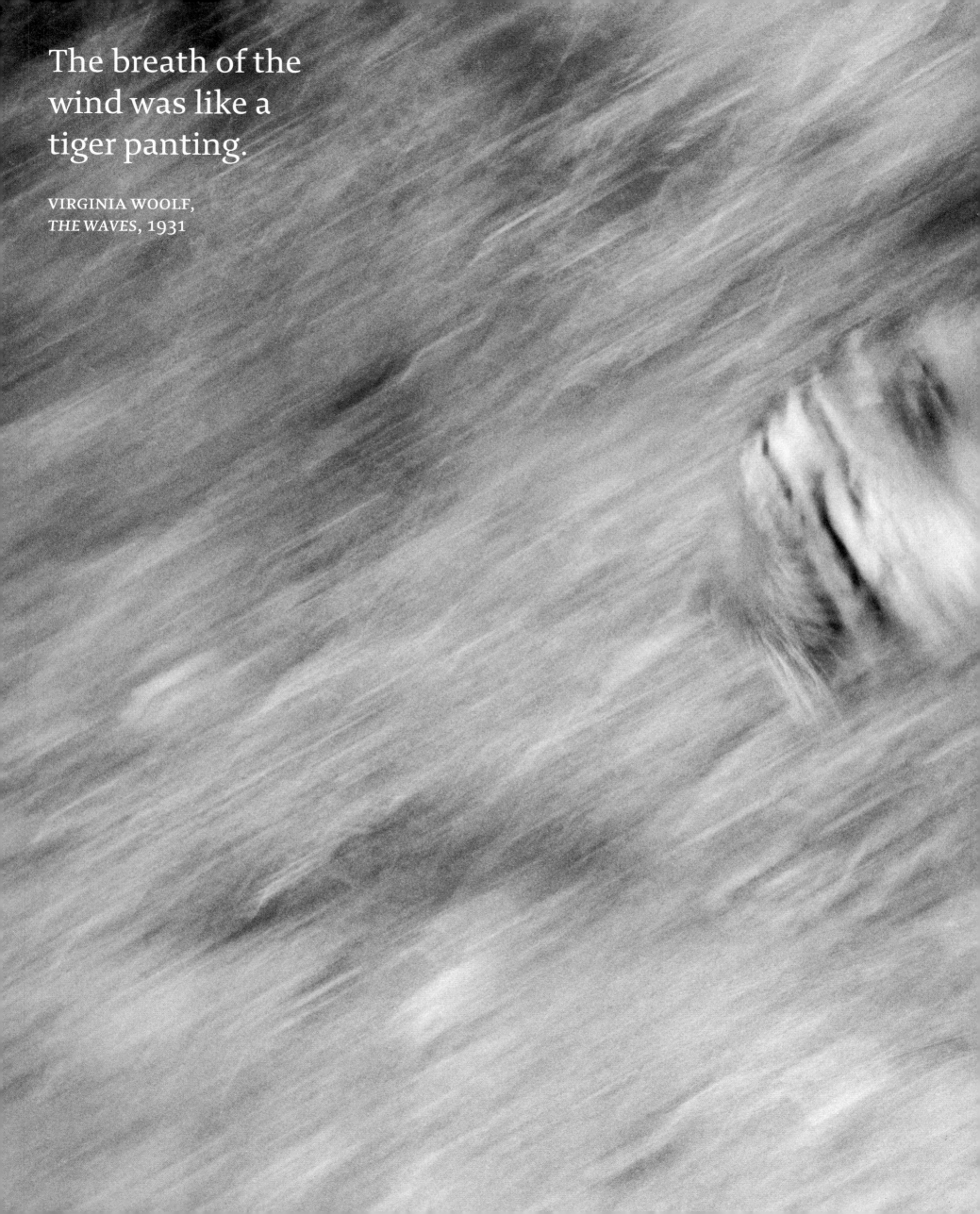

The breath of the wind was like a tiger panting.

VIRGINIA WOOLF,
THE WAVES, 1931

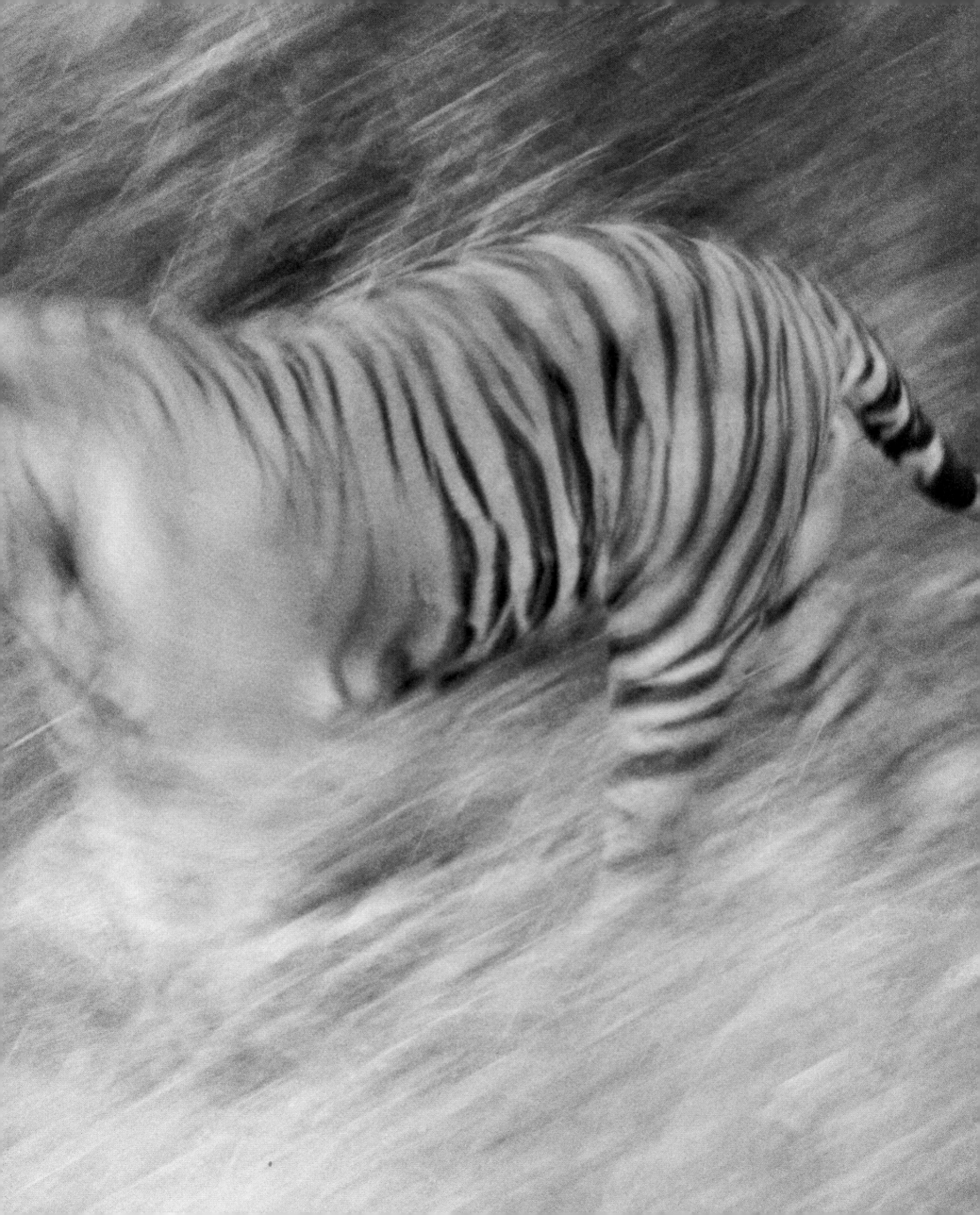

Witness the white bear of the poles, and the white shark of the tropics; what but their smooth, flaky whiteness makes them the transcendent horrors they are?

HERMAN MELVILLE,
MOBY-DICK, 1851

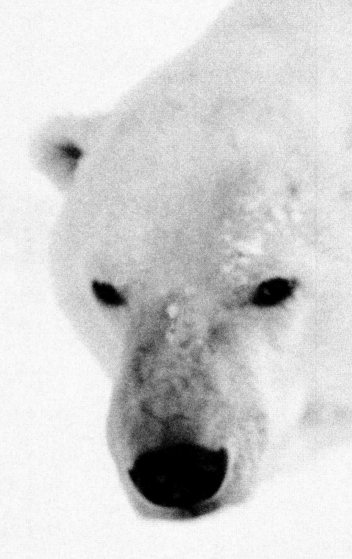

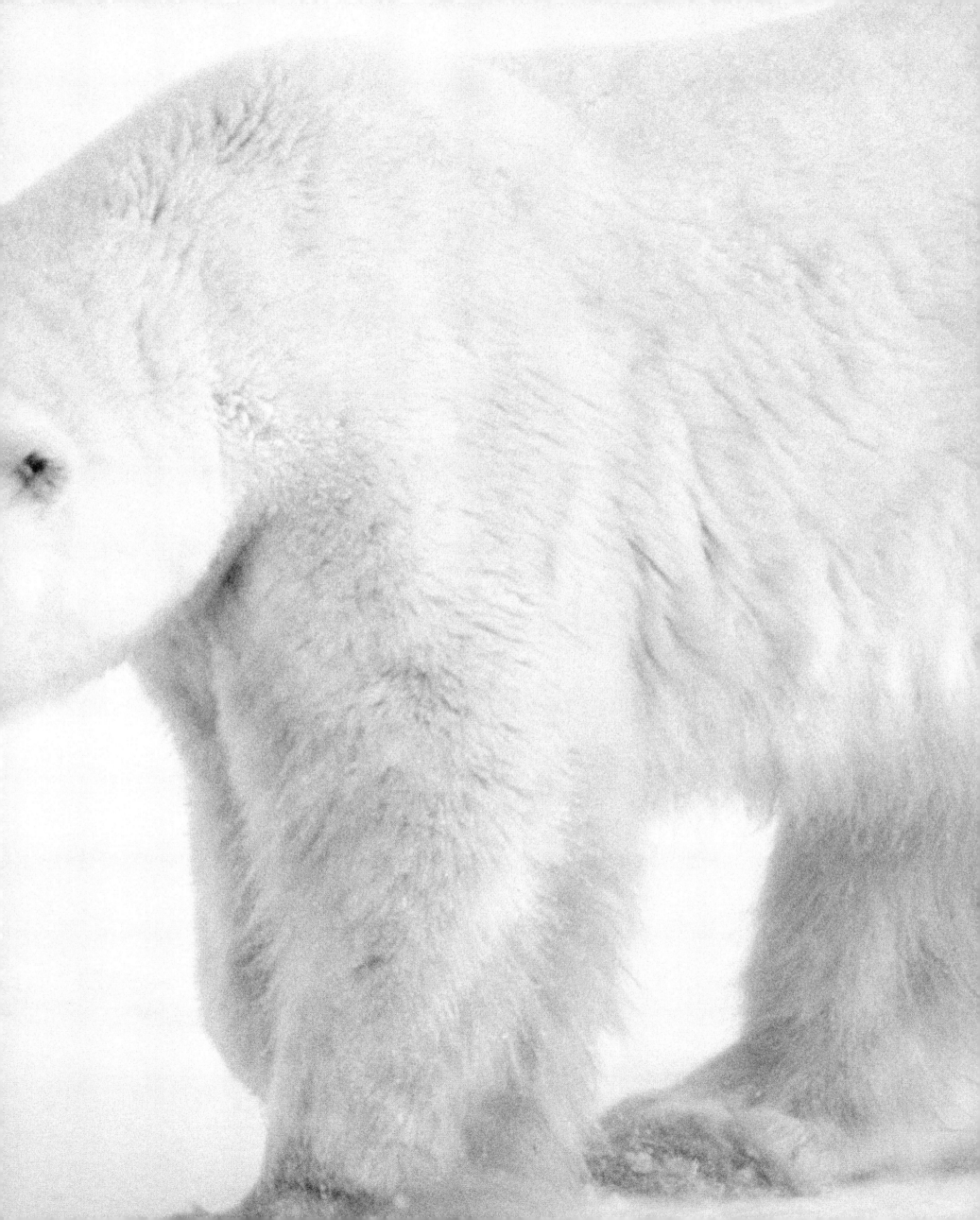

PROLOGUE

> The so-called 'civilized' people? They had no excuse. They hunted for what they called 'trophies', for the excitement of it, for pleasure, in fact.
>
> ROMAIN GARY,
> *THE ROOTS OF HEAVEN*, 1958

'Everything is spirit. This is the essential thing for you to remember. The forces are our friends, our relatives', an Inuit elder once told the French Arctic explorer Jean Malaurie, as he recounted in his book *The Last Kings of Thule* (1956). The Inuit people's cardinal precept was never to oppose the life force. Today's dominant Western society may have long ago dispensed with the animist beliefs of our ancestors, but the guardian spirits of our past still inhabit our deepest consciousness. We need 'the others', the four-footed ones, and the life force that they embody more than ever. And yet in evolutionary history, no species has menaced the biosphere to the extent that humans do. It is now a fragile time for the world's species, and especially for humanity's arch-'rivals', the predators. These inhabit every sea and every land mass on the planet, and have moved alongside the human species ever since we started to defend ourselves against 'the other' – that is, since the beginning of our kind.

The lion, the tiger and the bear share a common power as the supreme predatory mammals of their respective ecosystems, and as such inhabit an invaluable place in our mythology and psyches. The lion emerged in Africa about three million years ago, and expanded beyond the continent probably around the same time humans did, some 100,000 years ago. In the short timeline of our species, we have been forced to confront the reality of the lion as we have been for no other predator. The tiger emerged some two million years ago in Asia. Today, the tiger could die out altogether if the peoples of that continent do not mobilize every conservation tool and anti-poaching effort at their disposal. The polar bear diverged from the brown bear around 250,000 years ago; indications are that, because of displacement brought about by the disappearing ice and snow in the Arctic, it is breeding with its grizzly-bear cousin and that it may return to the original genetic pool from

which it emerged. The lion, the tiger and the polar bear have nourished our spirits as uniquely powerful totemic and tutelary beings. That we now think we can dispense with them says as much about our civilization as any other indicator of our time, for we have become the dominant predator on earth.

The lion, the tiger, the polar bear and the grizzly, the Nile crocodile, the myriad shark species, the wolf, the coyote, the jaguar, the snow leopard … the list of predators reads like a menagerie of the world's most secretive and exquisite beings. All have been variously honoured, vilified and desecrated because of their carnivorous imperative and their ability to prey on others and to command life. The bear cults of the northern hemisphere, from those of the Ainu of Japan to the Inuit of the Arctic, underscore a spiritual bond with beings that are considered to be peers. Yet for millennia the great predators have also been demonized, and now they are mutilated for so-called sport and bloodlust. Modern civilization's relationship with the non-human has become almost grotesque. As a result of an ever-expanding human population and unceasing habitat loss, the planet's mammalian animal population has taken a direct hit. The native peoples of the world have always honoured lions, tigers and polar bears as a foil to our supremacy; but despite the endangered status of these great predators, they continue to be slaughtered like vermin for their luxuriant coats, or because we are terrified of them and their challenging demeanour. Now 'the others' watch us out of the corner of their wary eyes and affirm the final savagery of our kind.

The lion has been used as a symbol of nobility and power from antiquity to modern times. In his book *In Brightest Africa* (1923), Carl Akeley, the renowned taxidermist and conservationist who prepared many of the mammals for the American Museum of

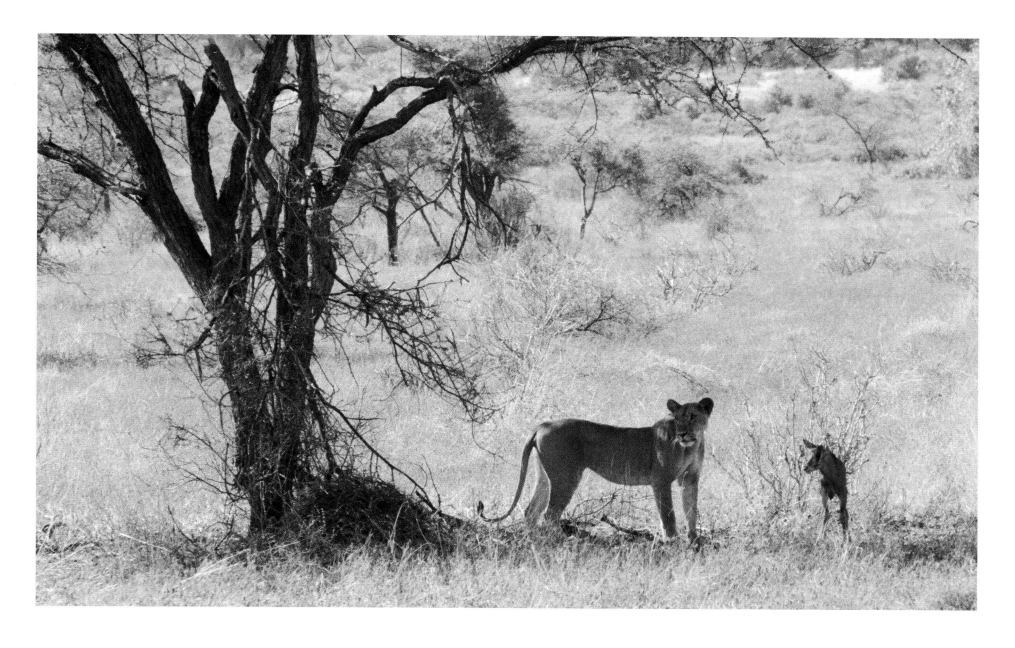

Natural History in New York, wrote: 'While many things about the lion's habits are controversial, I think practically everyone who has had experience with them will agree that they are not savage in the sense of killing for the mere sake of killing.' Nevertheless, the lion population has been decimated for mere entertainment. The tiger, a deity in much of Asia, is similarly walking the tightrope of existence. Tigers continue to be destroyed for body parts, many of which are considered in Asia, and especially China, to be aphrodisiacs. Polar bears, the great lords of the ice kingdom of the north, have to contend with the predation of trophy hunters and those who desire their fur for rugs, rugs that can fetch upwards of $40,000 (£25,500) – as if climate change, melting ice and other plagues on the modern cryosphere were not enough to challenge the survival of these superb beings.

Those who kill lions, tigers, polar bears and the earth's other predators are the destroyers of time, place and memory. Predators, of any species, are not simply unique presences or mythic confabulations that lurk in our imagination; they are singular and necessary events in the ecological script of the planet, and beyond that, they are symbols of beauty, power and the sublime. Woe betide the soul of India if that marvellous subcontinent, composed of a galaxy of cultures, does not manage to salvage the last great population of tigers on earth. Will the critically endangered Sumatran tiger, unique to the Indonesian island of Sumatra, escape extinction? Will Kamchatka, at the north-eastern edge of Russia, preserve the Siberian or Amur tiger, the 'tiger of the snows'? We should be extremely concerned about the future of the human species if we were to become the only surviving predator.

Those who wilfully kill, not in self-defence or for food but for the pride of it or for financial gain, are morally bankrupt, ruthless

killers of true majesty. Humans have become mutilators, demented thrill-seekers who search for and destroy predators, projecting viciousness on to those who kill only in order to survive. In the wanton destruction of 'the other' we underscore the evil that only our species incarnates. There is no evidence of viciousness in 'the other'. The often misinterpreted Darwinian theory of 'the survival of the fittest' needs radical revision, to include notions of cooperation and collaboration. As is symbolized by the mythical ancient Egyptian and Greek Sphinx – perhaps one of the greatest mysteries and human constructs in human civilization – we need a truce with 'the other', with life itself, with the non-human and the last remaining predators. If we can accomplish this, we may eventually find some measure of peace within ourselves. As the American anthropologist and natural-science writer Loren Eiseley posited eloquently in the late 1960s in his essay 'The Ghost Continent', 'We have become the world eaters. The march of machines has entered our blood'; but he also stated that

It is possible to add that for the soul to come to its true self it needs the help and recognition of the dog Argos. It craves that empathy clinging between man and beast, that nagging shadow of remembrance which, try as we may to deny it, asserts our unity with life ... Paradoxically, it establishes, in the end, our own humanity. One does not meet oneself until one catches the reflection from an eye other than human.[1]

The truce with 'the other' is exemplified by a remarkable story that was related to Marie, my wife, and me in 2012 in the Chyulu Hills of southern Kenya by Koni, a former elephant hunter of the Waliangulu tribe. It is the greatest lion story we have ever heard. As a young man, Koni's grandfather had once been stalking game for days without catching

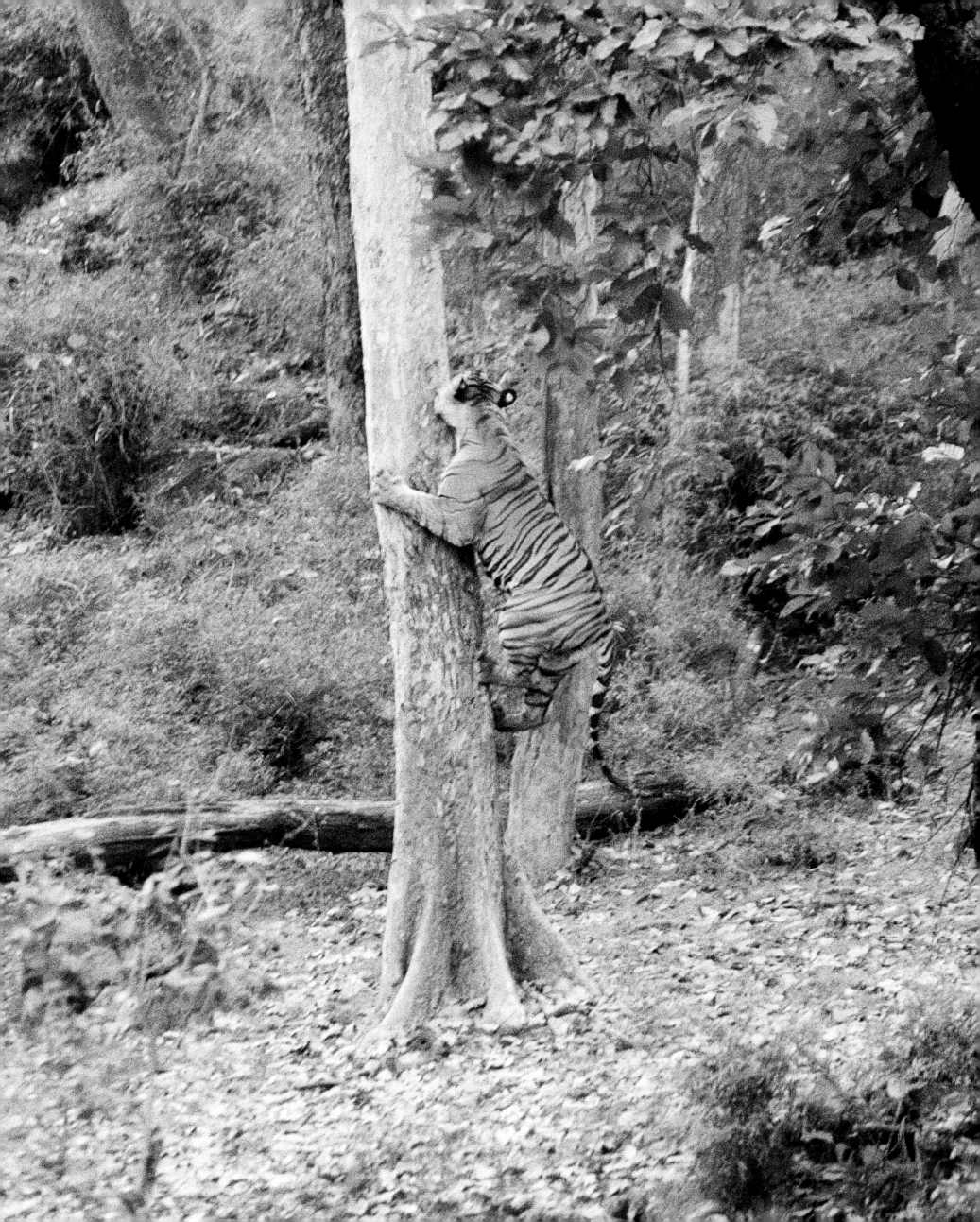

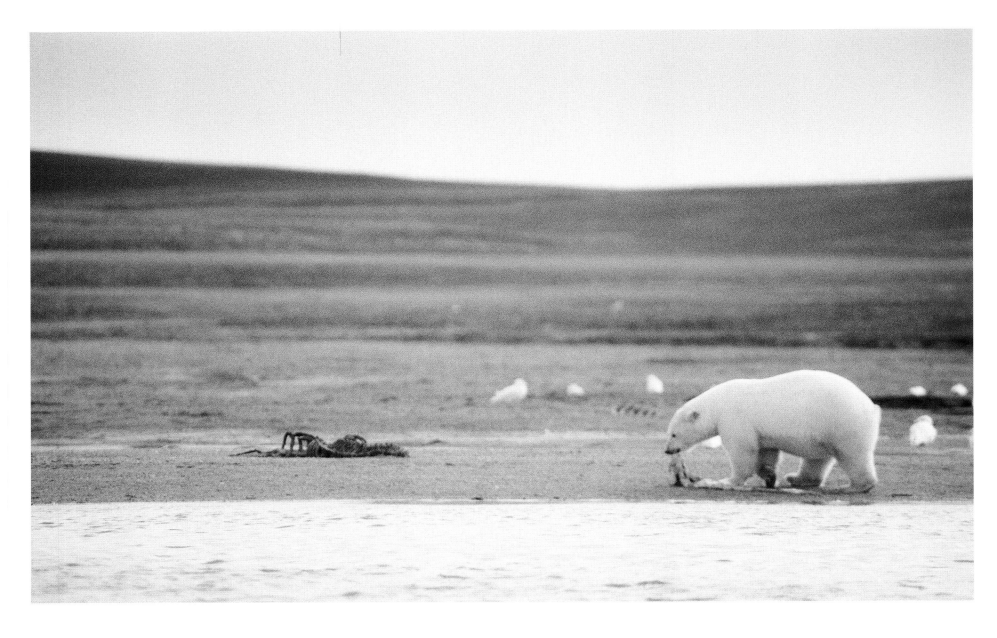

anything. One evening, after he had made a campfire and as he was settling down for the night, he heard a lion roaring in the vicinity. Its voice was not like the normal threatening roar Koni's grandfather had heard so many times, and it was getting late, so he covered his body in a blanket and prepared himself for sleep. A little while later he heard a breath bearing down on him, and he gingerly looked up to be faced by a fully grown male lion looking down at him and extending its paw to him. In the paw was a long and painful thorn, which to lions can be fatal because it impedes their hunting. Koni's grandfather took out his knife and removed the thorn! The lion then retreated into the night.

Four days later, Koni's grandfather was still hunting when he came across what he felt sure was the same lion. The animal looked at him, satisfied itself that he had noticed it, and then started to walk away slowly. Koni's grandfather sensed that something was odd and that the lion wanted to lead him somewhere, so he followed it, the lion stopping and looking over its shoulder every now and then to check that he was still there. Eventually the lion led him to a clearing, and there, like a miracle, lay a freshly killed giraffe, left untouched. Koni's grandfather understood that the lion had killed the giraffe as a thank-you to him, as a gift for having saved its life.

In India in 2009, while we were visiting Bandhavgarh National Park, home to a large population of Bengal tigers, we were told a story by a researcher who had studied the last surviving lions of Asia, in Gujarat, western India. He recounted a tale of two men making their way to visit a sannyasi (a Hindu religious mendicant) who lived deep in the Gir Forest. They had been walking for many miles when quite unexpectedly they were startled by a lion on the path; to their surprise, the animal

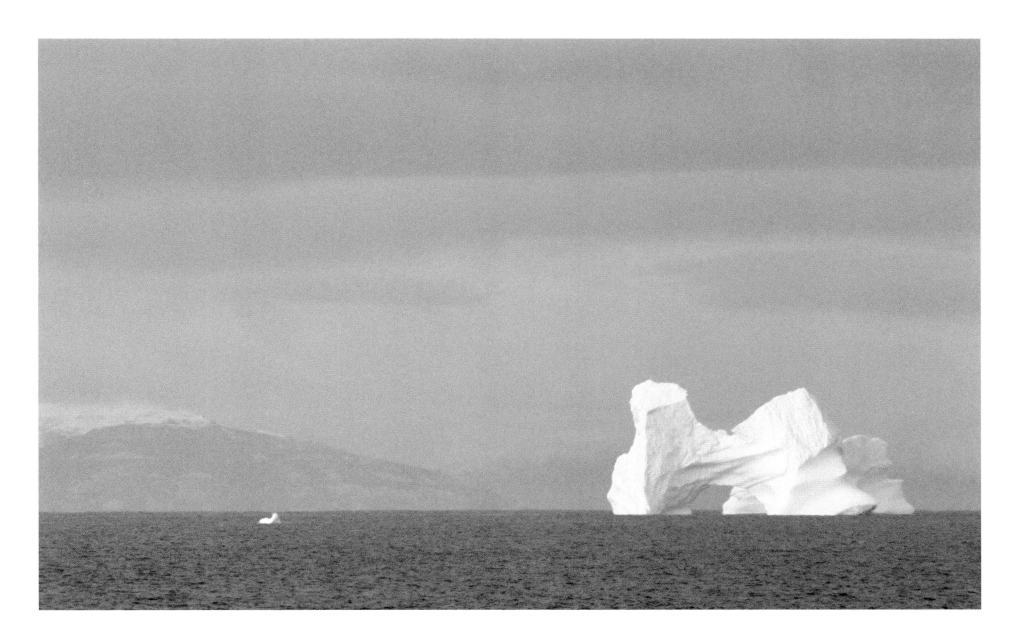

calmly let them pass. When the pilgrims finally reached the holy man a few hours later, they were greeted with the question, 'How was your experience with the lion?' This seemingly innocuous tale illustrates the inexpressible bond between man and beast, the super-sensory realities that are still the hallmark of much that is most wondrous in life. The relationship between human and wild creature such as lion, tiger or polar bear – which necessitates respect – is so much more astounding than that between human and the synthetic confabulations of the cybernetic world.

In the old days, when humans and other animals shared a different relationship, such stories as Koni's and the lion researcher's were more commonplace; think of the ancient Roman tale of the runaway African slave Androcles, who removed a thorn from a wild lion's paw and later, having been caught and condemned to be devoured by wild animals in a Roman stadium, was greeted with affection by the same lion. Such mythic tellings of interspecies connection speak of the bridge between two masterful hunters, hunters who respected each other's identities. It is the kind of truce and kinship that humanity needs now more than ever.

The death of the last predator, of the very last of the innocent killers, will signal our end. Predators are not our enemies; rather, they form part of the immune system of our planet. If we believe that we can do without them and subsist on the meagre distractions of 'gadget gods' (to paraphrase W.H. Auden in his poem 'The Age of Anxiety', 1947), we will suffer a great loneliness beyond repair. We will have become the monsters we have for so long projected on to 'the others'. No lions will roar the inimitable voice of dawn over the savannahs of Africa and western India; no tigers in Sumatra or Kamchatka will haunt us

with the amber eyes of a deity; no polar bears will roam the immense solitudes of the pack ice. We will never again be mesmerized by sleek sharks in the oceans, where life began; no leopards will stalk us with their serpentine grace through the fields in the Serengeti region of Tanzania and Kenya, where the human race was born; no grizzlies will lurk at the base of Denali (as the native Koyukon Athabaskan people call Mount McKinley, Alaska) like four-footed shamans. No wolves will howl among the towering geysers of Yellowstone National Park, Wyoming; no dingos will prowl in the harsh heat of the Australian outback and the Queensland coast; no jaguars will tantalize us in the emerald forests of Belize or the Amazon.

 Nothing will defy us. No other eyes will quite follow ours in the darkness of the universe. No other presence will defy our small frame on the great horizon of life. We will have become all-conquering. Without 'the other' to stand as a pause to our absolutist conduct, we will self-cannibalize. There will be no going back. We must fight as never before for the survival of 'the other'. We must never have to tell the children of the future, in a tragic twist on the title of Maurice Sendak's classic picture book, 'This is where the wild things were'.[2]

Notes
1. Loren Eiseley, 'The Ghost Continent', in *The Unexpected Universe*, New York (Harcourt Brace & World) 1969.
2. After Maurice Sendak, *Where the Wild Things Are*, New York (Harper & Row) 1963.

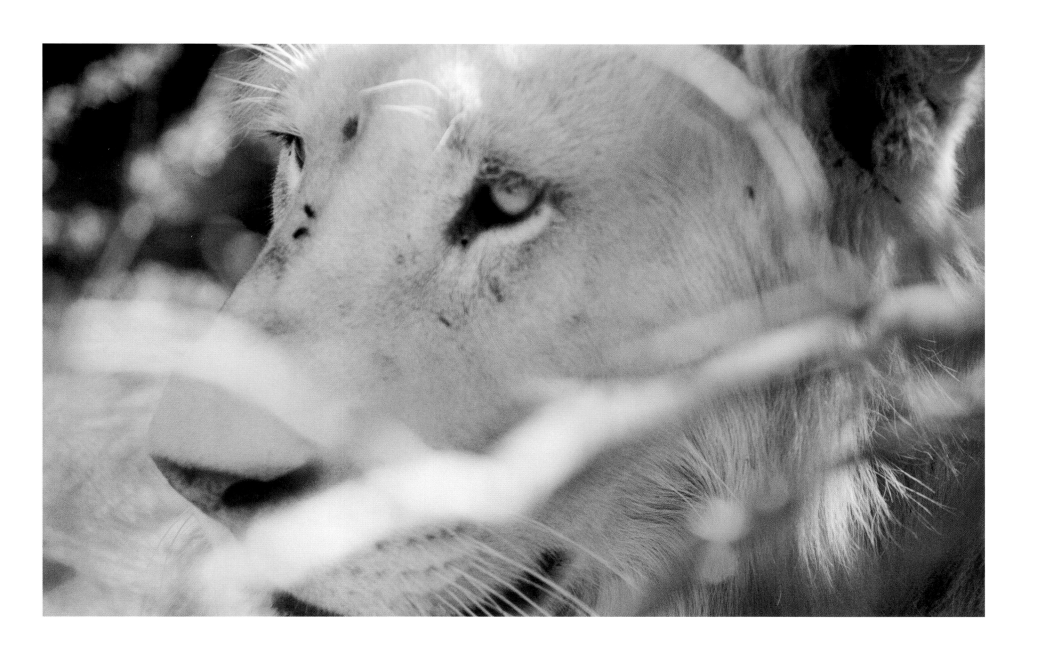

LIONS

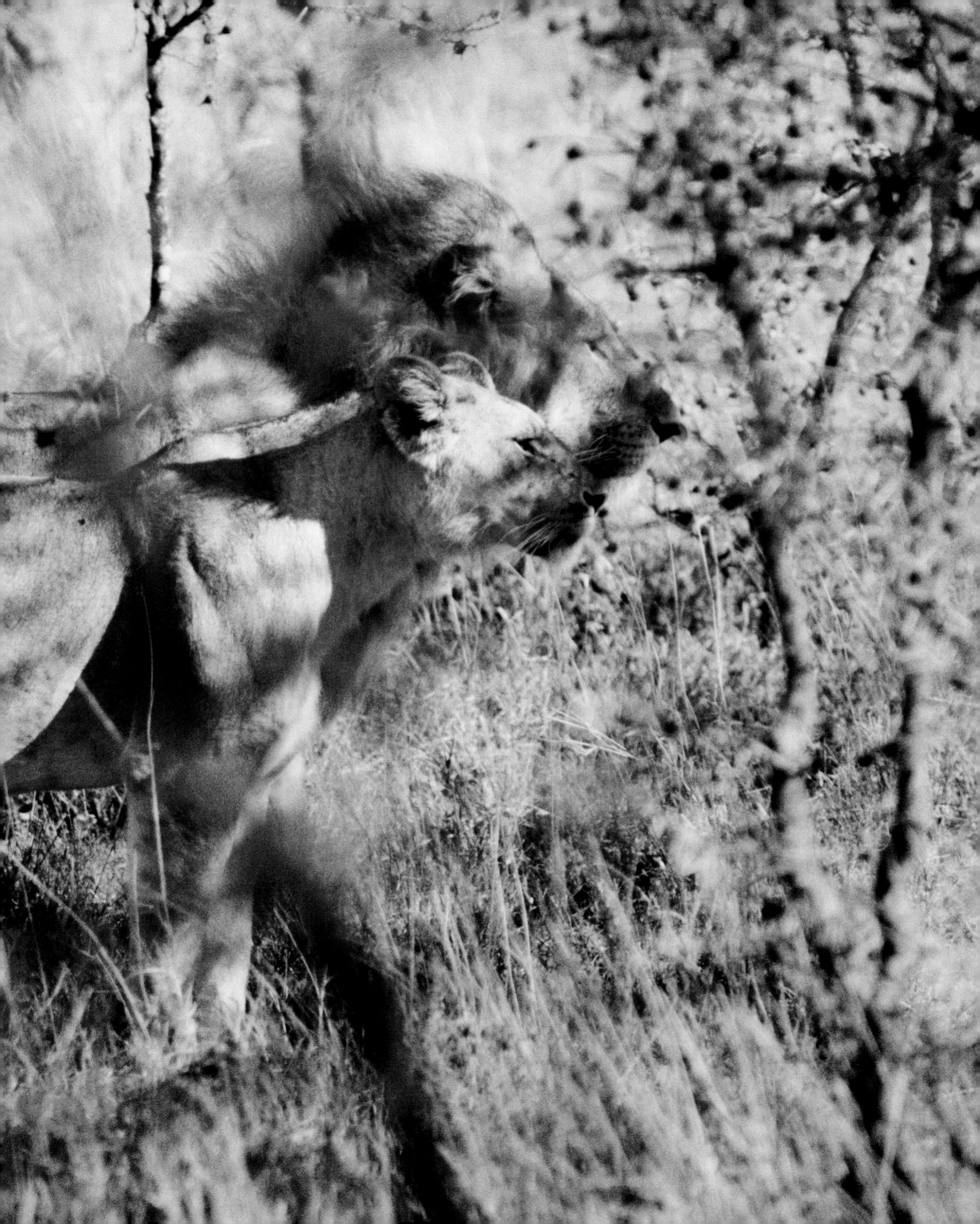

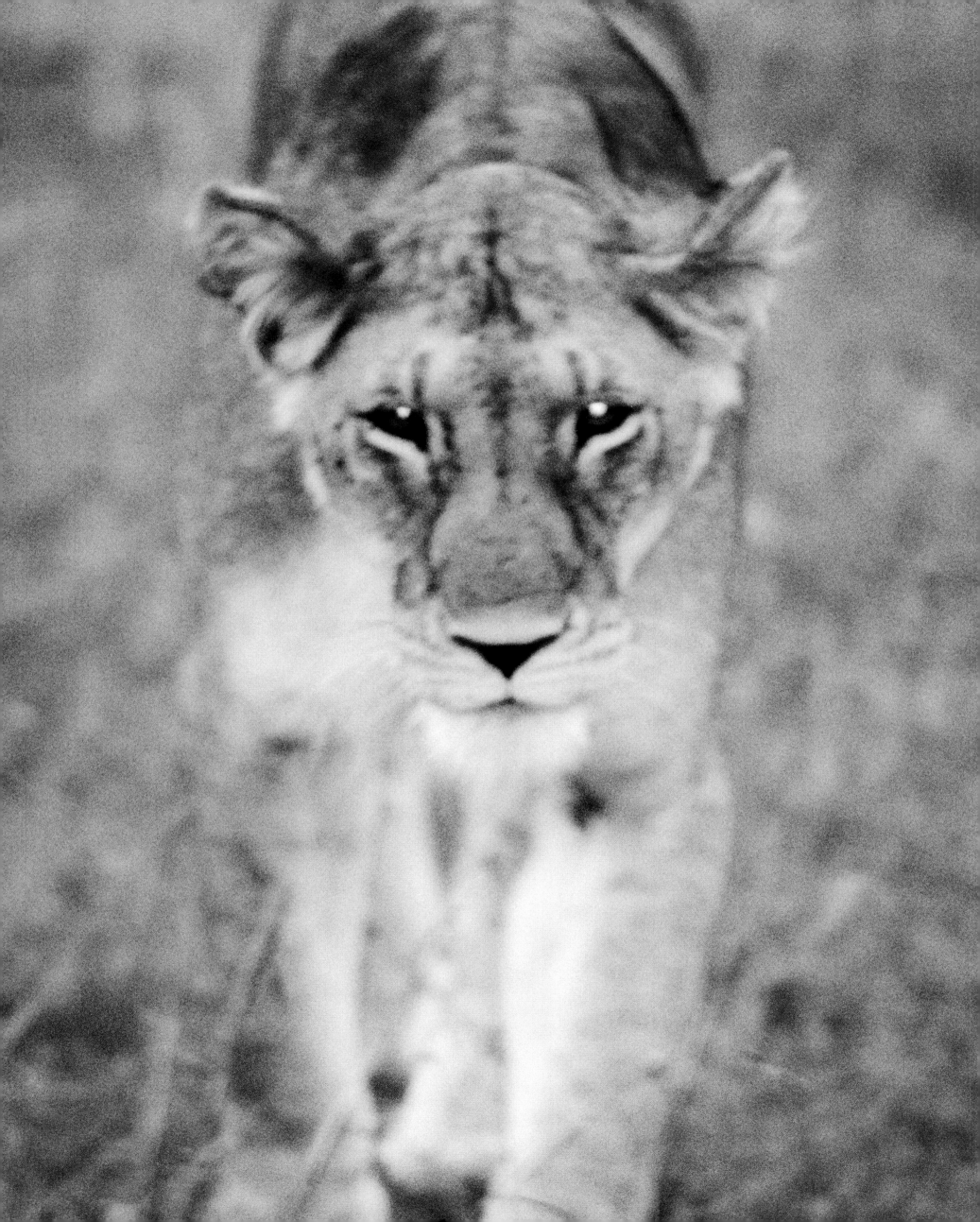

O beast of prey, let us now return home, for I have been dreaming about rain falling, the rain I dreamt about was an angry rain.

TRADITIONAL SONG OF THE
GWI BUSHMEN OF THE CENTRAL
KALAHARI, BOTSWANA

During a visit I made to the Chyulu Hills of southern Kenya in the 1970s, I was once woken in the middle of the night by the heart-stopping noise of lions roaring. One of the most fundamental sounds on earth erupted in a primal acoustic explosion through the jet-black African night. I'd long had a yearning for darkness, and it was realized in the Chyulu Hills, among the deposits of a vast volcanic field overlooked by Mount Kilimanjaro, across the border in Tanzania. As recently as the 1990s, several hundred thousand lions patrolled the outback of the African continent; at night, in one's tent, one felt as if the human world were just a vestige of a much larger mind, and the light of galaxies reigned over the imagination. The lion's roar was the voice of a parallel force, a competitor, but also an ally in time, in space, in evolution. I was travelling as part of a group of American students, and as we made our way from Nairobi to the Indian Ocean we had to stop on numerous occasions to mend tyres, and at night we set up campfires to keep the lions at bay. With a sense of wonder we listened to them roaring amid the impenetrable blackness.

Today, research by the organization LionAid indicates that there may be no more than 20,000 lions in all of Africa. Male lions may number only 3000. That is a catastrophic decline. The possible extinction of the lion imperils not only the relationship between prey and predator, but also much of the African wilderness.

In September 2002, by a small island in the Zambezi river on the border of Zambia and Zimbabwe, Marie and I watched, spellbound, as two superb black-maned lion brothers contemplated the waters before them. It was late afternoon. We were with our guides in a small boat, and were mesmerized by the grace, stealth and power of these carnivores. They seemed curious and fidgety, scanning the currents in front of them and looking to the Zambian side of the river, away from the mayhem of political unrest and devastation that had besieged Zimbabwe. We wondered if these lions might be political refugees. We will never know where they came from, but we were certain they wanted to get off the island. Perhaps they were fleeing Robert Mugabe's regime: Zimbabwe's autocratic ruler had created such misery and poverty for his people that they had wrought havoc on the nation's wildlife. The human race has, throughout its history, overlooked the pain and destruction imposed on the other beings of the world. Looking at these two majestic brothers, Marie and I were entranced by the beauty and freedom of two formidable beasts, animals that have been mankind's competitors for our entire evolution but also our peers in evolutionary time.

As the sun sank behind the forest canopy, the spectral light of the full moon glowed over the deep emerald-green of Africa. We watched the lions move towards the water and then retreat back into the bush as if to hide, seeming unsure of the best moment to cross. Perhaps they knew

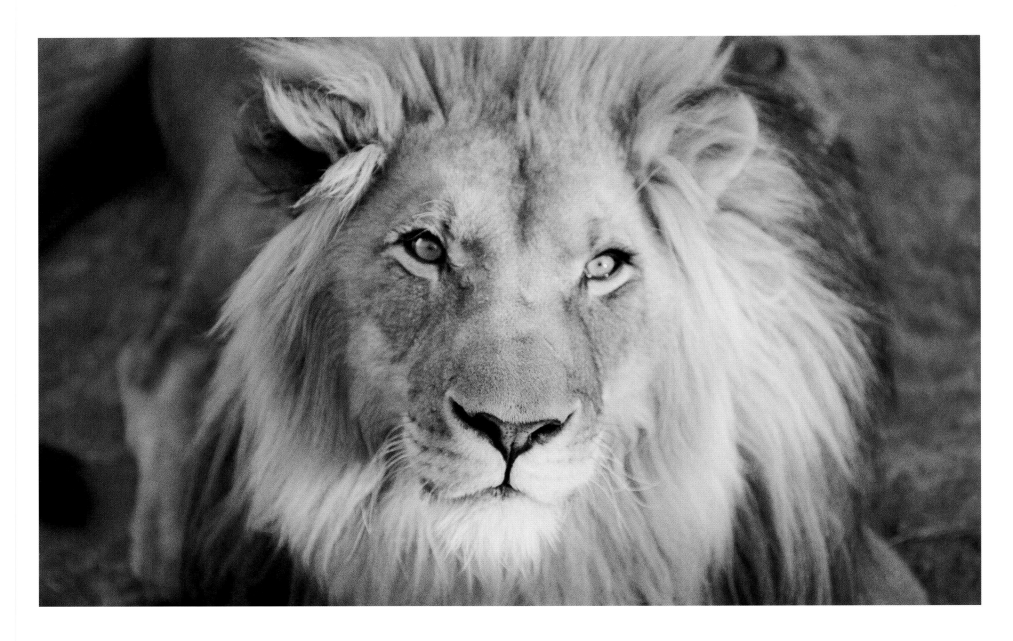

they were being observed. We wanted to see them swimming across the river, an act that few people have ever witnessed. Our guides did not want to disturb them and told us to wait. I was sceptical, because the lions were at the tip of the island, a few hundred yards away, and foliage blocked our view as they ambled between the river and tree cover. As the sun went down, I told our guides that we needed to approach the lions from the water and gauge what they were doing; I knew instinctively that they were up to something. They toyed with us, continually returning behind bushes as if sensing that intruders were gazing at them. I remember thinking, as the pearly luminescence of the rising moon was reflected in ripples across the river, that if we couldn't see where they were we would lose them entirely, and miss the possibility of witnessing two lions swimming across a river in the light of the moon.

Lions are not often found in water, and I was captivated by the idea of coming within a few feet of lions swimming in a current between two countries, as if on the edge between reality and dream. But when our guides finally decided to follow the lions and approach the point where the two would have entered the water, the cats had disappeared like phantoms into the netherworld. They were nowhere to be found; they had completely eluded us in the light of the full moon, and all that was left was the spell of tropical Africa, the soothing motion of water and the newly born moon. Part of me was glad that the two lions had succeeded in escaping our cameras. We could only hope that their cunning would serve them and their species well into the future, as humans everywhere in Africa challenged their existence at this fragile time.

It was in 1998 in Botswana that Marie and I first met the Kalahari Bushmen, often said to be the oldest continuous group of people on the planet. Their genetic line may go back more than 2000 generations. The Bushmen have traditionally been hunter-gatherers; they have no private property and show no sign of ever having indulged in warfare, and their egalitarian spirit is a paragon of the survivalist ethos. They have suffered persecution and racism since the Bantu and European powers invaded southern Africa over the past four hundred years; in the light of the hardships the Bushmen have had to withstand, their frequent joyous laughter is remarkable.

Roy Sesana, an elder whom we visited on our second trip to the Kalahari, in 2000, knows only too well that his people have been driven from their ancestral lands not because of their supposed hunting of wildlife, but because of the diamonds that lie underground. Roy once remarked to us that where you find Bushmen, you will find wildlife, and exclaimed, 'We are the diamonds of the desert!' The Bushmen honour 'the other', the surrounding wildlife on which they have always depended, and for countless

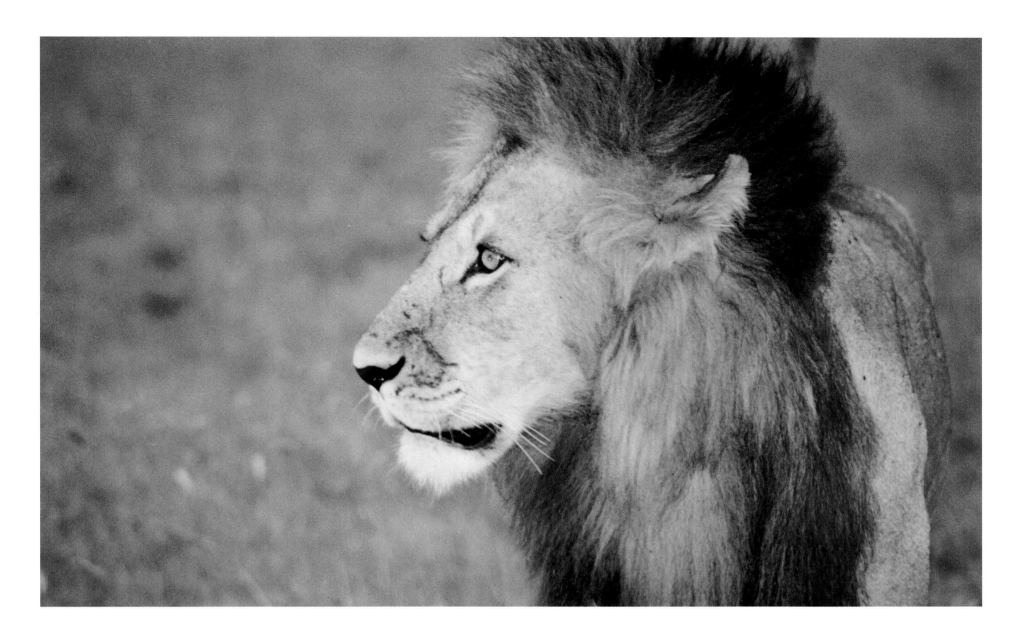

generations have considered lions to be their brothers. In contrast to the fantasies we in the West have projected on to the lion over the centuries, and to our merciless shooting down of trophies or the 'vermin' that has shattered our idealization of paradise and the wild, the Bushmen have lived in metaphysical and ecological kinship with the king of beasts, whose nobility and power represent the perfect hunter.

On our second trip to the Kalahari, we stayed with a Bushmen community in Kai-Kai in north-western Botswana, near the border of Namibia. There we were transfixed by tales of medicine men who climbed the threads to God's village far above the earth, and at night we witnessed the famed trance dance, possibly the oldest human ritual on earth. The shamans' respect for 'the other', especially the lion, was exceptional. One numinous night, under the mantle of the most brilliant Milky Way imaginable, the dance lasted nine hours, with medicine men in shorts circling the fire in what seemed a pageant to invoke the sun, accompanied by women clapping and singing. It was after this that we were told an other-worldly lion story by Bom, an elder who carried a scar from an old lion that had jumped on him when he was a young man. He wore the scar proudly, as if it were a talisman. One day, in the early morning after one of their dances, Bom and his friends had heard a lion roaring. The roar dissipated, but not before everyone had been alerted to the animal's proximity, and the senior men went out into the bush to try to find its tracks in the vast Kalahari sands. They found lion paw prints not far from their camp and followed them for a distance, and then saw that, amazingly, the tracks became human footprints that made their way towards the next Bushmen settlement a few miles away.

We cannot dismiss such tales as pure superstition. Things today are so very difficult for the Bushmen, but their lore and the trance dance help to keep their spirits afloat. One lion did pass through our camp at night on our first visit in 1998, but the great symbiotic relationship between two remarkable allies and supreme predators was altered over the course of the twentieth century. The bond between the Bushmen and the lion is a primordial gift few of us can fathom. It is a relationship defined by a unity of spirit and inseparability of mind. It is one of the great interspecies mysteries only the lion shamans truly understand. For the rest of us these stories must reside in the realm of myth.

In the Kalahari Desert of South Africa in 1998, a Bushmen elder by the name of Isak told us that, in his youth, 'when lion was sleeping you approached him to get his beard hairs to prove your bravery as a hunter … Everything we know on this earth we learned from the animals.' All the Bushmen we encountered agreed with Isak that 'lions bring freedom'. 'When lions roar you feel

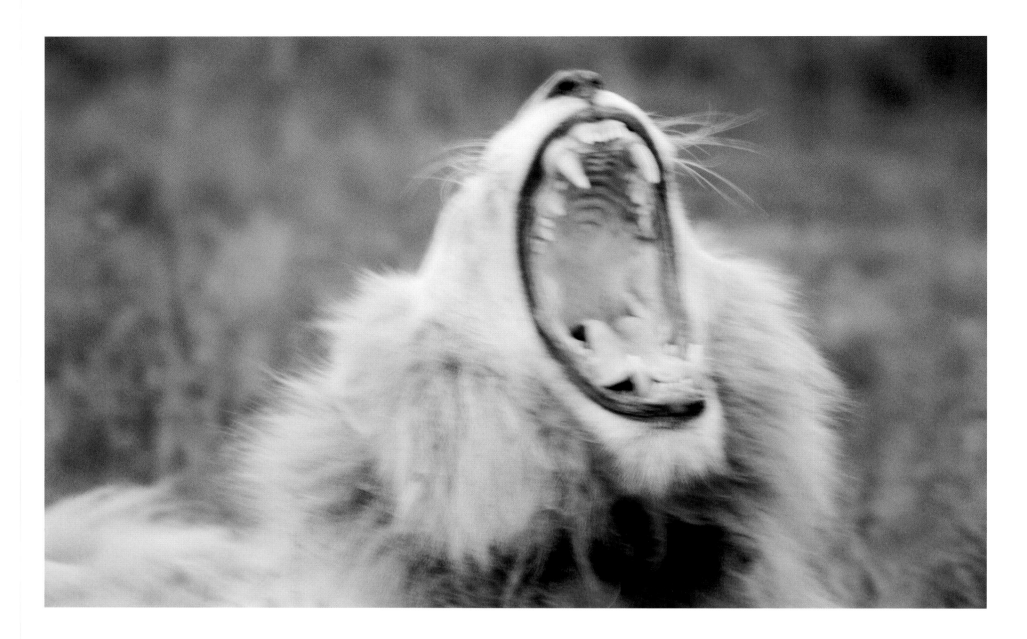

scared but you also feel happy', said one. 'The lion is our forefather, our ancestor', said the elder Lena, who at eighty years of age wore the wisdom of the desert sands on her wrinkled skin. Her half-brother Bukse told us that 'The lions of the Kalahari listen to you – but you must not swear at lions because they will come after you!'; and 'When the stars come out the lions make noise, they roar because it is time to walk, to look for food. They also roar when the sun comes up.' He also said: 'You have to be careful of them, but you must love them.'

Today, how many of us can say that we truly love lions – real lions, not the oversized imaginings of C.S. Lewis's *Chronicles of Narnia* (1950–56) and the musical *The Lion King*? If the lion should vanish within a generation, as we have been warned by such conservationists as the Botswanan film-makers Dereck and Beverly Joubert, the voice of the wild in Africa will have been silenced. The Afrikaner writer and conservationist Laurens van der Post put it succinctly in the 1980s:

> *I would find myself intensely grateful that I was living in a day when such a sound as that lion's roar had not yet vanished from life. For people so shackled with negative aspects of culture and civilization as we war-time soldiers were, there was in these sounds and sights something of the nature of a prayer for a song of life for sheer living's sake which is Africa's great gift to the modern world.*[1]

Who today can forgive big-game hunters and canned hunts – trophy hunts in which the animals are kept in a confined space from which they cannot escape? Who, having paid to kill a caged mother lion with nursing cubs, would dare to regard themselves as big or brave or a real hunter? What lies in the shadow of the human mind that lusts for destruction for its own sake? As the German geologist Henno Martin wrote after spending two years in the wilds of Namibia during the Second World War,

> *We had slid so readily into the life of primitive hunters that we came to the conclusion that underneath the veneer modern man still had a 'Stone Age soul', which was difficult to reconcile with the civilized life he was leading. Could that contradiction be resolved?*[2]

During a trip to Botswana in May 2010 we talked to Golaotsemang Senase of the Tswana people. As a young man, he'd had several close encounters with lions. Most Tswana have hunted lions only as a last resort, in order to defend their villages and cattle, and the anecdote Golaotsemang shared with us emphasizes the extent to which lions were simultaneously feared and respected.

> *In the village where I was born, we have cattle, goats and donkeys. We used to have a couple of prides of lions visiting the village. One day a pride entered the village*

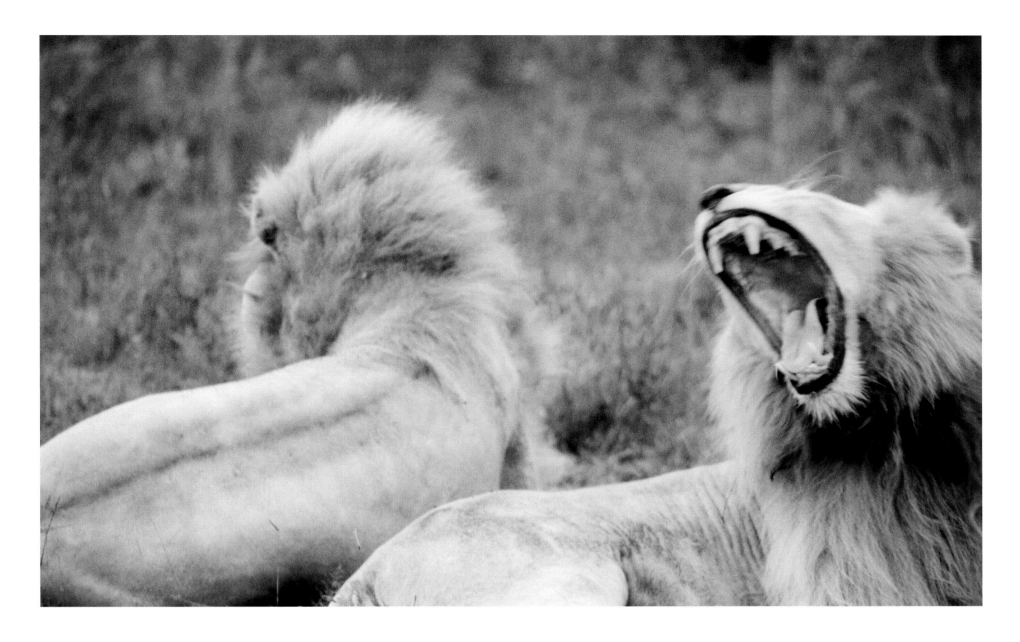

and killed cattle. Village people and the headman decided to hold a meeting in the boma [livestock enclosure] concerning matters affecting the community. All the guys who were experienced in hunting lions went out in a group called a maputo and set a couple of traps; they knew where in the bush the big male had gone, knew its movements and where it would come out. They took a piece of meat and used it as bait. The lion, attracted to the meat, came into the trap. Once the big male was caught, the rest of the pride moved out because there wasn't protection from the male.

After the lion was caught, the maputo called another meeting, and the men decided who would kill the lion. One man stabbed it with a spear. When it was killed they sent another man to the village to tell the khosi – the chief – that the big male had been killed. Young boys eleven or twelve years old were taken to the site where the lion was killed, to make them brave, in case they came across lions. One by one, the boys were told to lift the head of the lion and look into its eyes, to see for the first time a big male lion face to face. Some boys would start to cry, seeing how big its teeth were. They were made to see how dangerous this animal was. Then the men put each boy on top of it as if it were still alive. The first time riding that animal is really scary. Once you were released you ran back to the village. They did the same thing to all the boys until all had ridden the lion, to make them brave. Africa is great thanks to her lions.

For the semi-nomadic Maasai of Kenya's Chyulu Hills and Maasai Mara (the Kenyan part of the Serengeti region, which also takes in northern Tanzania), lion-hunting is linked to the pastoralist need to protect their herds of cattle, sheep and goats. The Maasai used to be initiated into manhood by their famed lion hunts, and had to defend their flocks against the ultimate predator, the lion, which they both feared and respected; nowadays conservation measures to protect the lion are paramount, even among the Maasai, as the animal is seen as a way of earning revenue from tourism. In 1998, we were told a story by the elder Paramitoro ole Kasiaro: one night there was a commotion outside the boma of a Maasai moran, or warrior, who had attended a Christian school, and he discovered that a big cat had taken one of his goats. He went to try to find his goat, only to be attacked by a leopard, which killed him. It could just as easily have been a lion. Paramitoro felt that the young warrior had been killed because he had gone to the 'other side' and become indoctrinated with Christian values.

As we tried to spot some of the elusive black rhino that range over the Chyulu Hills, our Maasai guide Jackson reminisced about a large male lion that had once entered his boma and made off with a cow. The ensuing lion hunt had taken several days, and the moment when three warriors finally converged on the lion with their spears and shields had taken on the drama of an initiation rite.

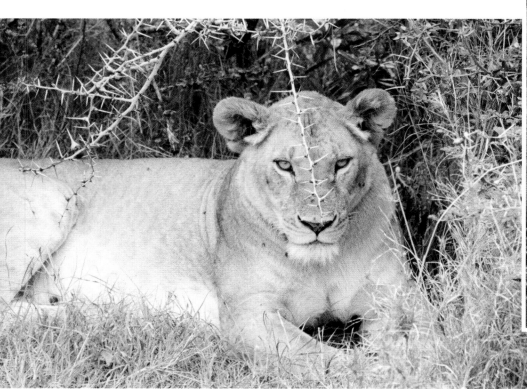
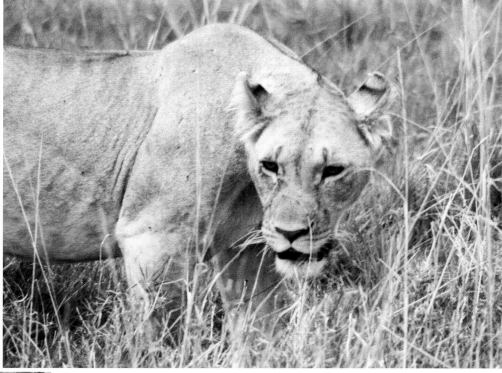

That killing was for lost wealth and pride; it was not a blood-thirsty and depraved act of murder. While the Maasai took lions for their manhood rites, and defended their livestock against the supreme hunter (more recently even killing lions with poisoned cow carcasses), they did so for reasons that are bound to their culture and way of life. Today, the Maasai know that, instead of being slayers of lions, they must become the animals' saviours, not only to encourage tourism and business but also in order to salvage the very ethos of their land and their people.

Both the Maasai and the Kalahari Bushmen evince a dignity and a respect for life that 'modern' man has lost. Ours is the morality of the destroyer, and not that of a warrior or a shaman who seeks to understand the essential being of 'the other'. Ours are the ethics of the coward. We exult in persecution for its own sake, in the infamy of mutilation. Our conceit will haunt us if one day we find ourselves alone with no great mystery to stalk us, no 'other' to watch and pursue us. The final retribution of the wild will be to condemn us to utter loneliness.

Kamunyak, 'the blessed one' in the language of the Samburu people of north-central Kenya, is a name we will always remember. Marie and I first heard of this lioness while we were in New Mexico in January 2002; she was said to have adopted as her own some oryx calves, which are normally among lions' standard prey, and we felt stranded thousands of miles away, unable to witness this remarkable event. A few months later, we heard that this strange predatory being had adopted three more oryx calves, as if in a Biblical fable. We happened to return to Kenya in September, and found ourselves with five days between camps. So we took the opportunity to visit the Samburu National Reserve, hoping to catch a glimpse of this amazing cat that had baffled biologists and won the hearts of people the world over. While we were there we saw Samburu herdsmen daily walking to the Ewaso Ng'iro river with their goats. We witnessed a few large bull 'white' elephants covered in lime to protect their skin against the sun and insects, giving a remarkable lustre to their skin. And we had our closest encounter yet with a leopard, which we saw stalking impala in broad daylight some 15 feet from our car; alone with this select predator, we felt that this sanctuary had favoured us.

But then, the afternoon before we were due to leave, our guides told us that Kamunyak had once again adopted a baby oryx. There are encounters in the wild that surprise us with their drama, stories from the likes of the American adventurers Martin and Osa Johnson, whose filmed encounters with African wildlife in the 1920s are historic. But how many lion sightings and close encounters would the Johnsons have exchanged for a glimpse of this amazing anomaly? Our jeep practically flew over the sand to where Kamunyak had been spotted. When we arrived,

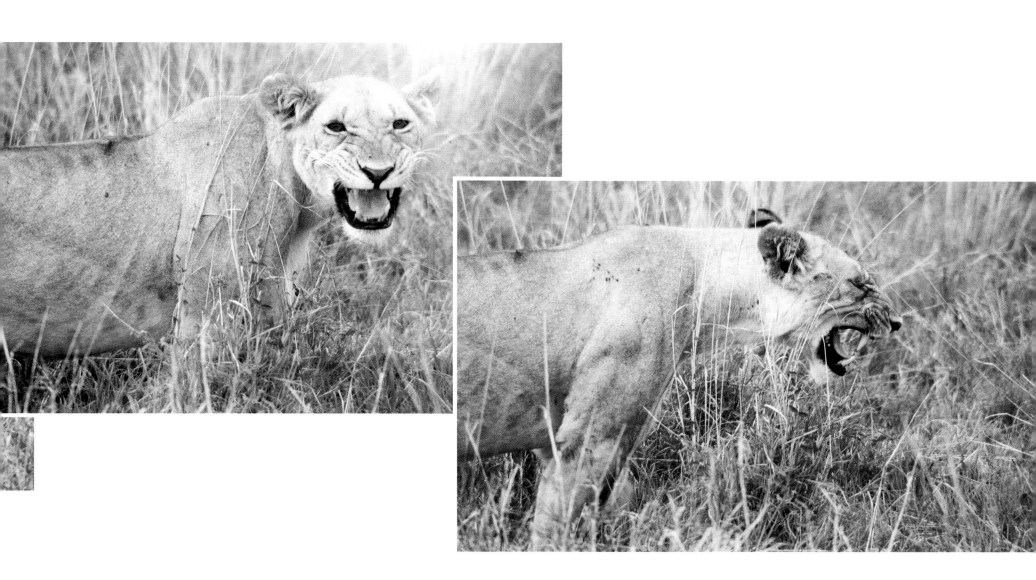

she was lying in the grass with her adopted 'baby' barely discernible beside her. Dozens of cars were parked there for hours, their occupants transfixed by the lion. We waited, hoping that she would move, walk about or play with her oryx calf, but she did not budge. It was as if the human world did not exist. We left at sunset, satisfied that we had seen her and her adopted calf, and felt the privilege of having witnessed one of the miracles of modern biological lore. But we returned the following morning, and were able to see the full extent of Kamunyak's gentleness and playfulness. We had her all to ourselves in the acacia forest, and saw the fantastic duo playing together and lying side by side, the oryx calf seemingly without a care in the world. The scene felt as if it were from an African Eden that might have existed before the European powers began their colonial conquest, a fable that had come to life for a lucky few who would report to the modern world that the lion could indeed lie down with the lamb.

The calf seemed carefree until its oryx family arrived, and as it tried to join them Kamunyak remained near by to retain her calf. For an hour we watched the young oryx trying to reach its mother as she circled about the acacias with two other oryxes, but then we had to catch our plane and left this caravan of the quixotic to its own destiny. In this lonely spot in the savannah a miracle had taken place: predator and prey for a brief while had become allies in the dance of life. This last oryx eventually died of thirst and was eaten by Kamunyak, following the natural order of the savannah. Kamunyak, unlike us, did not kill wantonly and for bloodlust or vanity. She was last seen in 2004. Kamunyak was perhaps an aberration even to her own kind, and to this day neither biologists nor conservationists can fully explain her behaviour.

Ultimately, whether the lions survive (and the tigers, and the polar bears) will depend on whether we can create a new ethic, a new way of coming to terms with 'the other'. There are signs – such as the Nagoya Protocol on biological diversity (2010) and the International Tiger Conservation Forum in St Petersburg, the first international summit held for a single species (also 2010) – that humanity realizes what is at stake. Few have observed the wonders of the natural world as eloquently as Loren Eiseley, who in his 1950s essay 'Man of the Future' asserted:

> *The need is not really for more brains, the need is now for a gentler, a more tolerant people than those who won for us against the ice, the tiger and the bear. The hand that hefted the axe, out of some blind allegiance to the past fondles the machine gun as lovingly. It is a habit man will have to break to survive, but the roots go very deep.*[3]

Lions continue to be savaged for their skins and their body parts. We have to wonder if we have left the savage state ourselves, for we kill mercilessly, out of caprice, out

In another generation, perhaps, the animals of Africa, the little, beautiful animals of the plains and the strange, gigantic animals, the last survivors of the age of mammals, will be all but extinct.

OSA JOHNSON,
FOUR YEARS IN PARADISE, 1942

of misplaced notions of manhood. Our century entirely depends on our coming to terms with the shadow side of our psyche. All the great predators have been considered to be both royal game and vermin, at once icons of majesty and ruthless predators. Perhaps it is time that we see them instead as beneficiaries of a supreme freedom that we no longer possess, and if we were to exterminate them, our freedom, too, will have dissolved into the mists. As the aviator and explorer Charles Lindbergh tells us in his book *Autobiography of Values* (1976), when a Maasai elder said to him, 'We have known a freedom far greater than yours', he was alluding to the ultimate freedom of belonging to the world. In killing the supreme hunters, we lose our dialogue with existence; we desecrate beauty with vanity, grace with perfidy. If humanity is to survive, we must hold ourselves accountable. The time draws near when we will find out decisively if we are saviours of species, or their slayers.

One of the greatest lion tales that we heard came from our guide Gee in Botswana in 2010. He told us of the time when, as a young teenager, he was walking in the Okavango Delta with his father and came upon some lion cubs. His father cried out for him to 'freeze', and Gee had the intuition to know that the mother lion was somewhere near by and that if she arrived, he should not demonstrate fear. And indeed, from just a few paces away the lioness erupted from the grass at full speed towards Gee, who stood his ground. The lioness stopped right in front of him, creating a cloud of dust, raised herself on her back paws and rested her front paws on his chest. Somehow in that moment the lioness sensed that Gee was not there to hurt the cubs; she gazed briefly into his face, returned to the ground and turned to see to her cubs. Gee had shown no fear, the lioness had recognized that he posed no threat, and he was spared.

Gee's story is one that many will not believe, but I trust it because it is set in a time when there was less suspicion between lions and men, when a truce between two killers was more the norm. Today the lions are fighting for their lives. What we must understand is that we humans are also fighting for our lives, or more precisely for our souls. Without the beauty and the unfathomable eyes of 'the other', we will have only ourselves to gaze at and will lose forever our claim to be the stewards of the earth. As the Danish polar explorer and anthropologist Knud Rasmussen was once told by an Eskimo shaman in the Arctic, we should 'fear only the heedless ones amongst ourselves'.[4]

During our son Lysander's first visit to Kenya as an infant in 2006 and 2007, he learned to walk among the plains of Africa with several Maasai guides, including Rakita, who is of the Ndorobo sub-clan of the Maasai. It was with Rakita, in the Maasai Mara, that one late afternoon we witnessed

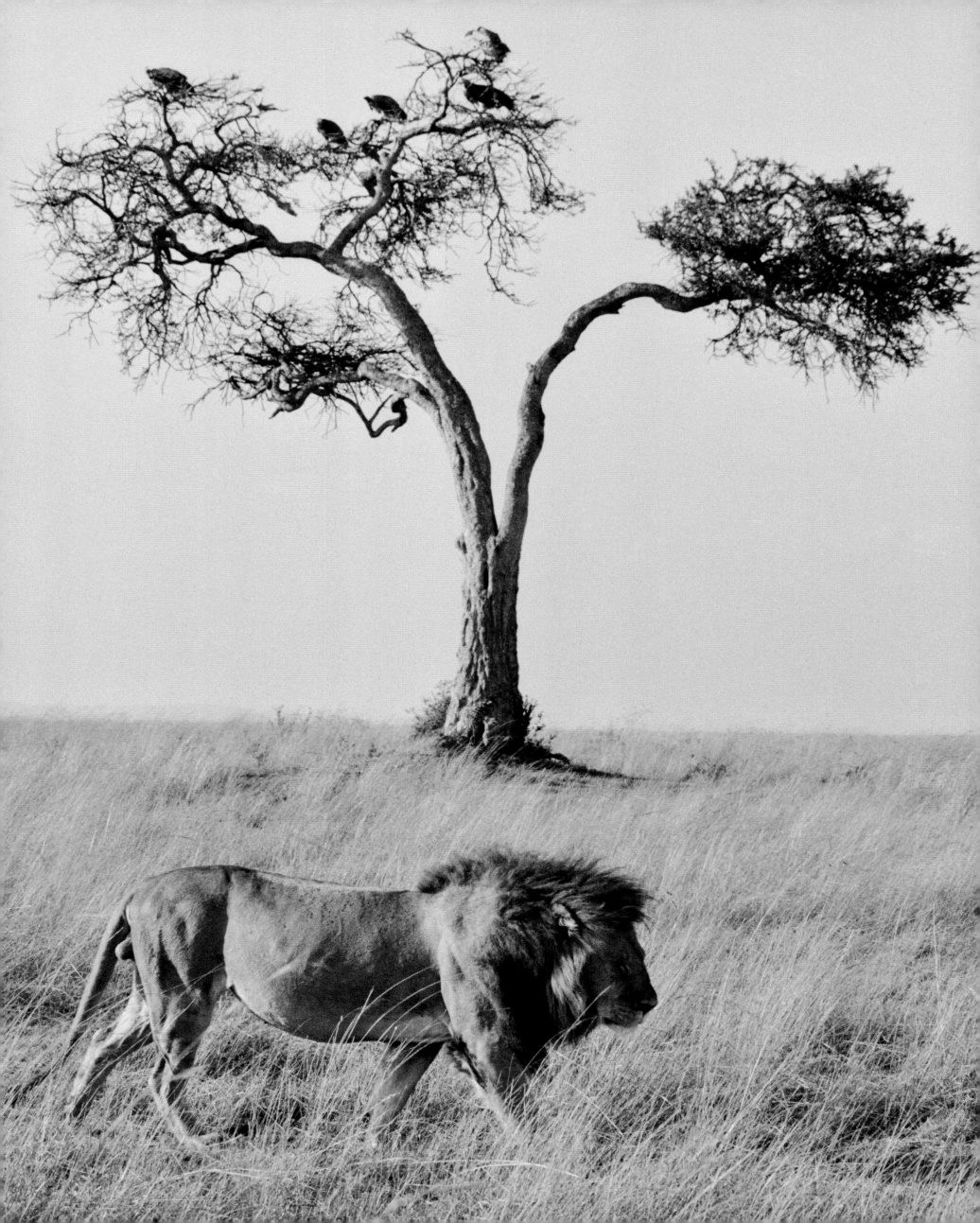

our first kill by a hyena, in which a young wildebeest was charged at and separated from the rest of its herd. One day in 2011, I was startled to see Rakita and a few Maasai companions on American television, demonstrating a behaviour that goes back to the roots of our species. As a pride of about eight lionesses were busy eating their newly taken buffalo, Rakita and his fellows very slowly and gingerly approached the pride, making their way towards them in a respectful and submissive hunch. Shortly before the men arrived at the dead buffalo, the lionesses growled but moved off to the side, allowing Rakita to cut off a few pounds of meat with his knife. No one was hurt, no conflict ensued. The Maasai slowly backed off, and soon the lionesses returned to the buffalo. I was happy to have seen Rakita again, if only through the vehicle of modern media. As in the case of Koni's tale (see page 16), what makes this story sing is that it exemplifies respect for 'the other'. A truce *is* possible between ourselves and even the most powerful exemplars of 'the other', and it has formed part of our relationship with 'the other' for mankind's entire history. It is part of who we are. It is a story of cooperation that is part of our past and must be part of our future.

In 2010, while we were visiting the Timbavati nature reserve in South Africa to see the unusual white lions that roam there, we met a researcher who was studying elephants and the grasses they eat. She told us she believed that the future of wildlife would rest not in science but in poetry. What I feel she was alluding to is the unearthly ability of the heart to be seized by the mystery of life. Much of what native peoples know and revere about other dimensions, other consciousnesses and the interspecies connection, modern science and psychology are only recently verifying. And there are deeper mysteries we can only marvel at. We should not depend on science and eco-philosophy to confirm that life is miraculous. At a time when we are trying to discover just a single form of life on other planets, let us try to hold on to the millions that inhabit our own. Species extinction and man's concomitant loss of soul are our greatest threats. Species loss is a threat to both our very humanity and the foundation of our human culture.

In menacing 'the other', we are eclipsing our own being, and defeating it. It is a defeat that no art, no symphony will ever be able to remedy. Primal man's most formidable totems will have been defeated, and so will have our imagination. Eiseley, who knew that 'modern man, the world eater, respects no space and no thing green or furred as sacred', honoured the ways of the first peoples when he wrote in the early 1970s:

On the African veldt the lion, the last of the great carnivores, is addressed by the Bushmen over a kill whose ownership is

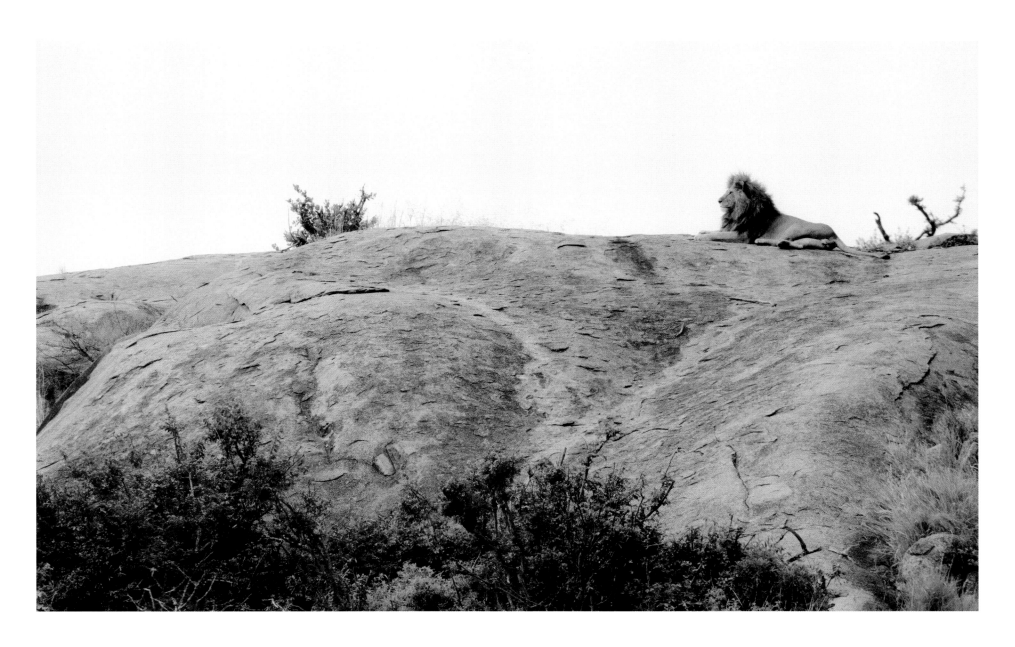

contested. They speak softly the age-old ritual words for the occasion, 'Great lions, old lions, we know you are brave'. Nevertheless the little, almost weaponless people steadily advance. The beginning and the end are dying in unison and the one is braver than the other. Dreaming on by the eclipse-darkened window, I know with a sudden sure premonition that Kingsfoot has put his paw once more against the moon. The animal gods will come out for one last hunt.[5]

But what if these gods were silenced forever, what if they came out no more? By leaving the timeless world of 'the other', of those we have maligned, we will have descended into a purgatory of our own making. We must look for the answers in the eyes of those who have preceded us. We must look for the answers in the eyes of 'the others', for theirs are the eyes of origin. And our origins inform our future as well.

Notes
1. Laurens van der Post, *A Walk with a White Bushman*, London (Penguin) 1986.
2. Henno Martin, *The Sheltering Desert* [1957], trans. Edward Fitzgerald, Johannesburg (Ad. Donker) 1983, p. 192.
3. Loren Eiseley, 'Man of the Future', in *The Immense Journey*, New York (Vintage) 1957, p. 140.
4. Knud Rasmussen, *Observations on the Intellectual Culture of the Caribou Eskimos* [1930], New York (AMS Press) 1976.
5. Loren Eiseley, *The Invisible Pyramid* [1971], Winnipeg (Bison Books) 1998, pp. 70–71.

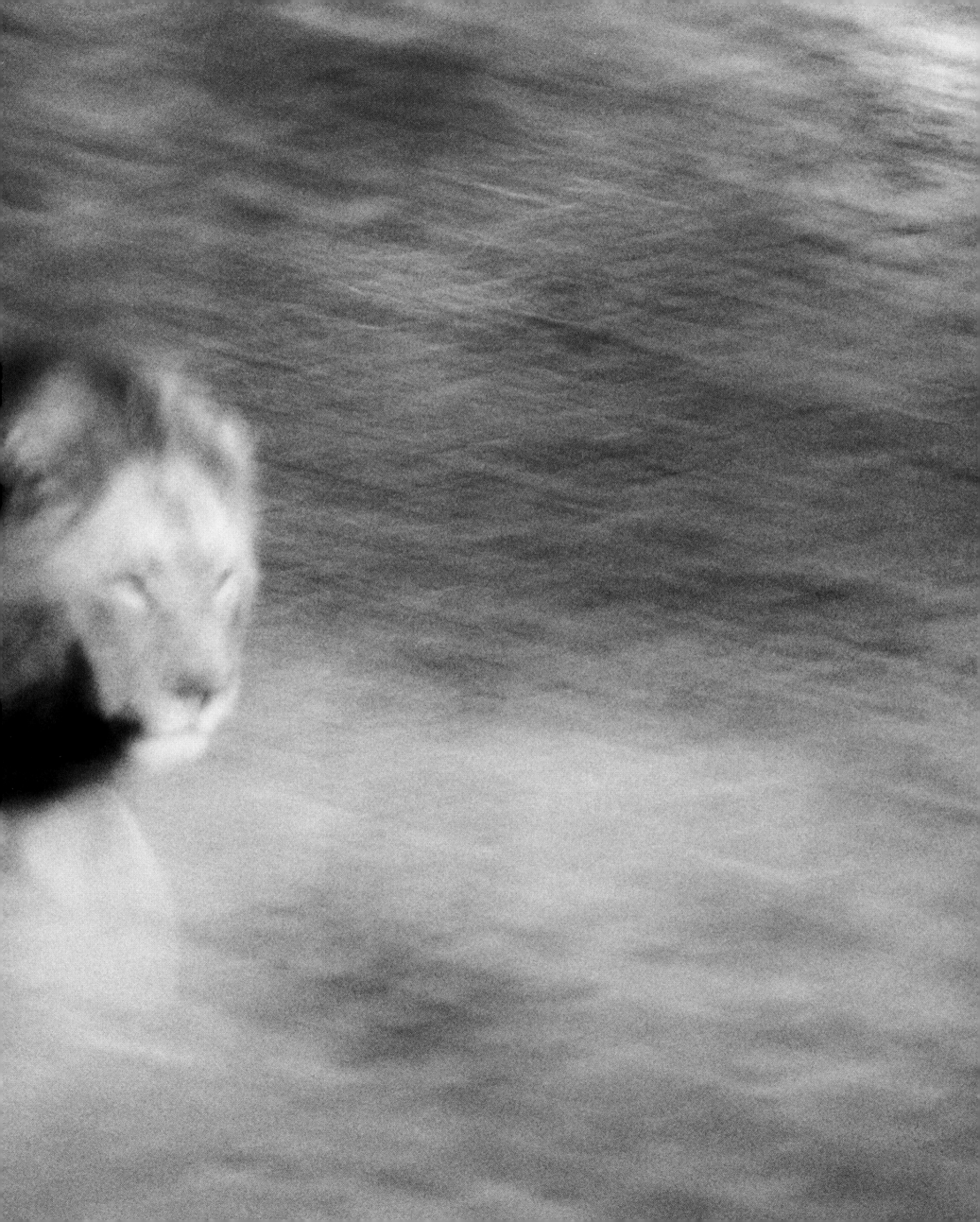

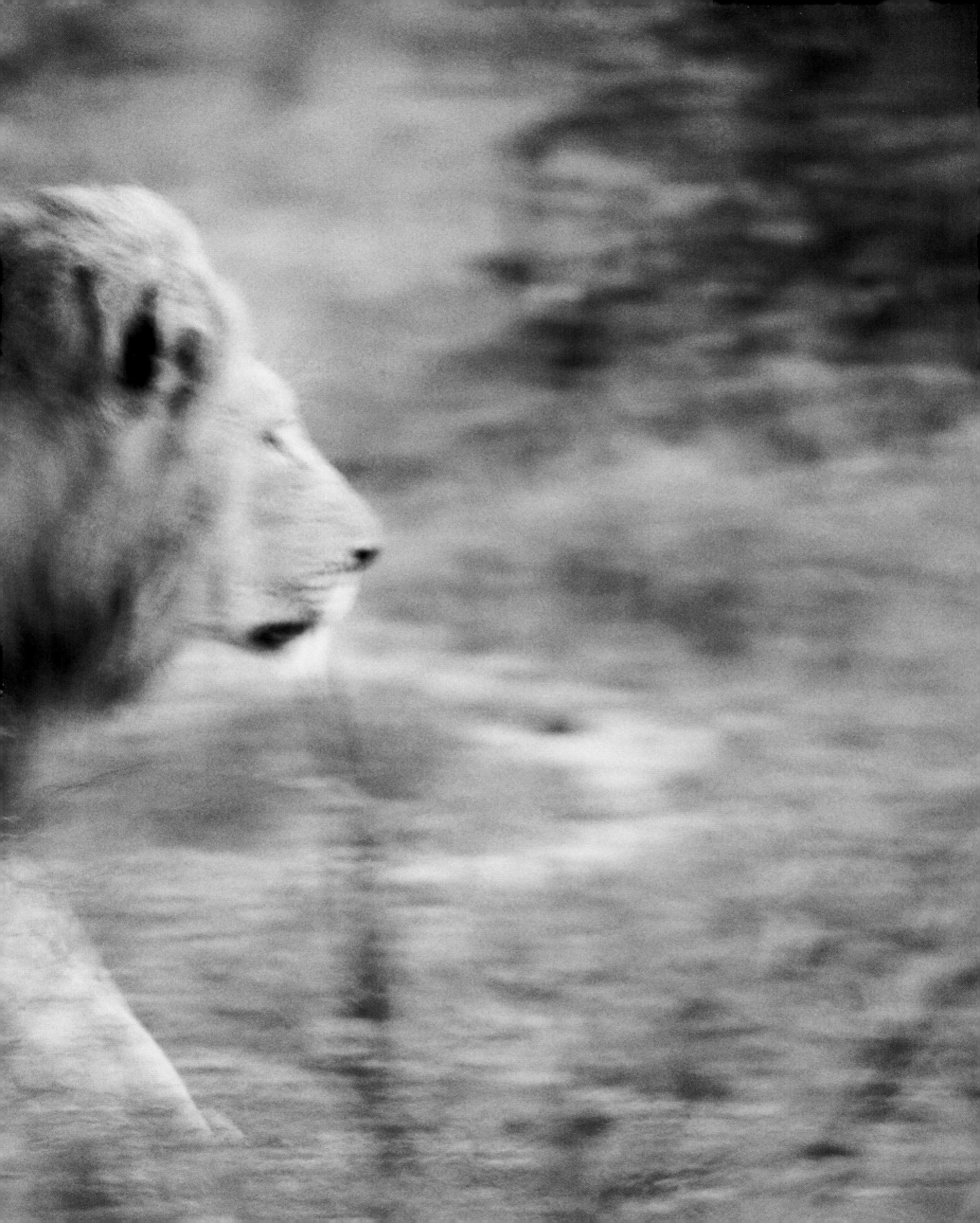

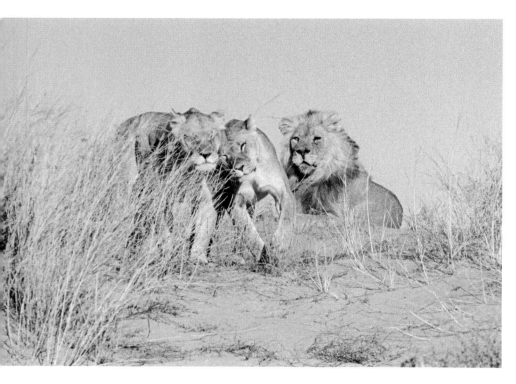
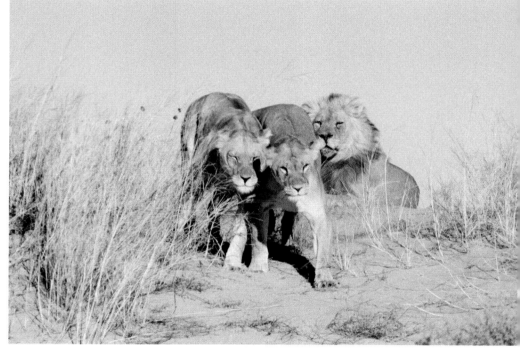

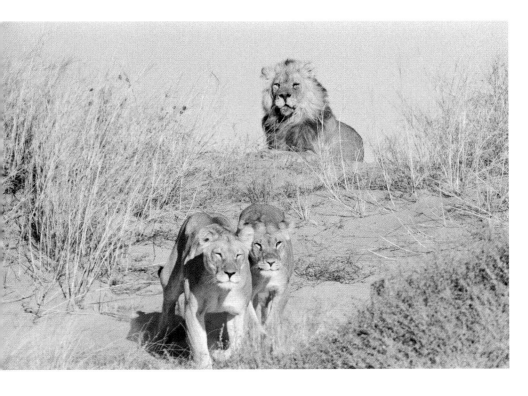
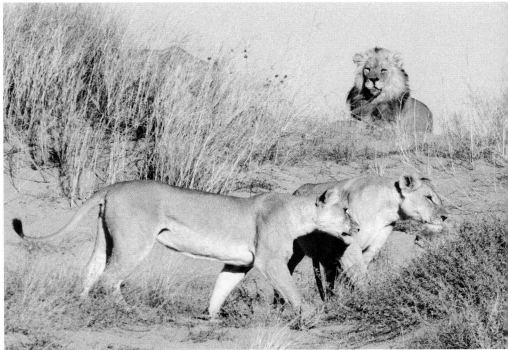

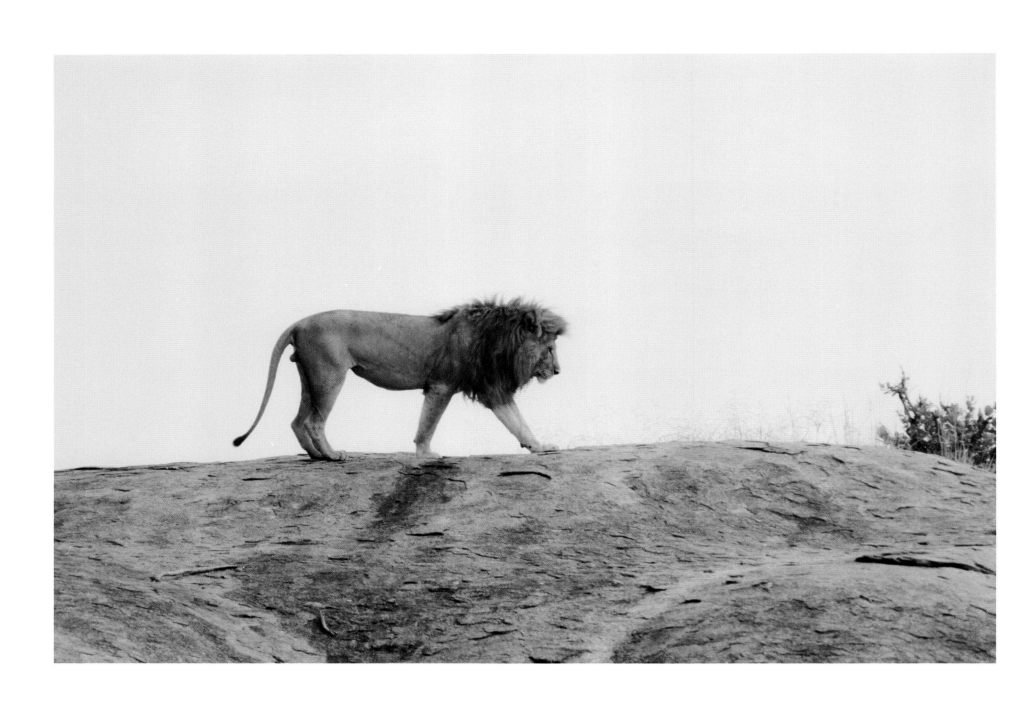

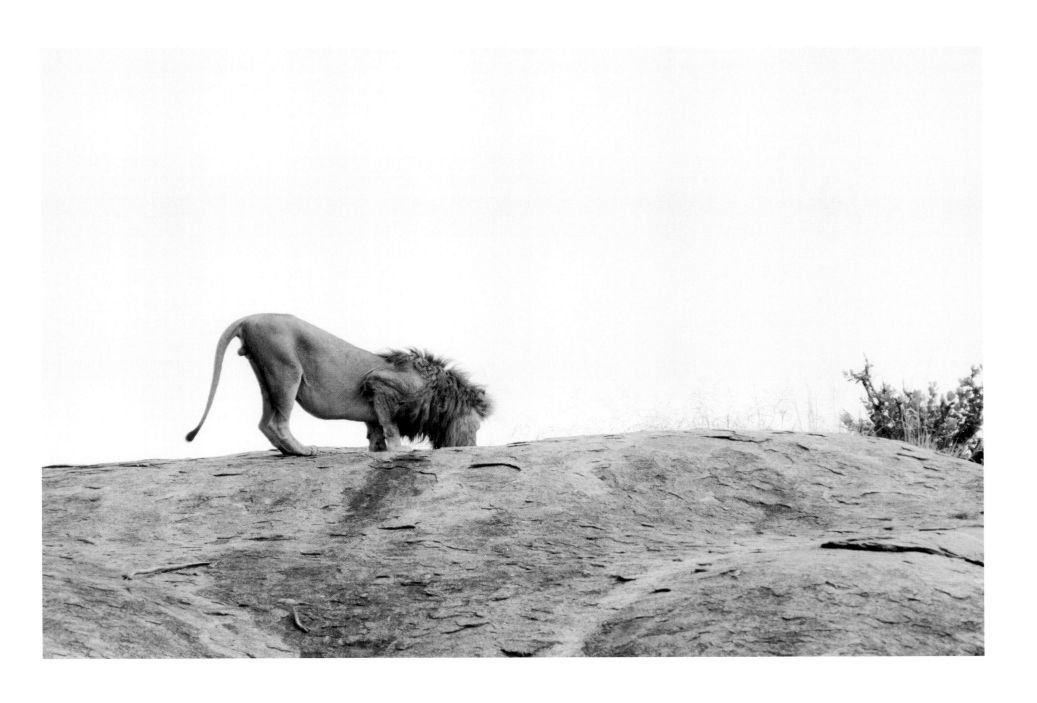

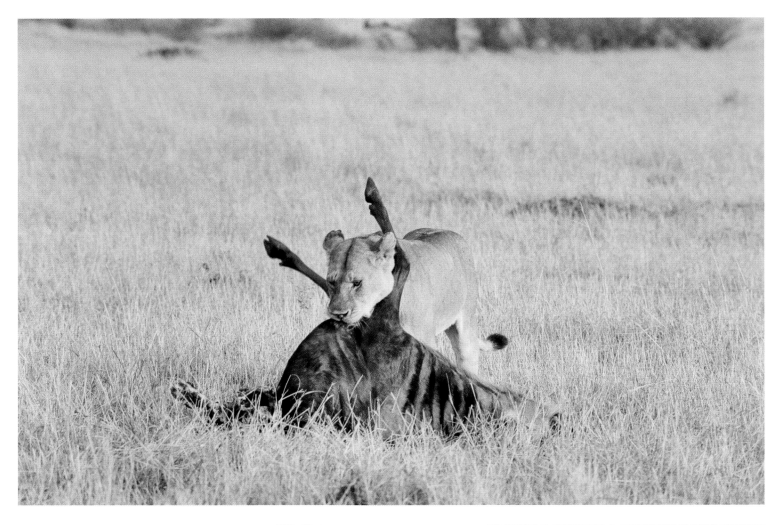
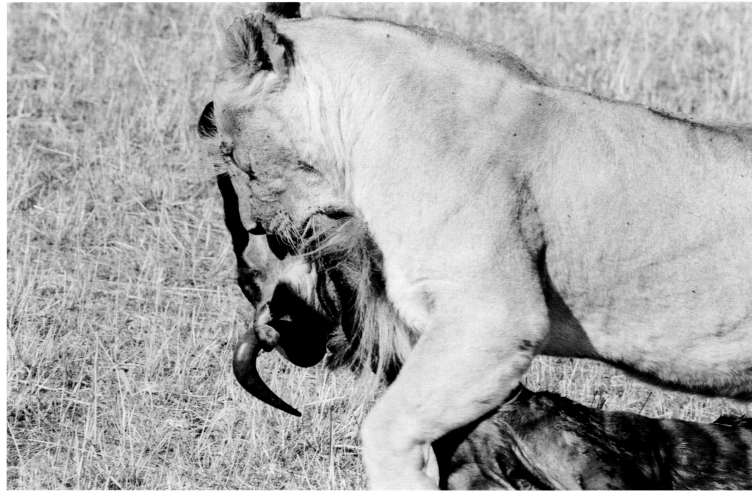

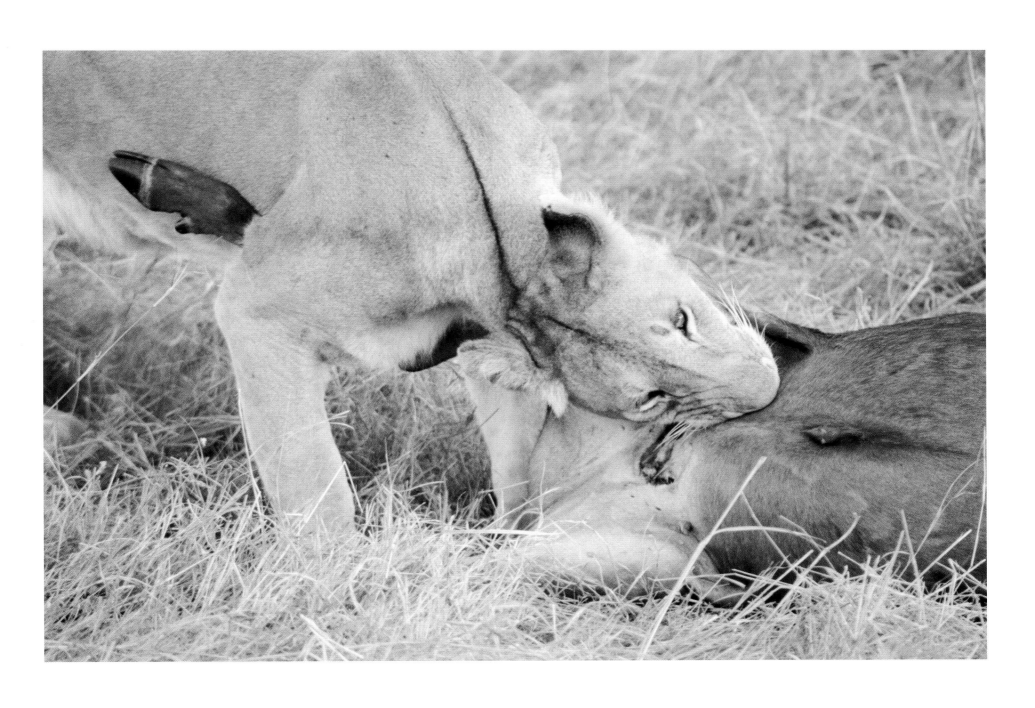

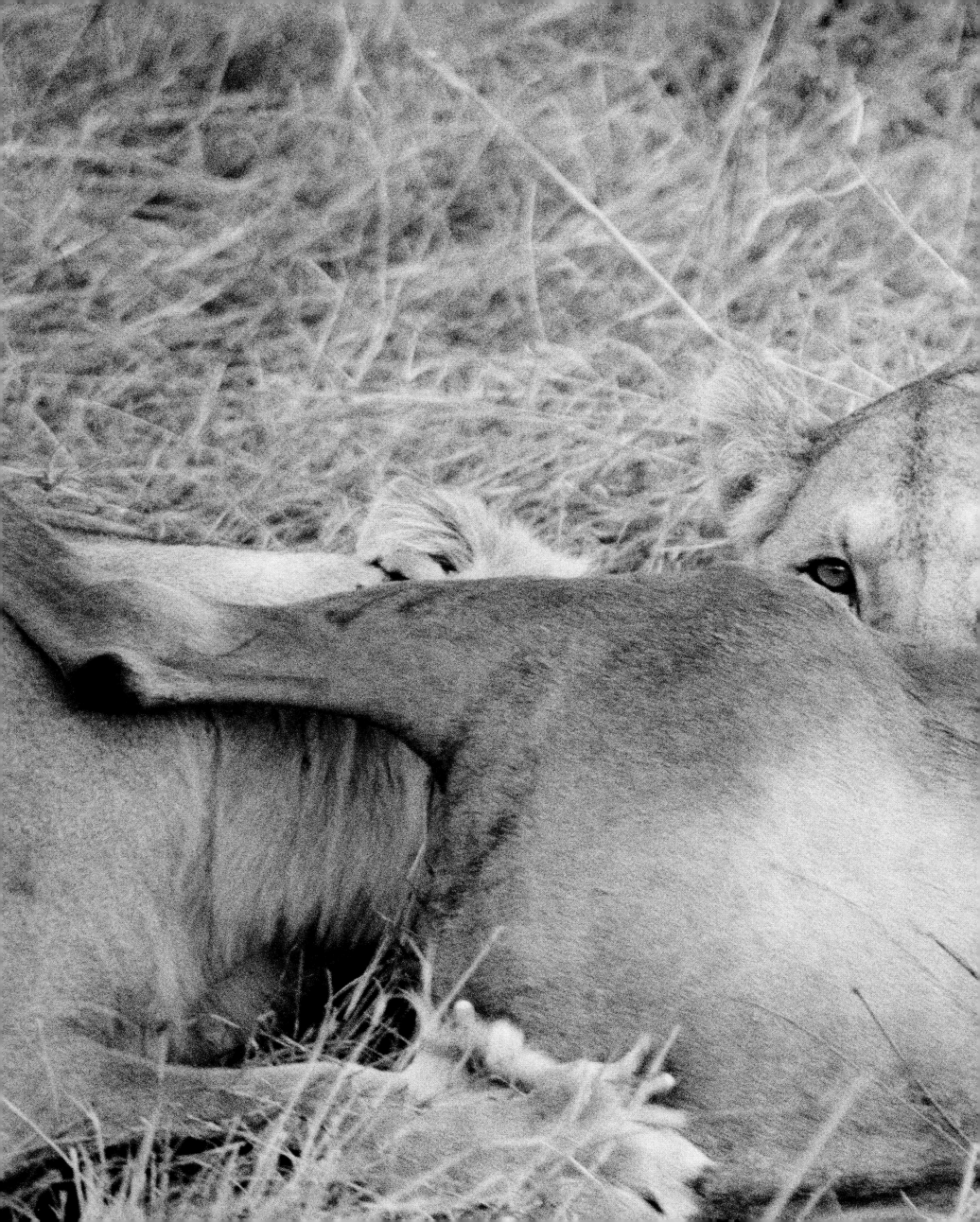

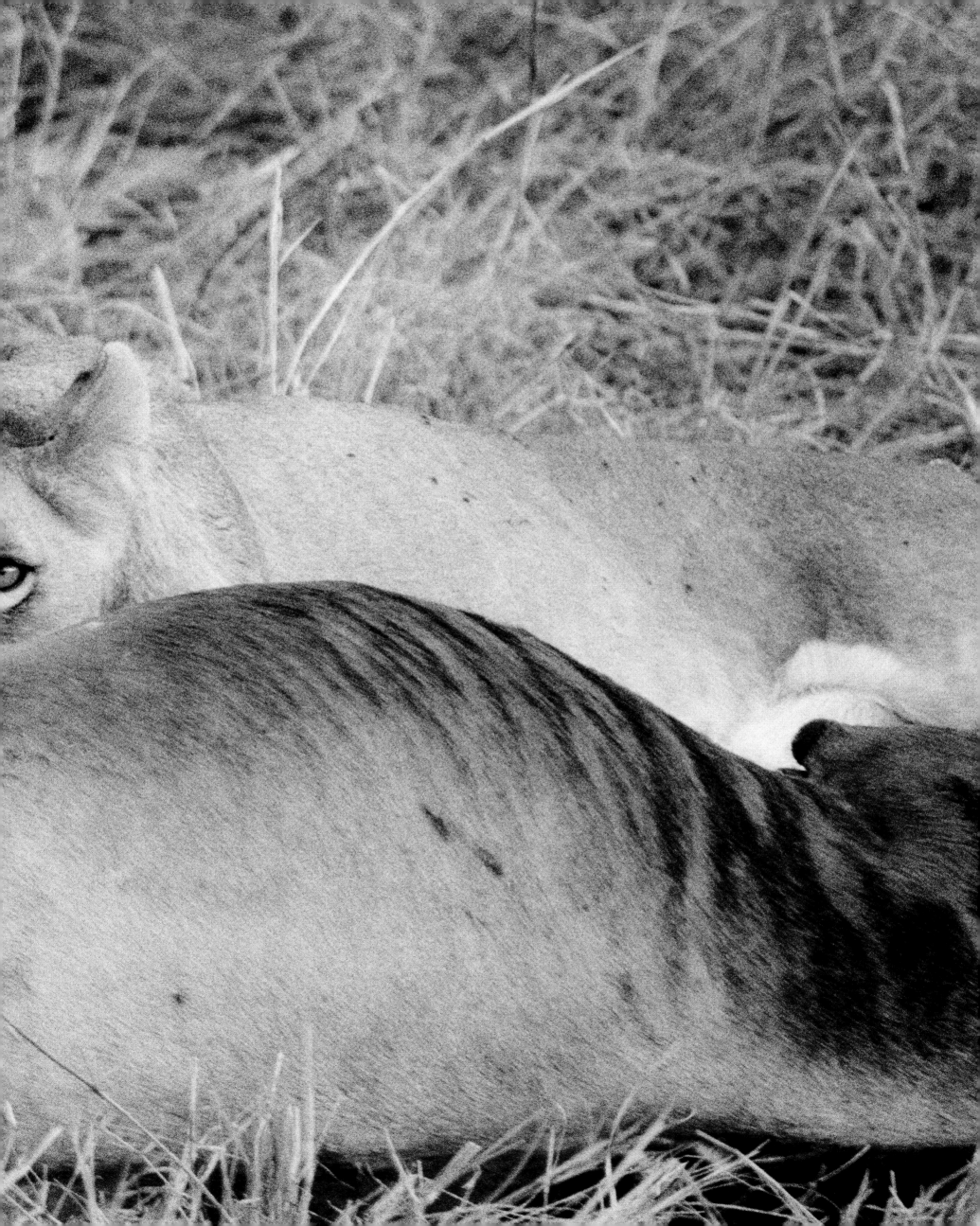

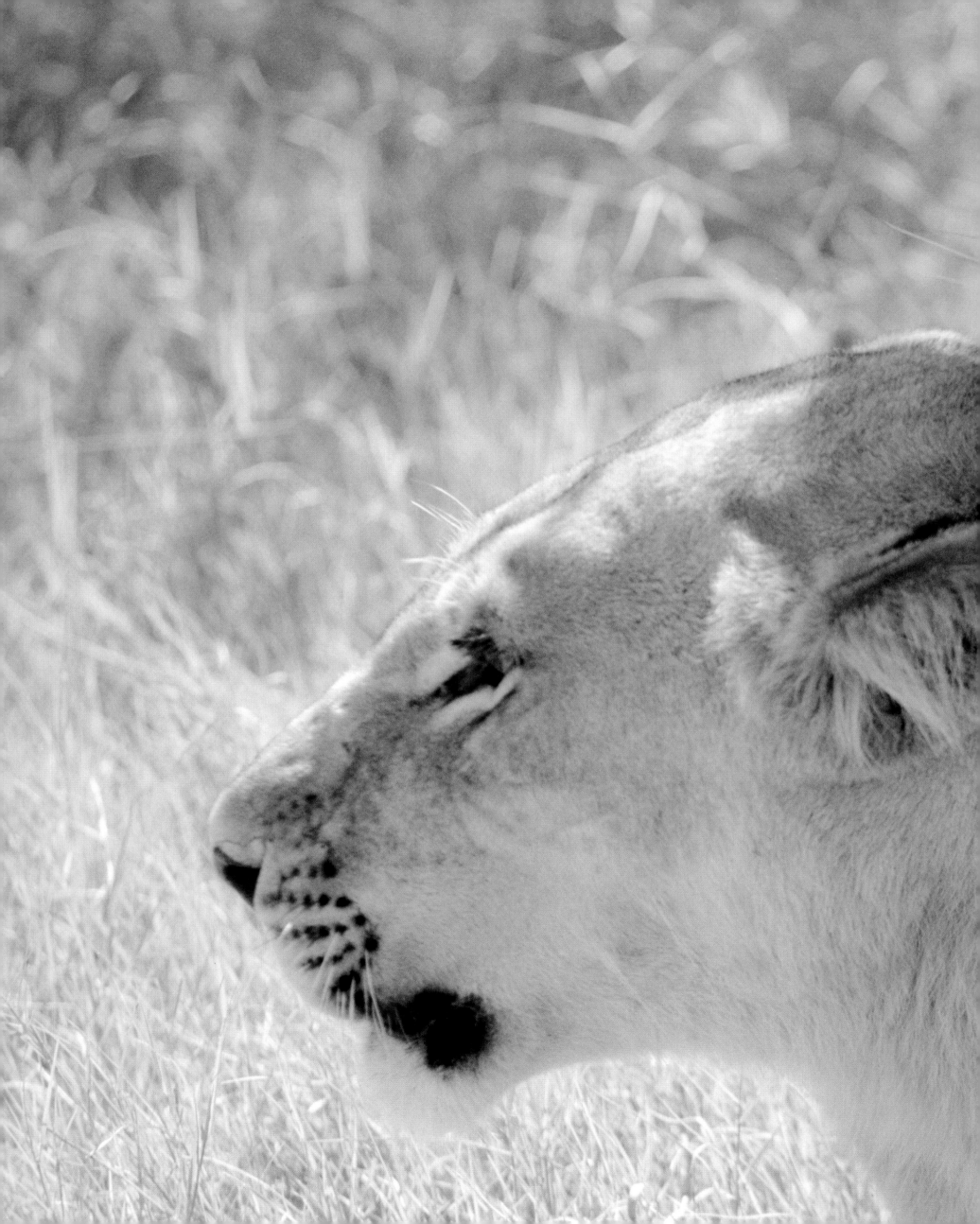

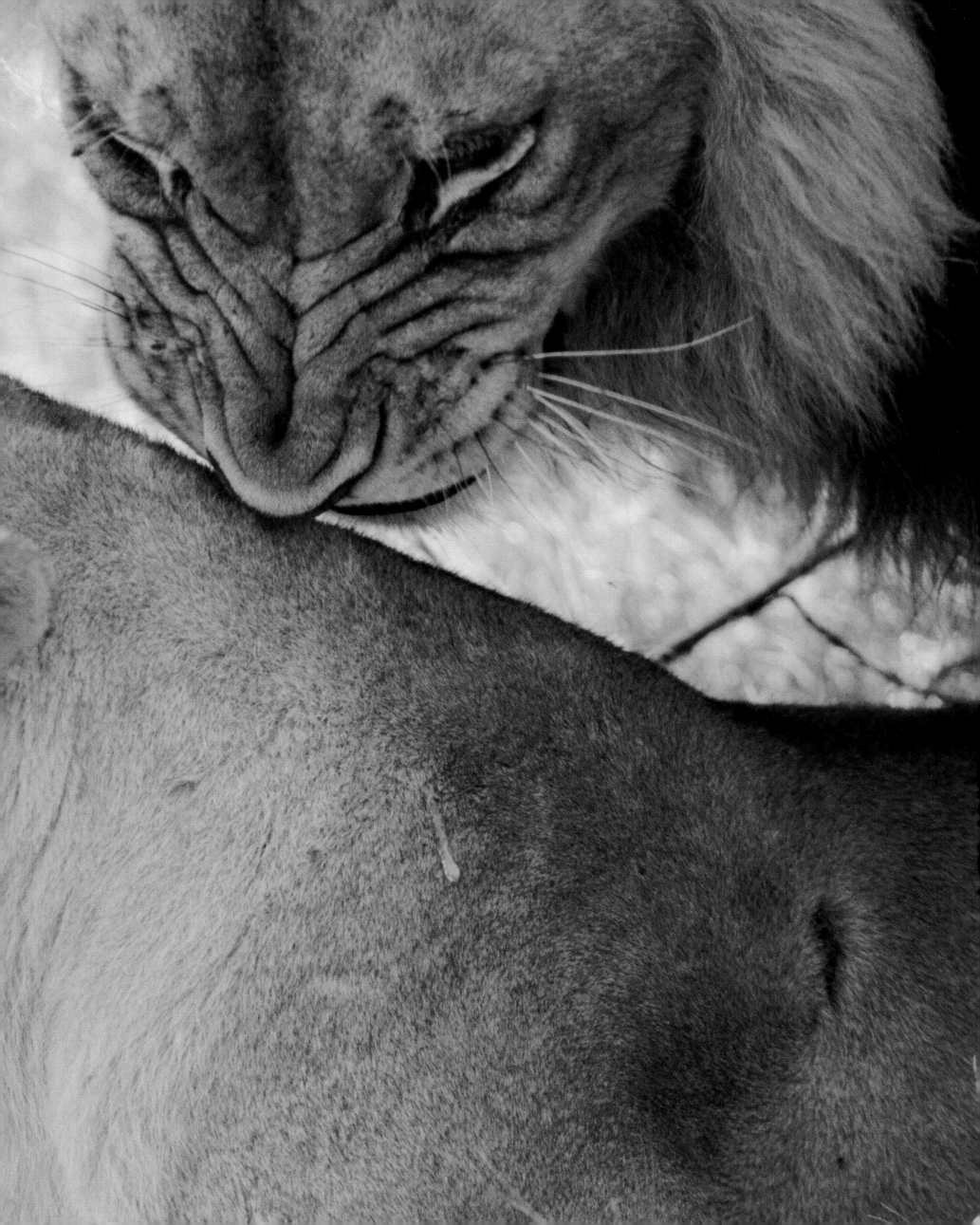

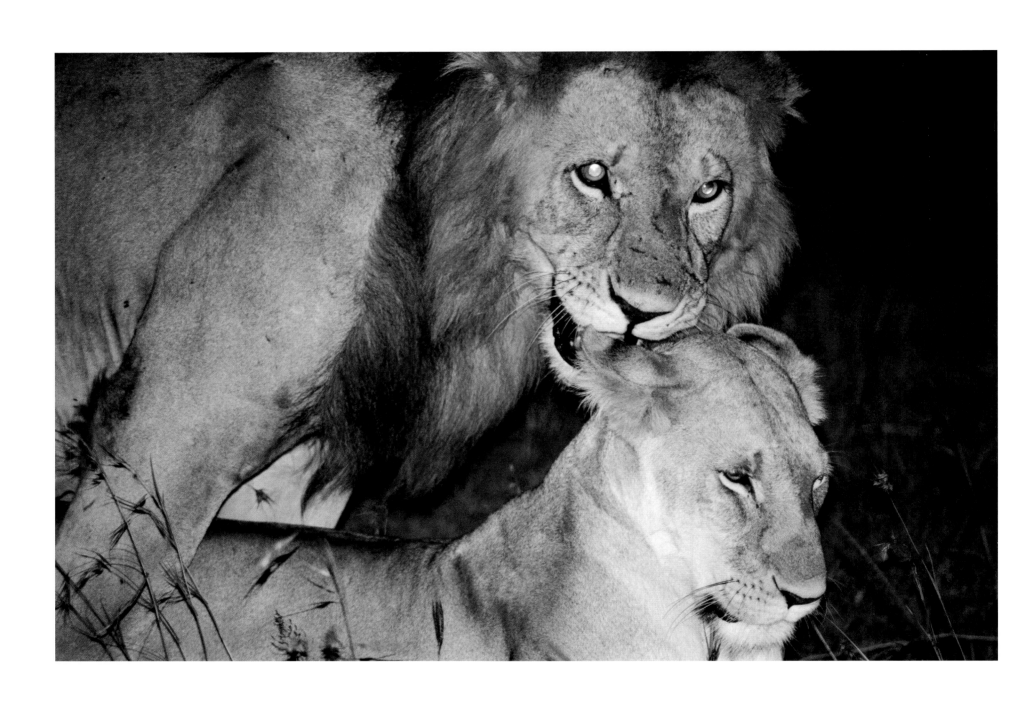

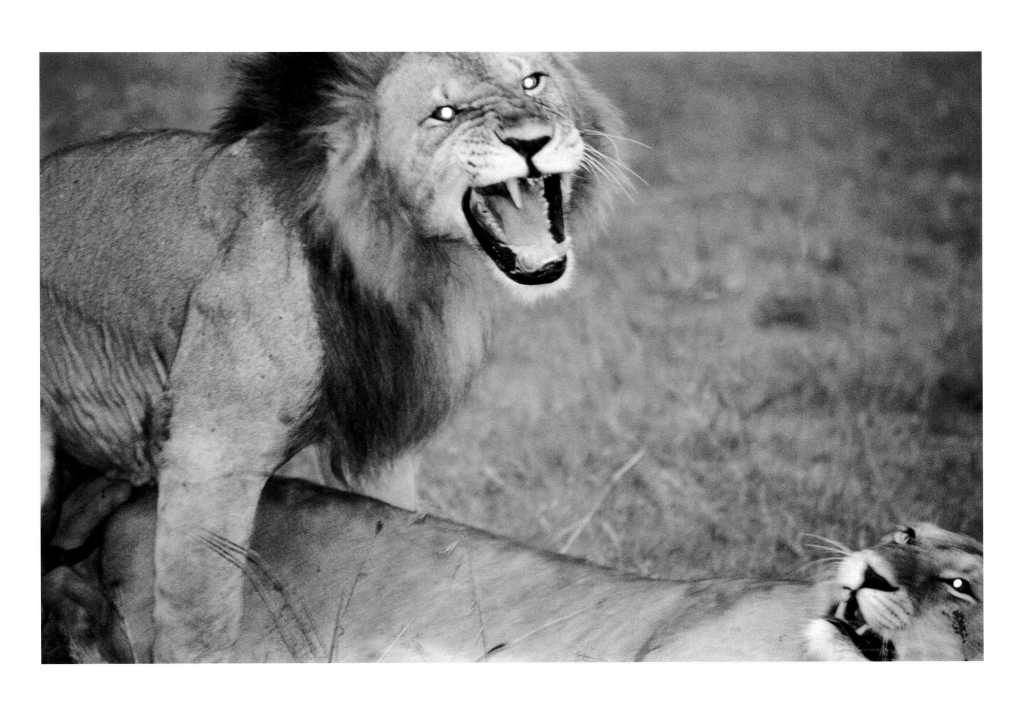

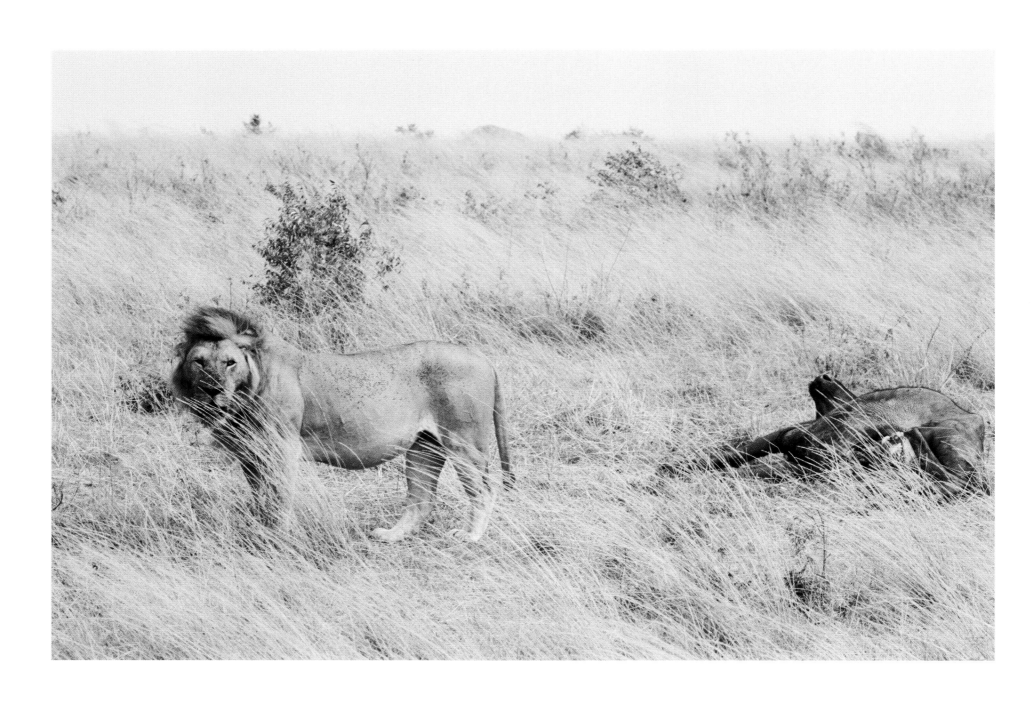

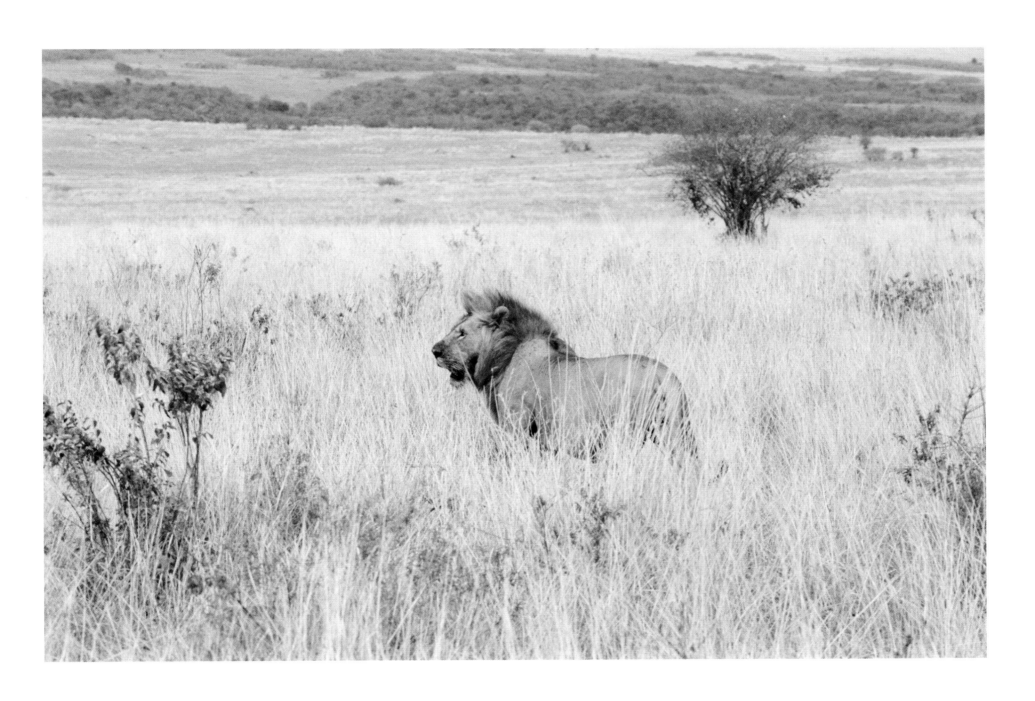

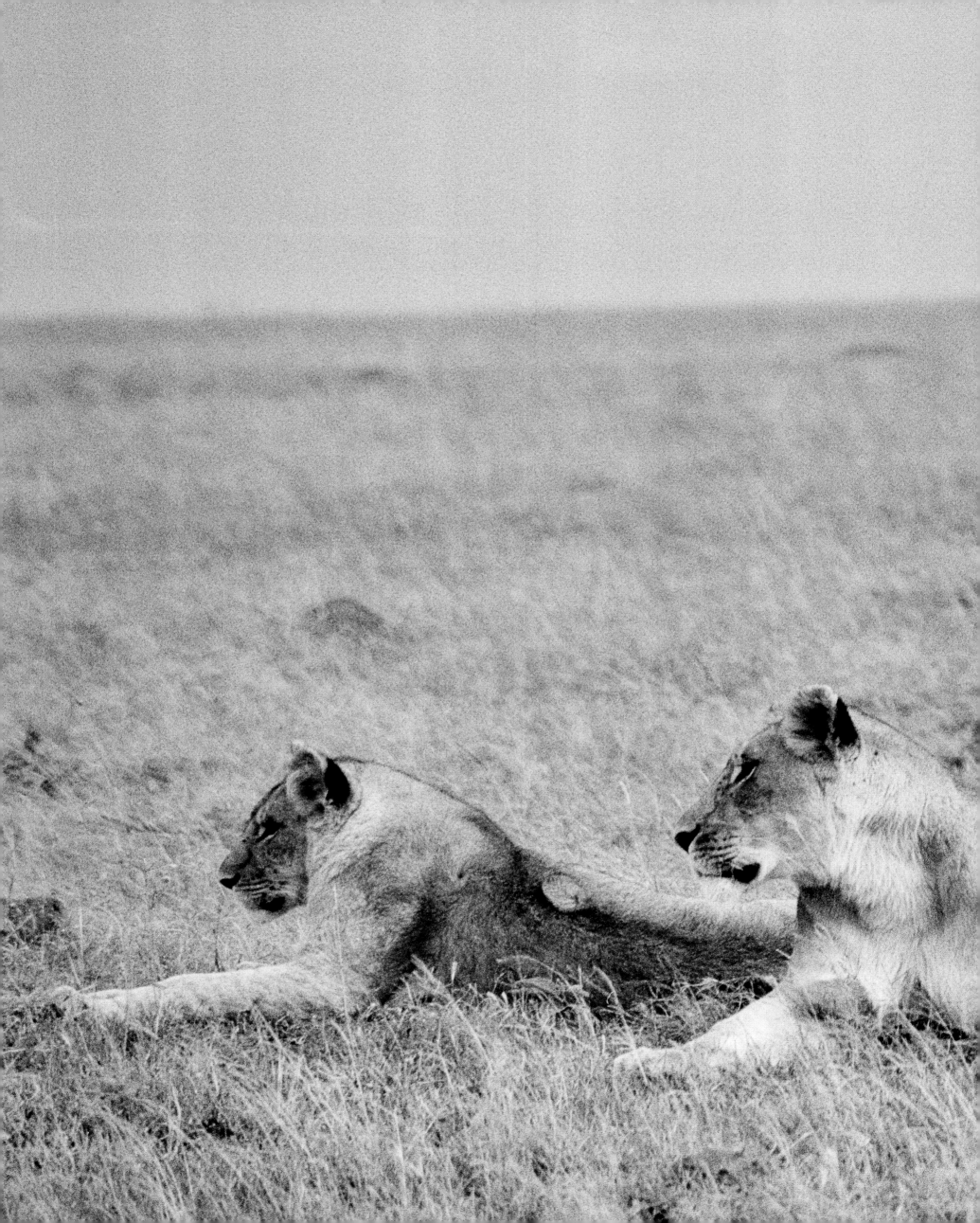

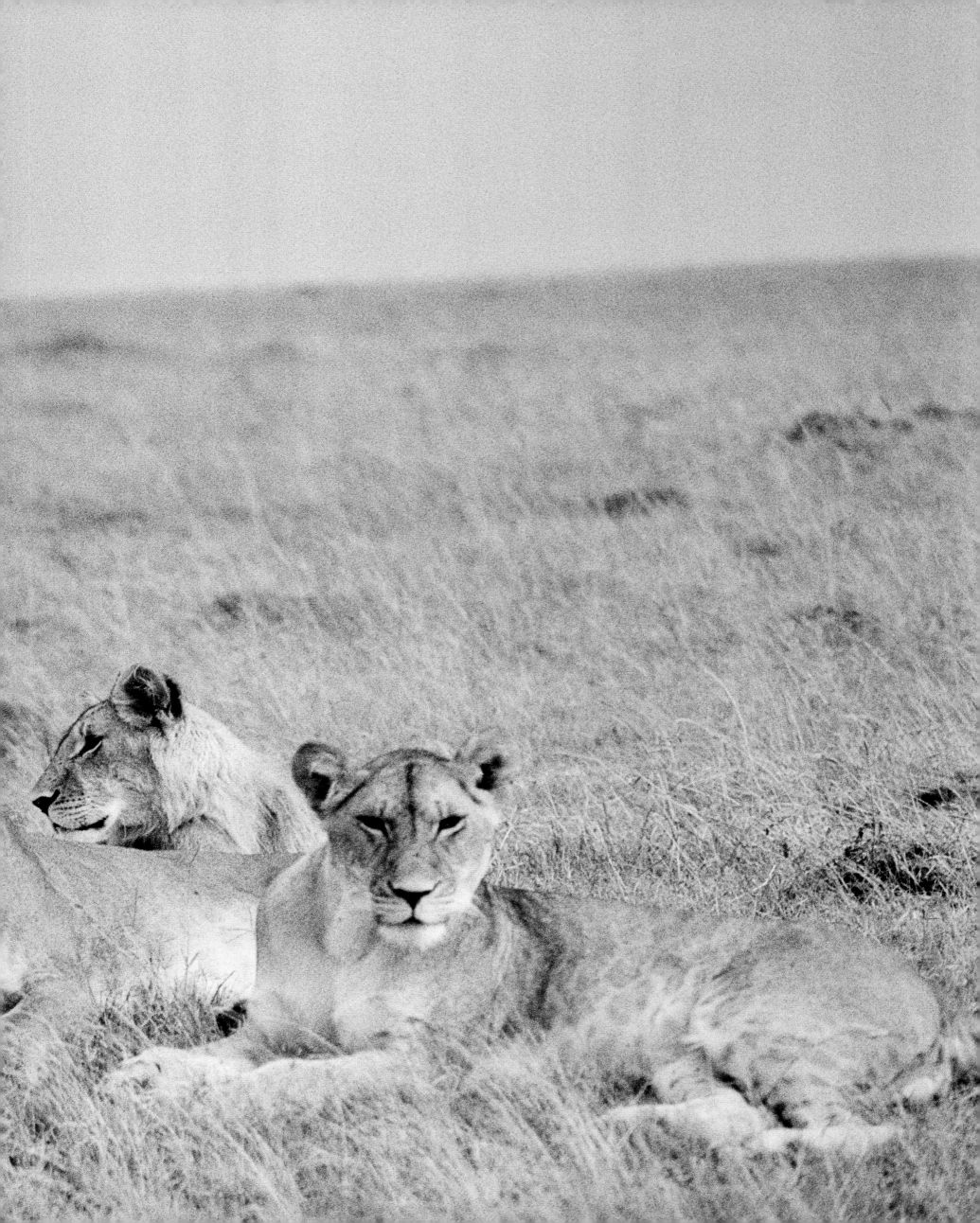

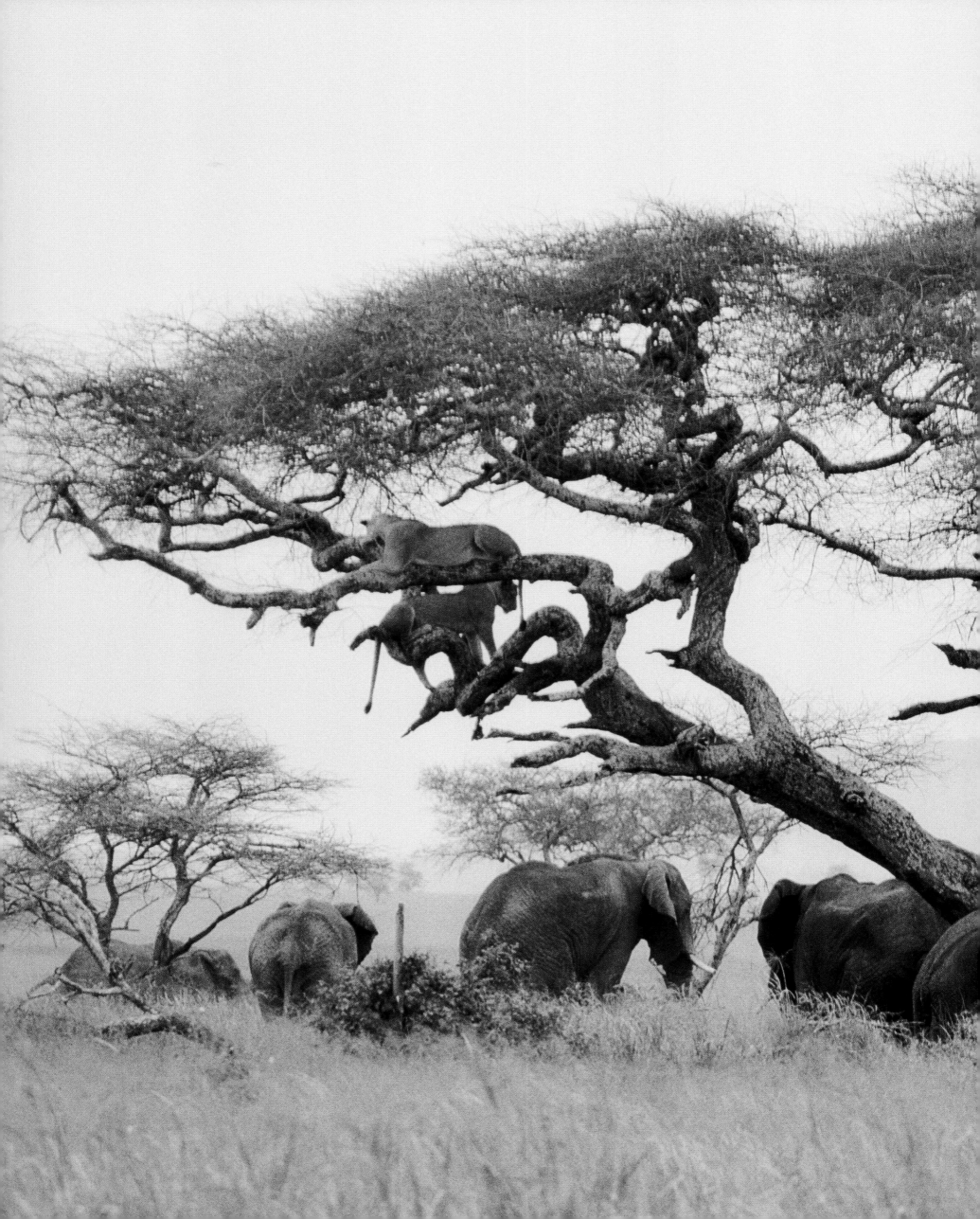

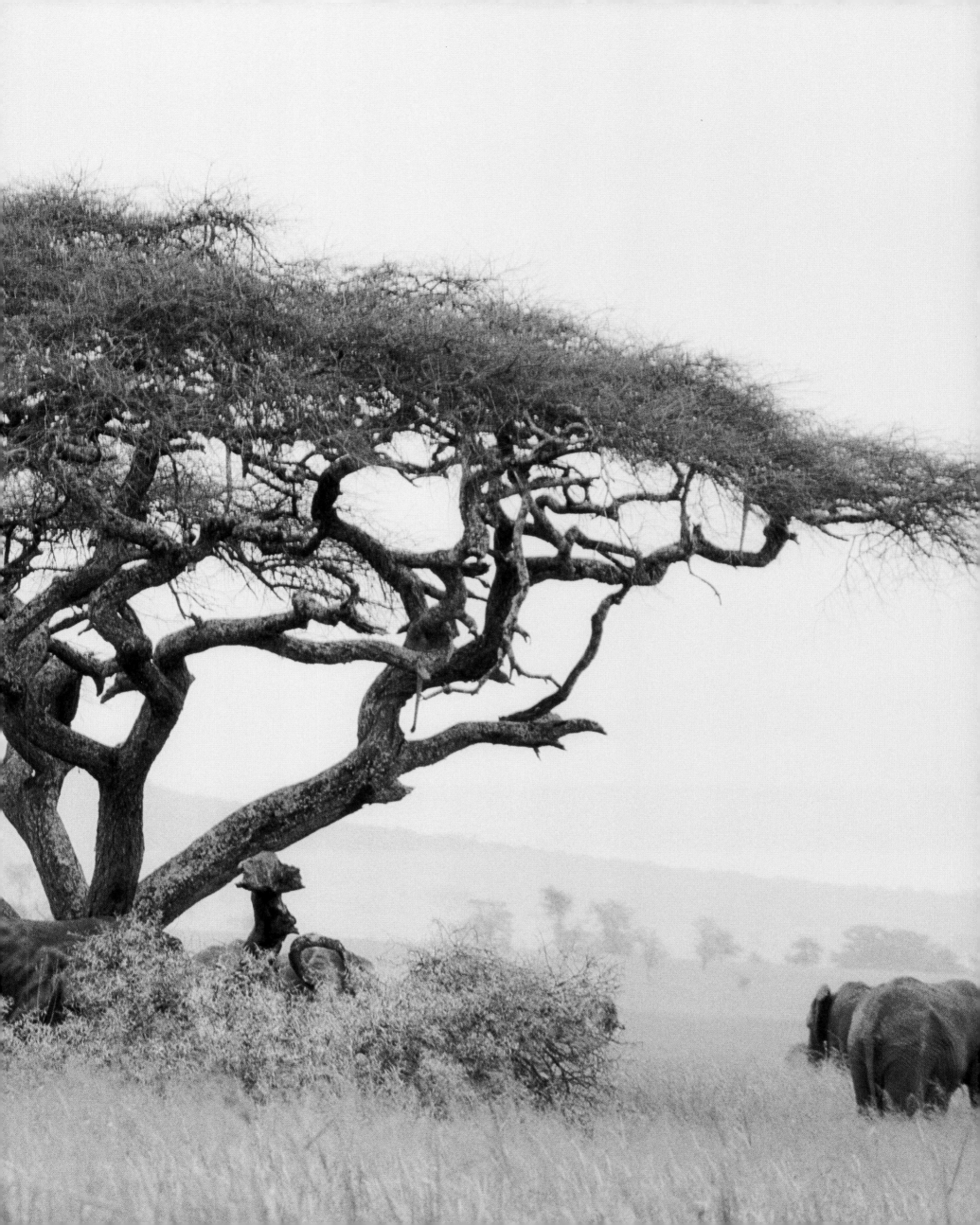

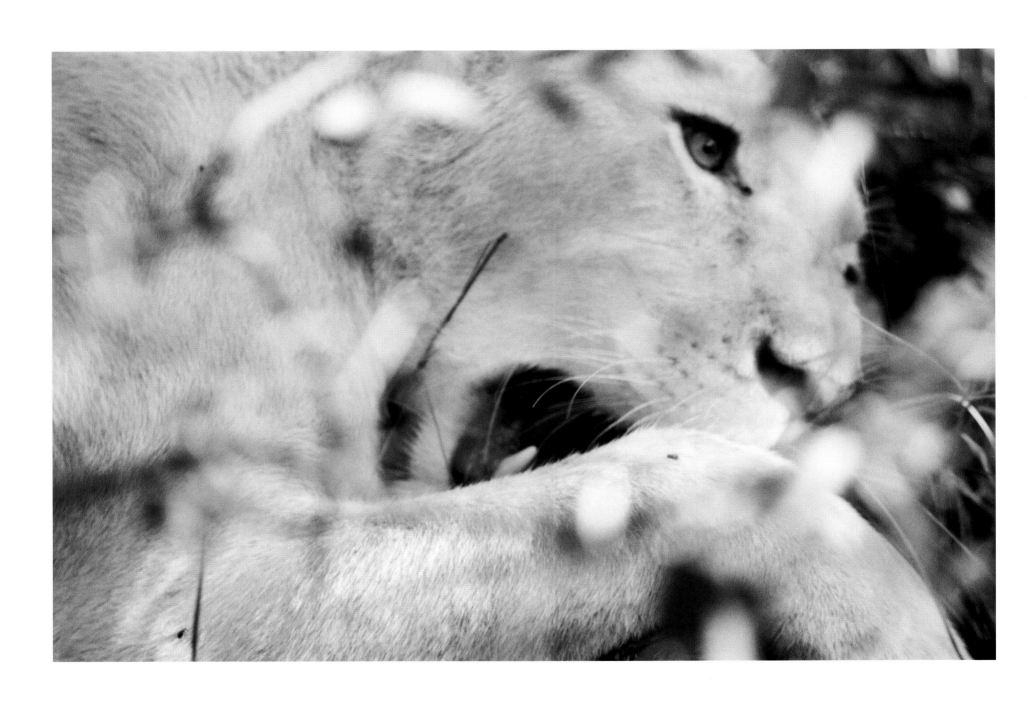

LIONS
Elizabeth Marshall Thomas

We became *Homo sapiens* on the African savannah about 200,000–150,000 years ago, and until modern times we coexisted with lions. During most of that period we were hunter-gatherers on the savannah, living in encampments, often on the shores of seasonal lakes and always within walking distance of water in the dry season because, unlike many of the savannah animals, we needed water every day. So did the lions. This meant, of course, that prides of lions and small groups of people spent every dry season within a few miles of one another, walking past one another's encampments, hunting the same game, drinking from the same sources of water. Each water source had its own population of lions and people; therefore, if things went wrong and two groups could not coexist, neither group could simply pick up and move to another water source because any other source would have its own 'owners'. Coexistence, therefore, was important.

In the 1950s, it was my great privilege to visit a part of Africa that had never been explored by Westerners. I went with my anthropologist parents into the Kalahari Basin, some 120,000 square miles of bush desert covering most of modern-day Botswana and parts of Namibia, South Africa, Angola, Zambia and Zimbabwe. In the interior, we met Ju/wa Bushmen living by the Thores of seasonal lakes in encampments that had been occupied continuously since the late Stone Age, with a material culture and presumably a social culture that were essentially unchanged. The place we visited came to be called Nyae Nyae, an area of 6000 square miles in what is now Namibia.

The region had seven permanent sources of water, and surrounding each was a population of savannah inhabitants who needed water, most conspicuously people and lions. The people had enormous respect for lions. In a way, lions were supernatural, like the spirits of the dead. At the night-time dances in which everyone in an encampment would participate, some of the men would fall into trance and run from the dance-fire into the darkness, where they would curse the spirits for bringing illness, misfortune and death. They would also curse the lions, as lions, too, bring death.

The Ju/wasi wouldn't utter the word 'lion' in the daytime, just as they wouldn't name the two gods, because when it was hot both lions and gods would be resting in the shade and not want to be disturbed. If the people wanted to speak of a lion in the daytime they'd use a hand sign, or a metaphor such as 'moonless night'. But they wouldn't say 'lion'. The reason for this, I believe, was the persona of lions – their size, their might, their voices, their hunting ability (they were better hunters than men were, said the Ju/wasi) – and the fact that they could wipe out an entire encampment of people if they felt like it.

However, the lions did not wipe out encampments. They tolerated the people with whom they coexisted, just as the people tolerated them. And unlike leopards and

hyenas, which sometimes hunted people, the lions never did. According to a study on cause of death among the Ju/wasi undertaken by my brother, John Marshall, and his colleague Claire Ritchie, before the 1970s, when the traditional way of life of the Ju/wasi came to an end, only one person was known to have been killed by a lion. The victim was a paraplegic girl who moved about by dragging herself, which perhaps excited the lion that killed her. (My daughter is paraplegic, and it's interesting to go with her to a zoo, as when the big cats see her they instantly come out of their stupor and run around in their cages with excitement. She's in a wheelchair, but she'd be even more exciting if she were dragging herself.)

One could argue that people are the wrong size for lions to hunt. A person is not much bigger than a duiker, a small antelope, and given a choice lions hunted the large antelopes, just as the Ju/wa men did – and for the same reason: both hunted to feed not just themselves but also their groups. Preference did not lead to restraint when it came to hunting, however, and both the lions and the Ju/wa hunters would take whatever came their way, especially if they were hungry.

We are now so urbanized, so divorced from the natural world, that it may be hard to understand why lions didn't hunt people, but the reason seemed to be that the lions and the people had a truce. The people believed, very simply, that if they left the lions alone the lions would leave them alone. And this was true. This was the situation that we found at Nyae Nyae. The truce was virtually perfect.

There were rules, of course, and everybody followed them. The people had spears and poisoned arrows, but used them only for hunting antelope, never for attacking lions, if only because the poison could take a few days to do its work, during which time a lion could easily kill not only the attacker but other people, too. The short spears of the Ju/wasi were also useless against a lion; to throw a spear, the hunter would have to be certain of his aim, as a wounded lion would be upon him instantly. The people didn't spear lions.

If you met a lion in the veldt, you were not to run or to turn your back on the animal, but to walk away calmly at an oblique angle. This was what the Ju/wasi would do if they met a lion, and what they told us to do. Yet one day when my brother and I were walking in the veldt and met a lion, we were so struck with awe that we did nothing. But we were newcomers to the savannah, and the lion was not; it was the lion that turned away and calmly walked off at an oblique angle.

Another rule involved time of day. The lions hunted at night and spent the day sleeping in the shade. While they slept, the people were active. Women would go on gathering trips and men would go on hunting trips, often to places very far from the encampment. The women would always return before evening, and the men, if they were

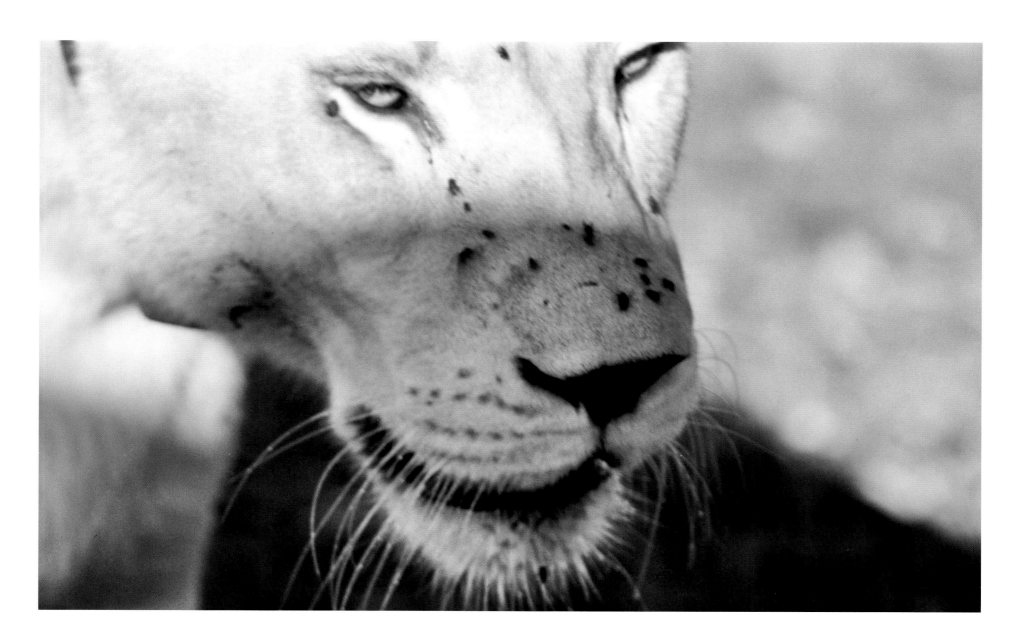

far away, would make a camp and stay in it for the night. Always the people were settled before dark, especially in the encampments, because these were near the water, and night was when the lions came to drink.

What did the lions think of the people? The question can't be fully answered, of course, but there were certain hints, one of which we experienced at a place called Cho//ana, where a group of Kavango pastoralists had cattle. The place was a water source where, of course, lions had lived alongside the Ju/wasi who, before the Kavango people came, had owned Cho//ana. We went there with Ju/wasi from another encampment, and set up a camp of our own on a hill. A large group of lions came that night and roared all around us. They used a special, choral roar, whereby several lions roar together until their breath begins to fade, then other lions start roaring, so that the terrifying, deafening roaring goes on in an unbroken fashion for what seems to be forever. The ground shakes.

Why do lions do that? They want to frighten their listeners. If they think other lions might be encroaching on their territory, they want to proclaim that their group is large and powerful, and that the other lions had better stay away.

But why did they do it to *us*? I think they saw the Ju/wasi as something like themselves. Why wouldn't they? They lived in close proximity to one another, used the same water, and hunted the same game. The lions who roared that night would have worked out some kind of living arrangement with the people at Cho//ana, but then we, a whole new group of people, showed up, and the local lions wanted to be sure that we understood the rules. It so happened that their audience that night was myself and my mother, alone in a tent with no better defence than a flashlight in which the batteries were running low, so the lions could have killed us easily if they had wanted to. But they were not hunting; hunting is done in silence, never with thunderous noise.

Rather, the lions wanted to tell us something, and they assumed we would understand what they meant. And I think we did. I think they wanted us to know that the place at which we were camped belonged to *them*. The roaring certainly didn't sound like a message of truce, but I believe the lions did it *because* of the truce. It's an interesting experience to be treated by an animal as if you were of the same species, or at least as if it thought you could understand it. Lions never treat prey animals or such inconsequential animals as jackals in that way.

We were warned by choral roaring several times, twice by prides of lions and once by a single lioness, who came to our home encampment and roared in the choral manner even though she was alone. She was trying to tell us something, but what? We had no clue. We had been at that campsite for a long time, and she would have passed by us every time she wanted a drink, so of course she knew about us. Even so, she felt it appropriate to

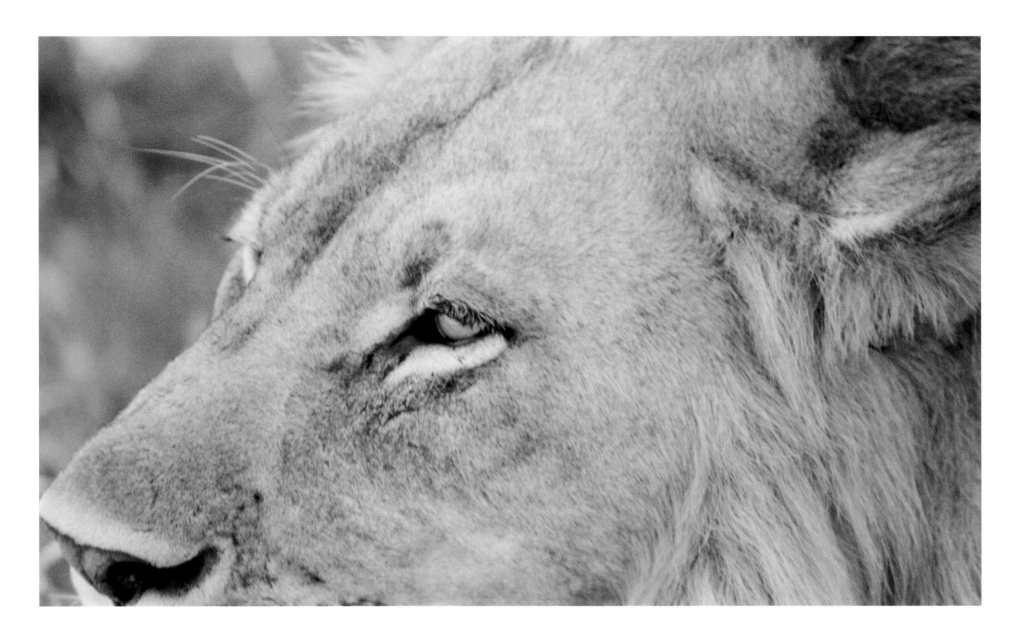

stand very near us and roar herself hoarse. Whatever her intention, she had purpose.

After a very long time, she felt she'd roared enough and strode away, her head high, without a backward glance. 'I've told you. Now you know', her manner said. We didn't know, but that didn't matter. She had gained our profound respect, which surely was at least part of her purpose. In the future we'd be alert to her desires. We wouldn't dream of opposing an individual like her.

If the lions treated people as they treated other lions, the people often treated the lions as if they were people. Sometimes lions came to view them at night. The people would see the animals' eyes shining in the dark, and the men would take branches from the campfire, raise them high, and approach the lions. With deep respect, they would tell the lions to leave. A man might shake his burning branch to make sparks fly; he might tell the lions that if they came any nearer, they'd be hurt. Lions weren't people, to be sure, but they understood. They would look around, then look at one another, and quietly move off into the night.

Once, some hunters following a wounded wildebeest found it lying down, sick with their arrow poison, and surrounded by the lions with whom they shared the area and the water. For some reason, the lions had not yet killed the wildebeest, but they were thinking about it. The men spoke to the lions respectfully, telling them that they honoured them, but that the wildebeest was theirs, and the lions must go away. As they spoke, they slowly advanced towards the lions, tossing bits of sod at them. The lions seemed uncomfortable; evidently, they understood that the wildebeest wasn't theirs, and, one by one, they began to leave. When all the lions had gone, the hunters killed the wildebeest and took the meat.

Such behaviour was characteristic of the Nyae Nyae lions, but it came home to me dramatically that it was by no means characteristic of *all* lions when, years later, I was involved with a wildlife research project in Namibia's Etosha National Park, some 200 miles from Nyae Nyae. My colleagues had put recording equipment near a water source, and I went in a van to retrieve it. When I arrived, a lioness was sitting on the equipment. Remembering the respectful words of the Ju/wasi, I got out of the van and spoke courteously to the lioness, ready to tell her that I honoured her but would she please move, when – *wham!* – she charged at me. I'd never seen anything move so fast, but I may have matched her as I jumped back into the van.

It's not surprising that this happened. Years earlier, hunter-gatherers had lived on the site of the park, and they would have had a truce and an understanding with lions, just as had the Ju/wasi at Nyae Nyae. But the hunter-gatherers had been evicted by the park authorities, and a generation of lions had grown up knowing nothing about people – not even about tourists, who were ordered to stay

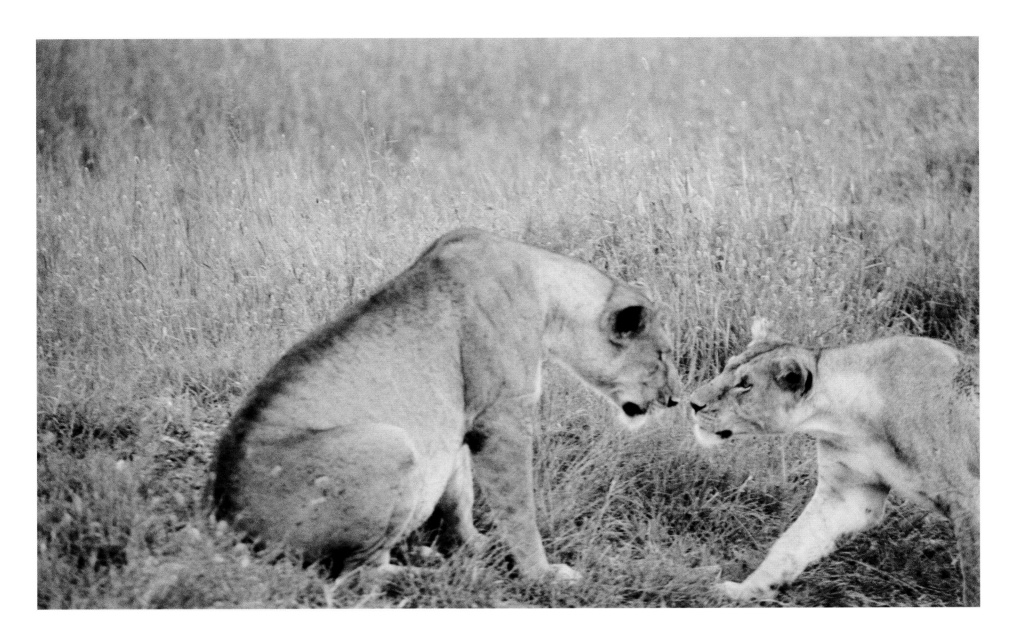

in their cars. In fact, at Etosha I was stalked by a lioness, probably because she didn't know what I was. Later, a colleague and I were hunted by a lioness. We were sitting at night in the above-mentioned van by a waterhole, trying to count the animals that came to drink there, when a lioness looked in through the window. Gosh, but she was close. We were almost nose to nose. She ducked down, but kept stalking us, keeping to the shadows, knowing not to look directly at us because her eyes would shine in the moonlight and reveal her presence. She was hunting. Nothing like that ever happened in Nyae Nyae. But in Etosha the truce was over. The lions had no relationship whatsoever with any kind of people. Everything had changed.

What can be understood from the experience of the Ju/wasi and the lions who lived near them is that our species are not enemies unless we make them so, that we have much to gain by coexistence and much to lose by enmity. Today, lions are confined to parts of Africa, except for a small, protected population of Asiatic lions in India; but lions once lived all over Africa, all over the grasslands of Asia, all across Siberia and throughout North America. Where they could, they lived in caves. So did many of the people. In the early Stone Age, the Cro-Magnon people of Europe painted images of lions on the walls of caves, such as those in the Dordogne region of France. Those people, too, would have coexisted with lions, which were bigger than modern African lions and perhaps more powerful –

and no doubt too dangerous to try to spear, let alone to shoot with an arrow. As in the case of the Ju/wasi, the Cro-Magnon people must have respected these animals. All this shows one thing very clearly: that we, too, can coexist with lions as our predecessors did, and we must do so if we wish to keep them on the planet.

One of the things that impressed me most about lions was their roaring. Sometimes at night they would spread out and advance in a line, each lion perhaps a quarter of a mile from any other. They kept in touch by roaring. One lion would roar, and the next would answer, then the next and the next, until all were accounted for. Interestingly, they would also reply to thunder. Perhaps this was because a lion's roar and overhead thunder are equally loud. One would hear a clap of thunder, then a brief silence as if the lions were thinking it over, then deafening roars as they replied. But lions know that whatever is roaring from the sky is not quite a lion. Why, then, do they answer? Perhaps because the noise *sounds* like a lion. Perhaps a lion god wants to know where the lions are. 'Where are you?' the lion god thunders. The lions on the ground think for a moment. 'Is he talking to me?' they ask themselves. 'He must be talking to me', they decide. So each lion takes a deep breath, and they roar with all their might. 'I'm here!' each answers. 'Right here.'

When the god speaks to lions, may there always be lions to reply.

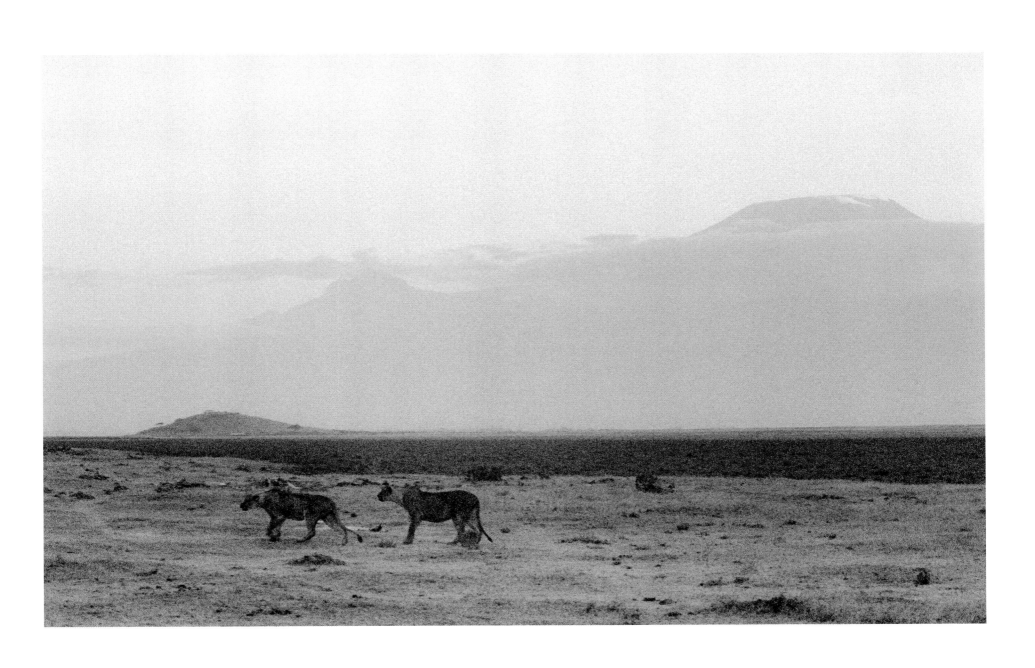

TIGERS

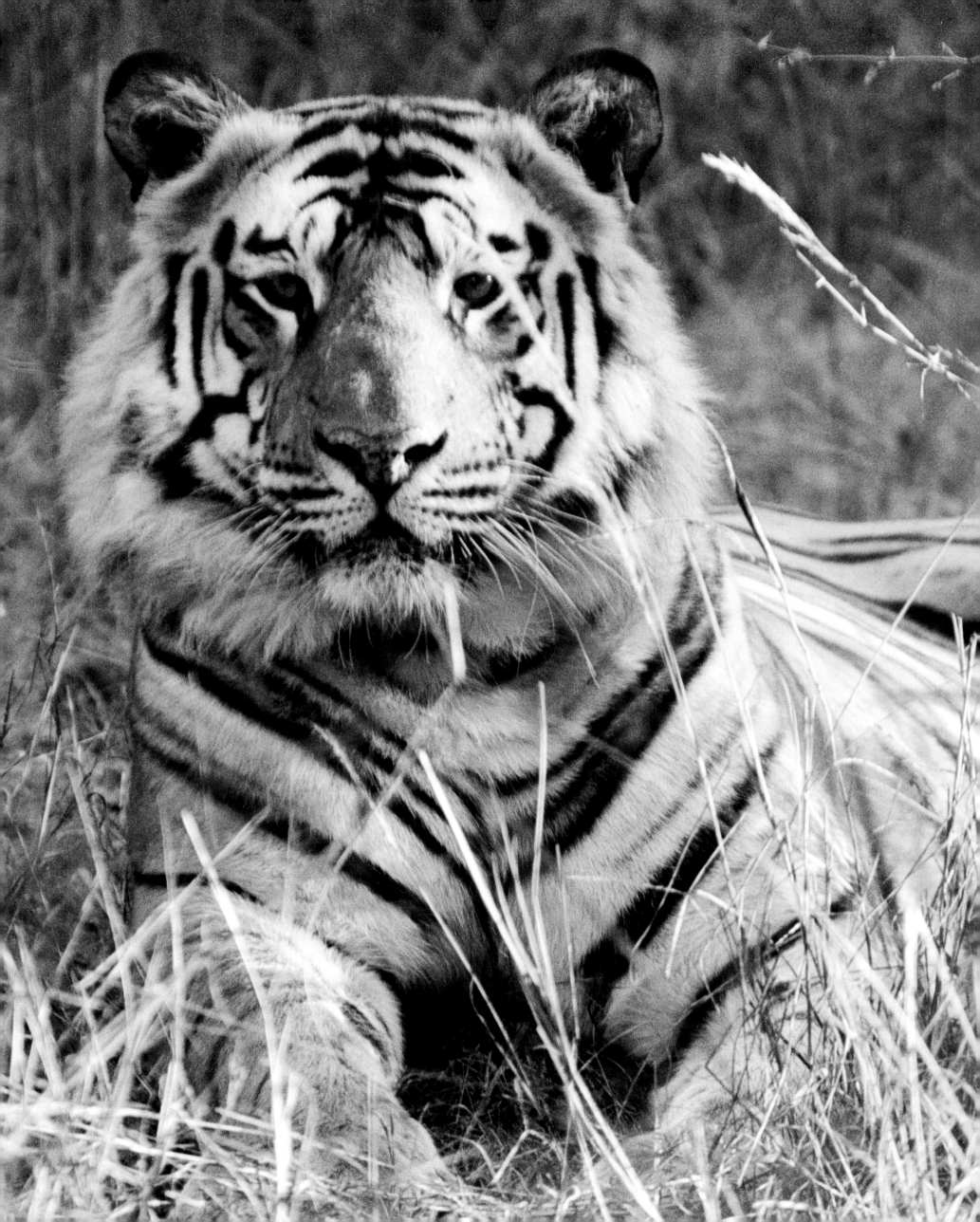

Do not blame God for having created the tiger, but thank Him for not having given it wings.

INDIAN PROVERB

Morning breaks in hazy, mystical mist among the mountains and sandstone ridges that make up central India's Vindhya Range, where rise some of the oldest hills on the planet. The earth here is composed of 'black cotton' soil favoured by the local farmers, farmers who are increasingly encroaching on Bandhavgarh National Park. The area is also terrain favoured by one of India's last viable tiger populations. We travelled to Bandhavgarh in the hope of seeing a Bengal tiger, the largest cat on earth, a ghost-like stalker and lethal killer, a being that moves between the visible and the invisible as few other creatures on this planet can; we left the park believing that we had felt the soul of an entire subcontinent.

We arrived in Bandhavgarh late one night in January 2009 after driving for five hours on small roads. On our way we had passed local villagers whose chariots were filled with enormous, storey-high bales of hay, as if a painting by Pieter Bruegel had been crossed with the ancient Indian epic poem the *Mahabharata*. Only a few weeks earlier, terrorist bombs had exploded in Mumbai, and we'd deliberated whether we would carry on with our plans for the journey. Also with us was our three-year-old son, Lysander, who so wanted to see a tiger in the wild. In the course of a few days we had travelled from the American south-west, via London, to Delhi, and then on to a small village by the park, in the state of Madhya Pradesh. Few farmers there had ever seen a tiger, but everywhere were tracks, scat and claw marks on trees that showed that a predator lived in the area, a place of refuge for a cat that in 1900 numbered in the tens of thousands worldwide but whose population now has plummeted to perhaps as few as 3000.

There is a mystique in the tiger's walk, its body branded in the colours of a blazing orange sun and the deepest black of night. This aura made it a consort of Durga, a Hindu deity with the power to vanquish evil and battle those forces that would threaten the stability of the universe. Each tiger killed for its skin and each tiger born forms a new equation as to whether the demons of globalization will prevail or whether conservation inside India and Asia's reserves will win out; whether increased security, privatization of parks and public awareness of tigers will enable this monarch to survive. For while there are plans to double the world's tiger population within a generation, and more Indians are showing great interest in their premier wildlife spectacle, poachers seeking to satisfy the Chinese market for body parts continue to set traps and slaughter the tiger. The 'fearful symmetry' that so entranced William Blake in his poem 'The Tyger' (1794) walks on a knife-edge between survival and oblivion.

In Bandhavgarh's forests of bamboo and sal lie dozens of caves, and there 2000 years ago Buddhist monks meditated on the nature of reality while tigers prowled in serenity around them. The story of how, in a previous life, the Buddha gave his body to a starving tigress and her

cubs underscores the vital link between the conscience of man and compassion for 'the other'. The power and stride of the tiger continue to haunt the human imagination, but human overpopulation and encroachment on the tiger habitat, and civilization's 'mind-forged manacles', as dubbed by Blake in his poem 'London' (1794), menace the world's largest cat. At Bandhavgarh, from the edge of a high cliff not far from the temple of Kabir – the fifteenth-century Indian poet and mystic who believed in the sanctity of life as the ultimate religion – we watched vultures gliding effortlessly below us. As far as the eye could see lay the reserve, only 10 per cent of which is open to the public. Its seeming endlessness harbours a source of optimism for the future of India's tigers. If the core group of India's main reserves can hold off the onslaught of India's burgeoning human numbers, then maybe the tiger can hold on for the next generation, and the one after that. But our guide, Joseph, and his father, Kattupan, a mahout (elephant handler) who started working in the area before it became a park in 1968, warn of the changes in the climate. The monsoon rains that used to fall for three or four months each year have been drastically reduced, to only fifteen to twenty days throughout the summer. Weather patterns on which the forest depends are radically altering, and it is not known how the tiger's prey base of sambar and chital deer will adapt to the increasing gravity of the changes now unfolding.

There is an electric charge, an almost electrical awakening one gets on first seeing a tiger in the wild, as if one had come face to face with a supernatural force. Some people come to Bandhavgarh and never see a tiger. Some only hear its magnificent voice. Its roar, and the concomitant alarm calls of the langur monkeys and the chital and sambar when they spot a tiger, are a primordial symphony that brings to mind the Hindu concept of the world, Nada Brahma ('everything is sound'). In the tiger, one beholds not only a keystone species, but also one of the most majestic personifications of both beauty and power the world has ever known.

In India, amid the more than a billion people and their superstitions, the tiger's mythic being is not mere lore but a continuing and vital essence of what is best in the world, one of the forces that hold the world together. Its ability to appear out of the blue and disappear in an instant leaves witnesses speechless. Once, while we were trying to see a well-camouflaged tiger lying only 50 feet from our jeep, a car parked up alongside us and a handful of eager Indian tourists jumped right into our vehicle. We did not protest, as this was their country and everyone was excited simply to be in the presence of a tiger, hoping to catch a glimpse of this magnificent animal. Eventually, we caught sight of it, but just barely, as it drifted off into the bush. It was the very incarnation of magic. Today, the greater magic would appear to be the tiger's capacity to

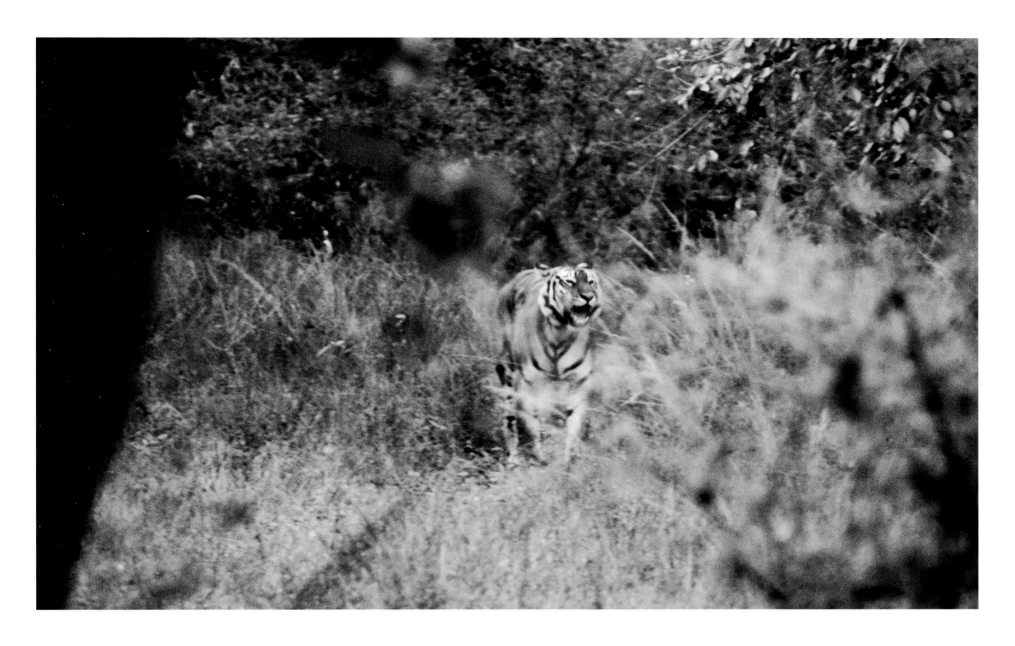

endure despite the bottomless greed and depravity of the human species.

And what if the tiger were to disappear forever? So many species have gone before it. How would the passing of one mammal species affect seven billion humans? In the case of the tiger, its passing would affect not just the biology of its immediate environment but also very likely the spiritual ecology of our souls. In her book *Spell of the Tiger* (1995), the naturalist Sy Montgomery describes how the death of the last Javan tiger was followed by a series of calamities for the Indonesian people in 1979: a plane crashed, killing pilgrims on their way to Mecca; a volcano erupted, causing many deaths; the crown prince and his mother died within a year of each other. As Montgomery comments, these disasters 'were widely attributed by the people of Indonesia to the shooting of the tiger and the extinction of the Javan subspecies'. Killing a tiger may or may not have consequences, but the world at large knows that if we do not save the Bengal tigers that survive in India (and to a lesser extent in Bangladesh, Nepal and Bhutan), and the remaining species of tiger, we may have lost the path that saves humanity from itself. Our guide at Bandhavgarh, Joseph, emphasized that the tiger is an honest and systematic animal; it kills only what it needs in order to survive, and kills only those people who do not respect it. There may be those who disagree, but the mind of the tiger is surely one of evolution's great miracles; it offers secrets about a force so clandestine that we can only marvel at its continuity over time. In the Hindu cosmological system, the three principal gods, Brahma, Shiva and Vishnu, define the properties of generation, destruction and preservation. There is no better personification than the tiger for another property, that of concealment, that which lurks behind the veil of *maya*, or illusion.

The tiger emerged from southern China some two million years ago, and its survival now may well depend on a conversion in the hearts of people from that part of the world, where many of its body parts are prized in traditional medicine: parts as varied as eyes, whiskers and bone in powder form are believed to cure such conditions as malaria, meningitis and rheumatism. In the greater battle for the planet, the tiger is a key; it stands as a living cipher at the crossroads of redemption and extinction. Just glimpsing the face of a tiger acts as a rite of passage for the onlooker. Knowing that the tiger still holds on in the last of the earth's jungles, surrounded by the mayhem of modern civilization, should make us shudder with thrill and awe; somewhere out there, an incomparable presence still breathes, its heart still beats on earth.

More than ten years before our trip to Bandhavgarh, in 1997, Marie and I were travelling round the world and stopped off in northern Thailand, on the border with Burma, to visit the famous hill tribes. That year was one

of the hottest on record, and there had been no substantial rain in the area for three years. Already back then we were hearing our first major accounts of global weather changes, stories of altered monsoons and rains. A novel climate pattern was hurting the crops locally; that year the rains had been particularly poor. We spoke to a Yao elder, and on his back door was a map from the *I Ching*, the classic Chinese text of divination, that hinted that the world would one day explode. The elder emphasized the fact that in the past few years most villages had been electrified and that the deities were not manifesting as they once did. Images of these deities had been removed by missionaries who wanted to purge the villagers of their animist beliefs, and the vibrations on which the spirits used to dance had been altered, perhaps irrevocably.

It was perhaps just such a spirit that influenced one young woman who told us she had been possessed; she had roamed her house growling, lurking about on all fours thinking she was a tiger. Yao and Hmong children wore silver ring necklaces to ward off evil spirits. In the age of quantum mechanics, many dismiss such superstitions as archaic, primitive and senseless. But perhaps there is a meaning, a reality behind them that is supra-sensible, in touch with hierophanies and beliefs in invisible worlds that are, like our own planet, increasingly endangered. As we reflected on this woman's story of possession, the elder was kind enough to play a tune on his flute that was said to call the souls of the dead to the next world. It was an honour to hear his music, the melodies of which had held his people together for hundreds of years. How many tigers, and how many of his people's songs, would be left for the next generations?

We saw our first tiger the following year, early in 1998, in Nepal. We flew from the capital, Kathmandu, to Bardiya National Park, in the Terai district in the west of the country, in the jungles at the foothills of the Himalayas. Flying past the central range of the tallest mountains on earth was breathtaking; so was, in a different way, the possibility that the World Bank would fund a dam on the Karnali river, exactly in the area in which some of Nepal's last remaining tigers survived. At the beginning of the twenty-first century there were dozens of tigers in Bardiya, but today only a handful remain. A long-running Maoist rebellion, and Chinese pressure on Nepal for tiger body parts, have almost wiped out the tiger population.

We talked to some Nepalese from Kathmandu about the unique beauty of the Bardiya area, a place where river dolphins and Asia's biggest cat could be seen on the same day. One computer expert had visited Bardiya many times to escape the din and clamour of cosmopolitan mayhem, and had always hoped to witness the majesty of a tiger, but so far his hopes had been in vain. You had to be very lucky, he exclaimed; just to be in the tigers' vicinity was a privilege.

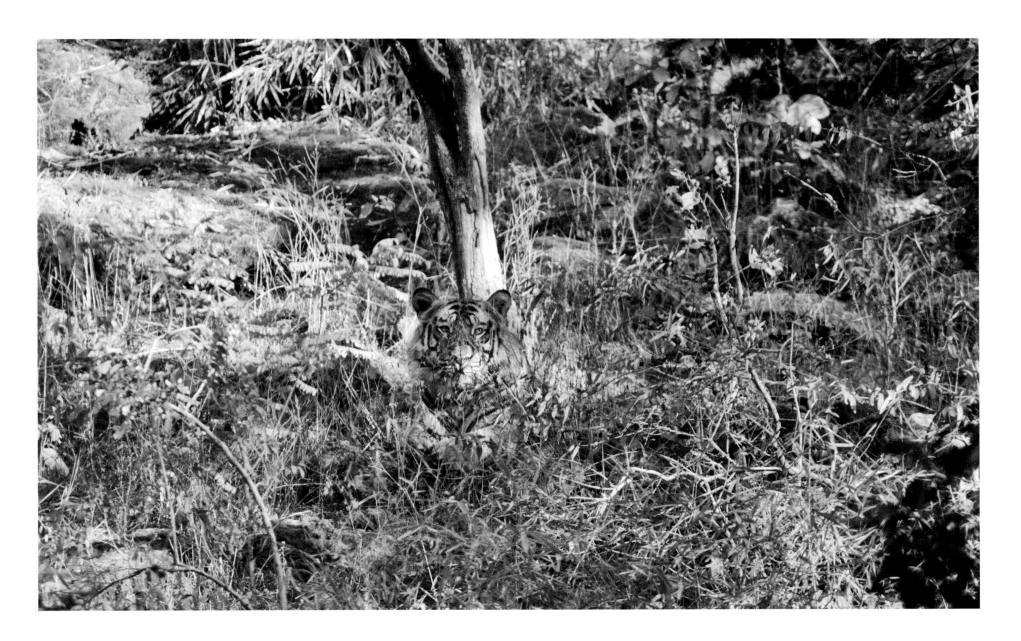

Marie and I dared not expect to see one, knowing the odds were against us, but, tucked in our adobe rooms exquisitely designed by Terai artisans, we secretly hoped against hope to see this phantom beauty of the jungle.

We awoke the next day to the screams of langurs and peacocks, and were seduced by the sounds of the forest and the early morning light. Before we were assigned our elephant and mahout, Marie had the notion to ask one of the guides if there were a deity or goddess one could pray to if one wanted to see a tiger. We were told of Bon Devi, the goddess of the forest, and were shown a large banyan tree in front of which candles and effigies of the goddess had been placed. Marie lit a candle, made an offering of oranges to Bon Devi and the spirit of the tiger, and then joined me on the back of our elephant.

With the snow-clad Himalayas in the background, we came across a superb, solitary rhino; it stood its ground only a few dozen yards from our elephant, but within half an hour it sensed something stirring in the bushes. Our mahout urged the elephant forward as it ambled among the bushes and elephant grass, clearly aroused by some presence very close to us. We looked all around for a sign of some approaching predator; suddenly, from our left, a tiger elegant beyond words and lithe as a demon passed just in front of us and vanished into the thickets on our right. Within minutes it returned from the right and disappeared in the opposite direction. Excited mahouts exchanged information as we let those behind us pass in front to have a look, but as we did so the tiger passed in front of us again. The people ahead of us never glimpsed their tiger. Had there been a link, a bridge between devotees of the wild and the goddess to whom Marie had prayed? So much of our dream-time and energy is overwhelmed by the modern world that the gift of serendipity and the magic of the unexpected are often hard to gauge. Is there such a thing as coincidence? What linked our prayer to Bon Devi with the tiger's brief appearance from behind the veil of invisibility?

We will never know what power a prayer, wish or thought will have in our lives, but our companions, who had come to Bardiya many times before, did not see the great orange and black apparition we had come so far to witness. Today one can only hope that a few tigers still hold dominion in one of the few remaining untouched jungle habitats on earth. The World Bank eventually decided not to fund the dam on the Karnali, but the snows and glaciers of the Himalayas are receding. Will the tigers be able to adapt, or will they vanish into that realm that is visited only by Bon Devi and other deities ?

In Montgomery's *Spell of the Tiger*, an examination of the tigers of the Sundarbans coastal mangrove area of India and Bangladesh, the author alludes to a mystical link between the people and the tiger, and tells of a goddess called Bonobibi. Bonobibi's tigers do not kill those who come in peace and respect the forest. Montgomery quotes

We will save them, if at all, because without them we are lost.

PAUL SHEPARD,
THINKING ANIMALS, 1978

Pranabesh Sanyal, a former director of the Sundarbans Tiger Reserve: 'The tiger understands the human mind.' Kalyan Chakrabarti, another former director of the reserve, tells her that 'A careful, watchful, respectful person is never killed by a tiger in Sundarbans.' Perhaps, but with the area suffering increasing tidal surges, climate change and a growth in human population, it is difficult to predict whether the bonds that existed between tiger and man will persist. In the early twentieth century India had more than 40,000 tigers, with no enmity between human and non-human. But with the massive increase in hunting for sport during British rule, the population of the greatest predator in Asia started to plummet. Bloodlust and trophies have ruled over honour and reverence. This debacle is exemplified by the area around the Panna National Park, no more than 50 miles north of Bandhavgarh: in 2009 the BBC reported that the state minister of forests, Rajendra Shukla, had admitted that Panna, which in 2006 counted twenty-four tigers, no longer had any at all.

During our stay in Bandhavgarh in 2009, the mist of early morning defined an otherworldly place, a primal forest that defied the human fog of the country's more than one billion people. The entrance to the park was thronged with jeeps filled with tourists, many of them Indian, eager to look into the eyes of a tiger. But once beyond the frenzy at the gate, we felt beckoned by the forest, despite its possible dangers (one of the gatekeepers wore a sash around his face to hide the monstrous gash he had suffered from a sloth bear that had attacked him years earlier). Here, in this 1500-square-mile haven, thirty or so tigers roamed without fear, as tigers used to before the hunting began a few hundred years ago; sometimes they were responsible for almost causing vehicle collisions, as people stared at them, spellbound.

We heard stories of the famed Charger, who would feign attacks on cars, stopping within yards of them as if to prove he was the boss, and of his son Batia ('son' in Hindi), who now stood as ruler of Charger's former territory. Our guide, Joseph, recounted a story about his father, Kattupan, from more than forty years ago. Kattupan, the head mahout, was walking in the forest and unexpectedly came across a tiger that seemed about to charge at him. Kattupan ran towards his elephant, which, sensing the situation, bent its front legs and head to the ground, allowing Kattupan to run up its trunk and head and on to its back. The elephant proceeded to pick up a rock with its trunk and threw it at the tiger, chasing the cat away and perhaps even saving Kattupan's life. It was while we were on the back of this same elephant that we came within 10 feet of a tiger who, luxuriating in the brilliant light of day, looked as if it were charging itself up by the rays of the sun. 'The tiger is a very special animal', Kattupan told us. 'It never charges unnecessarily ... In the morning the tiger

prays to God to bring all the animals in front of it except humans.' Kattupan's regard for his elephant can be attested by an anecdote he shared about the times he would search for tigers with other mahouts at 5 o'clock in the morning: 'If elephants knew there were tigers sitting there in the bush, they would come and gently push mahouts with their trunks', as if to warn them to be careful.

In the course of our time in Bandhavgarh we heard stories of rare black tigers, and of the famed maneater who had once been attacked by men and had gone on to kill and eat eighteen villagers over the course of twenty years. It had originally been attacked for trying to get a cow, and remembered the ways of men, men who had tried to kill it. Shortly after our arrival in Bandhavgarh we heard of a local villager who had just been killed trying to fend off a tiger that had attacked a cow; the man had taken a stick and attempted to hit the beast and scare it off, but to no avail. Despite such encounters, local people know that something special lurks in their midst. We were told stories of a tiger that would lie quietly like an overgrown kitty in the grass near our cottage while herdsmen tended to their cattle. Tigers are the pride of Tala, the village by the north-eastern entrance to the park; thanks to tourism, they are the source of revenue for the entire community. However, a tiger skin alone can fetch as much as 2 million rupees (about $37,000/£23,500), and for those who have to raise a family on meagre wages the lure of poaching can be almost irresistible. Villagers know the ways of the big cat, and snares can trap even the most powerful of unsuspecting tigers.

For now at Bandhavgarh, the tiger population seems to be holding its own. About twenty cubs are born there every year; and, on average, each female tiger will give birth to perhaps more than twenty-five cubs in its lifetime. But many tigers are taken each year by poachers. In the few months before our visit, several had been killed, their pelts probably travelling via New Delhi, Kathmandu and Lhasa in Tibet on their way to China, where they are bought by the rising middle class to adorn their homes. The hope for India's tigers, and the remaining tiger population worldwide, we were told, lay with the villagers, who needed to become 'shareholders', to have a stake in the land and in conservation, as in Africa where indigenous peoples are learning to have a stake in the big game. People had to be educated and involved, to accept that the survival of the tiger was in the national and local interest. Policing had to increase nationwide, and people had to learn to protect their assets. Indians already knew about the transcendent quality of the tiger, which inhabited their dreams and superstitions and was part of the national character. Now they had to learn to fight for its future, for the forests and, in many ways, for part of their very soul.

In a temple near Tala, a small effigy of a tiger lay wrapped in a shawl behind bars, as if protected from

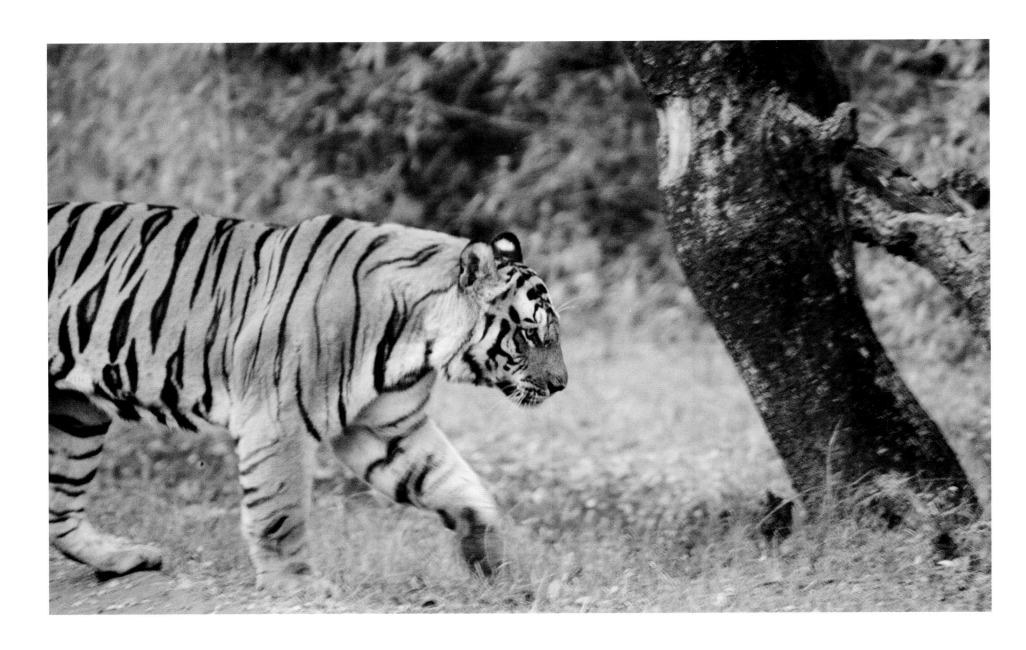

the rest of the world. In the courtyard, where droves of young Indians, mothers and children came to pay their respect to life-size statues of a cow (considered to be sacred in Hinduism and Buddhism) and a tiger, I talked to the local priest and asked him what would become of humanity if we lost the tiger. He responded simply, 'It would not matter, because if we lost the tiger, there will not be humanity any more.' Yes, the tiger is an 'umbrella species' – protecting tigers also protects the many other species that make up the ecology of their habitat – but I sense it is even more than that. The very shape, colour and overwhelming beauty of the world's biggest cat haunt the stone age of our imagination. Eons ago humans were hunted and eaten by tigers. Later we made them into deities. Are we not karmically bound to such a species? If we desecrate the life force of this splendid beast we lose ourselves. If we render the last tigers into rugs and pharmaceutical items for the wealthy merchants of animal parts, we will have self-cannibalized. Mere photographs can never satisfy the burning desire within human children to know 'the other', to recognize the primal ground we share with the lion, the tiger and the polar bear. These great predators were with us at our origins as hunters, and without recognizing and honouring the face of our beginning, we lose the face of the future and stare into the eyes of oblivion.

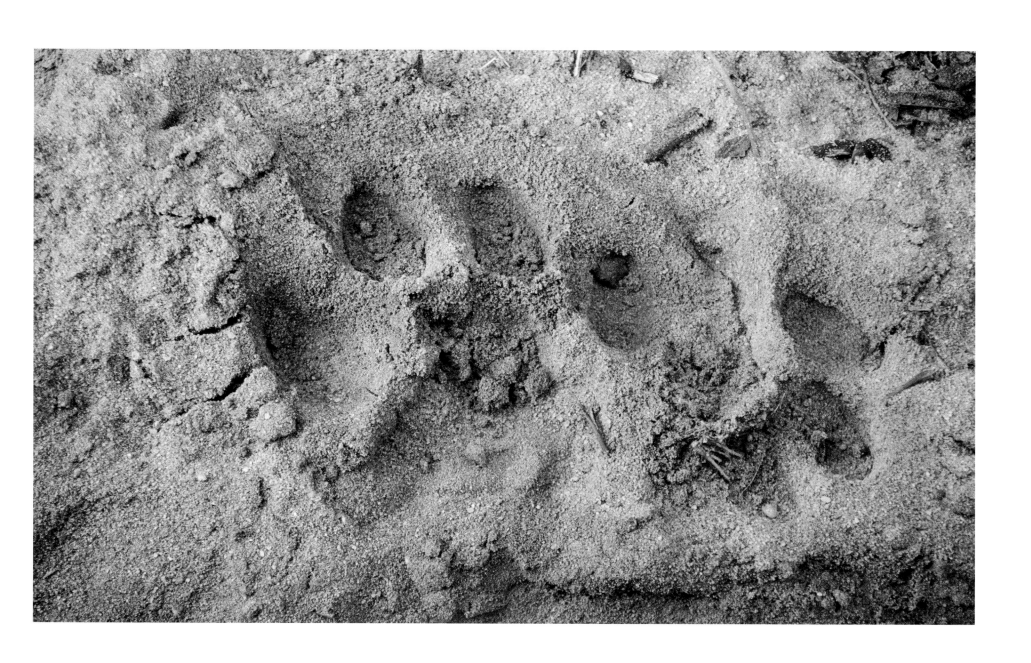

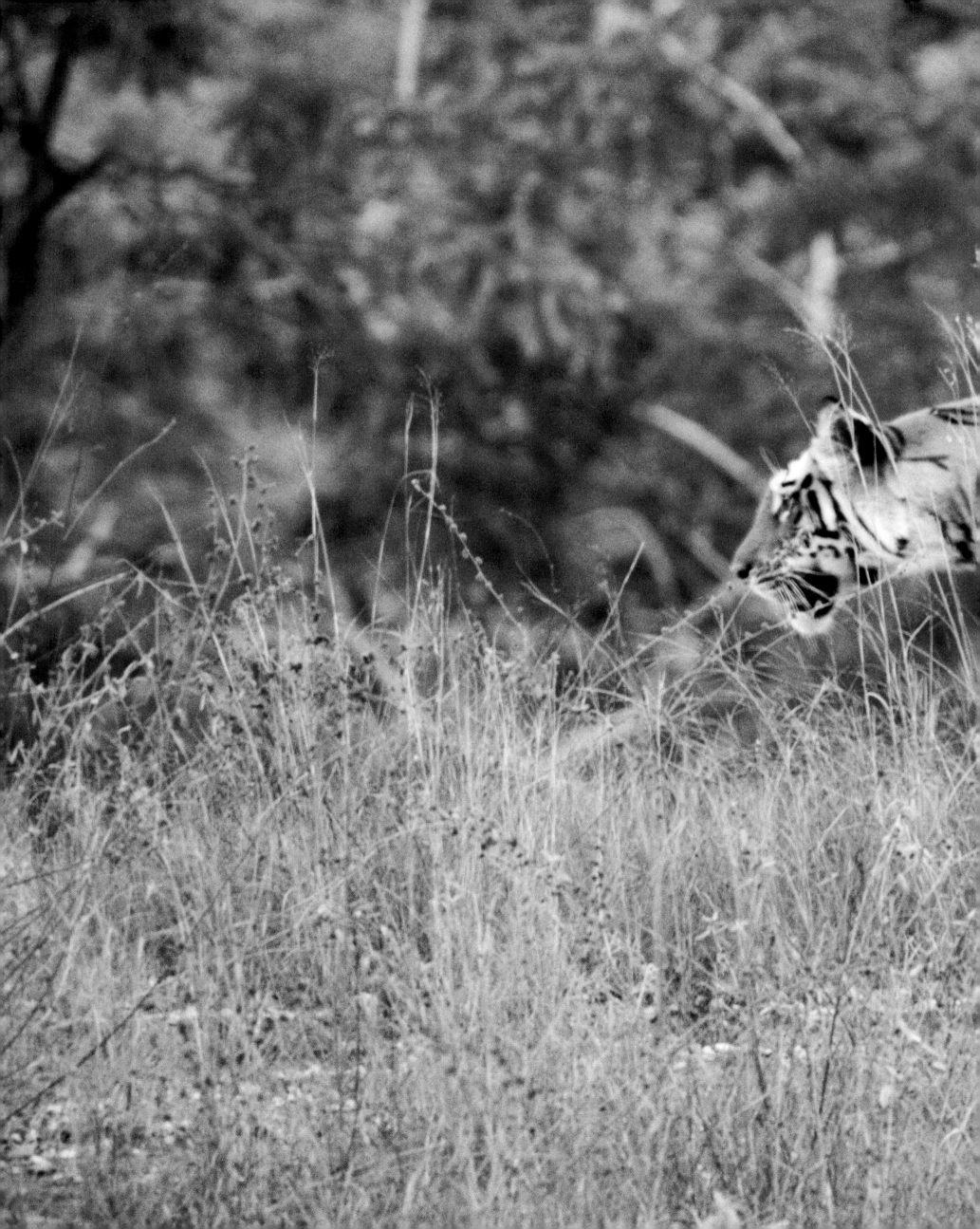

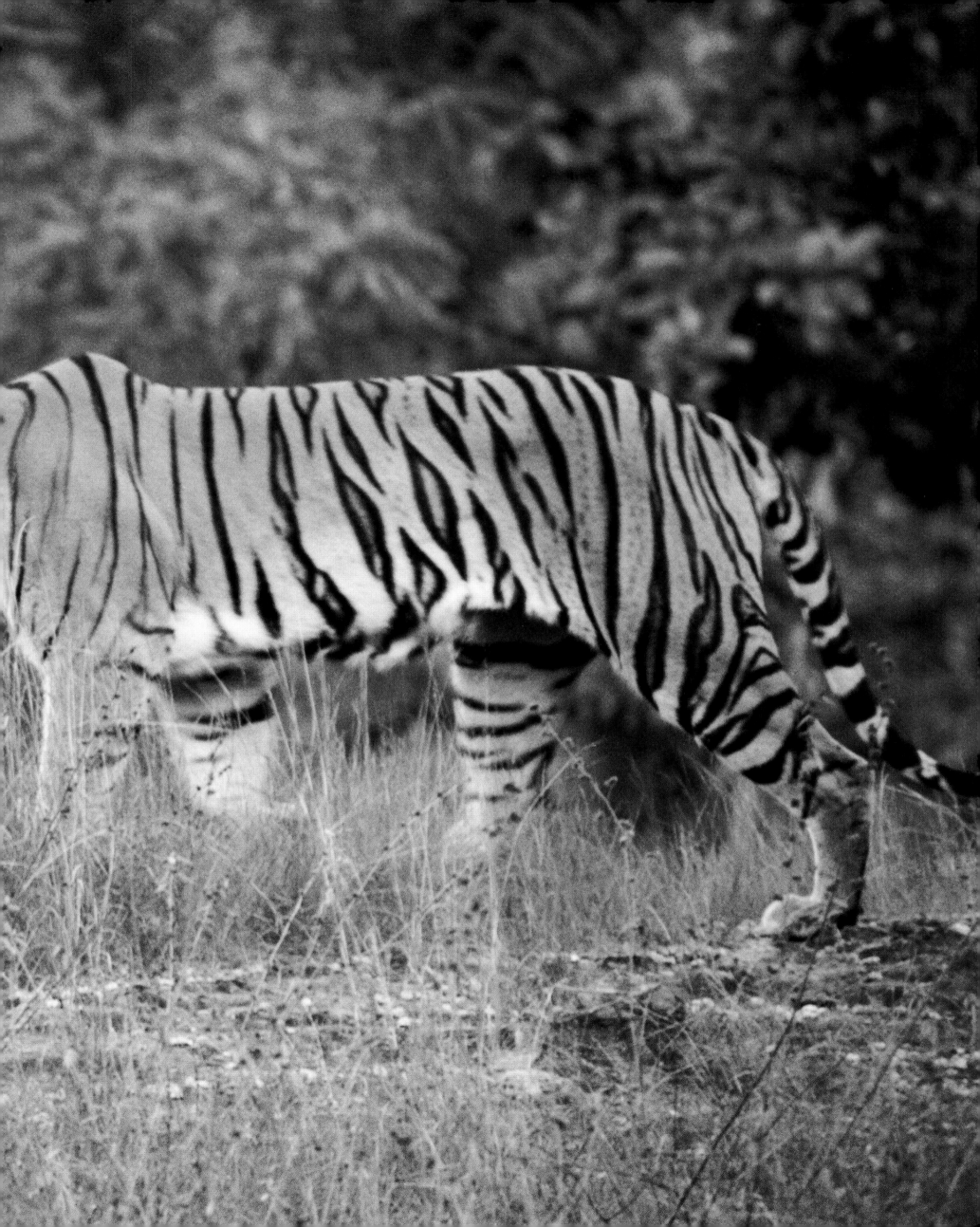

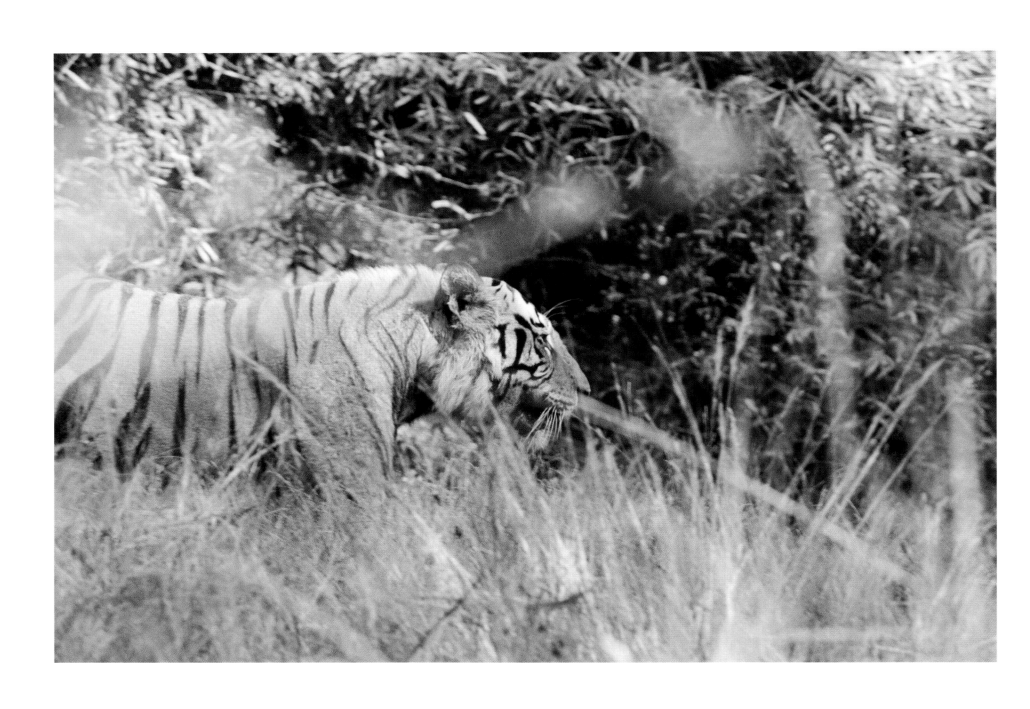

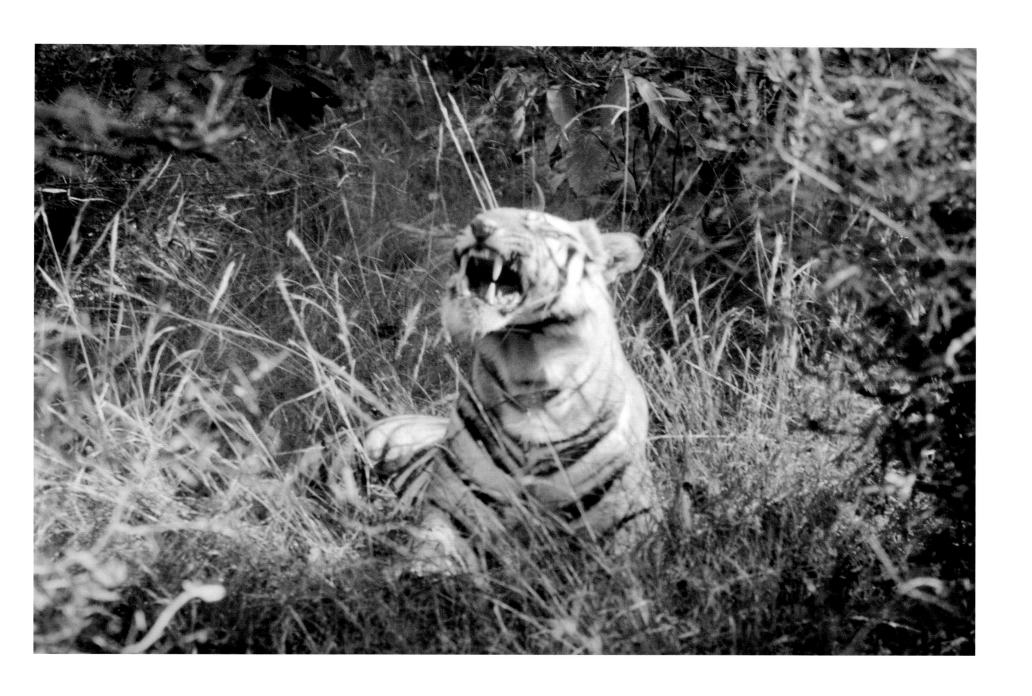

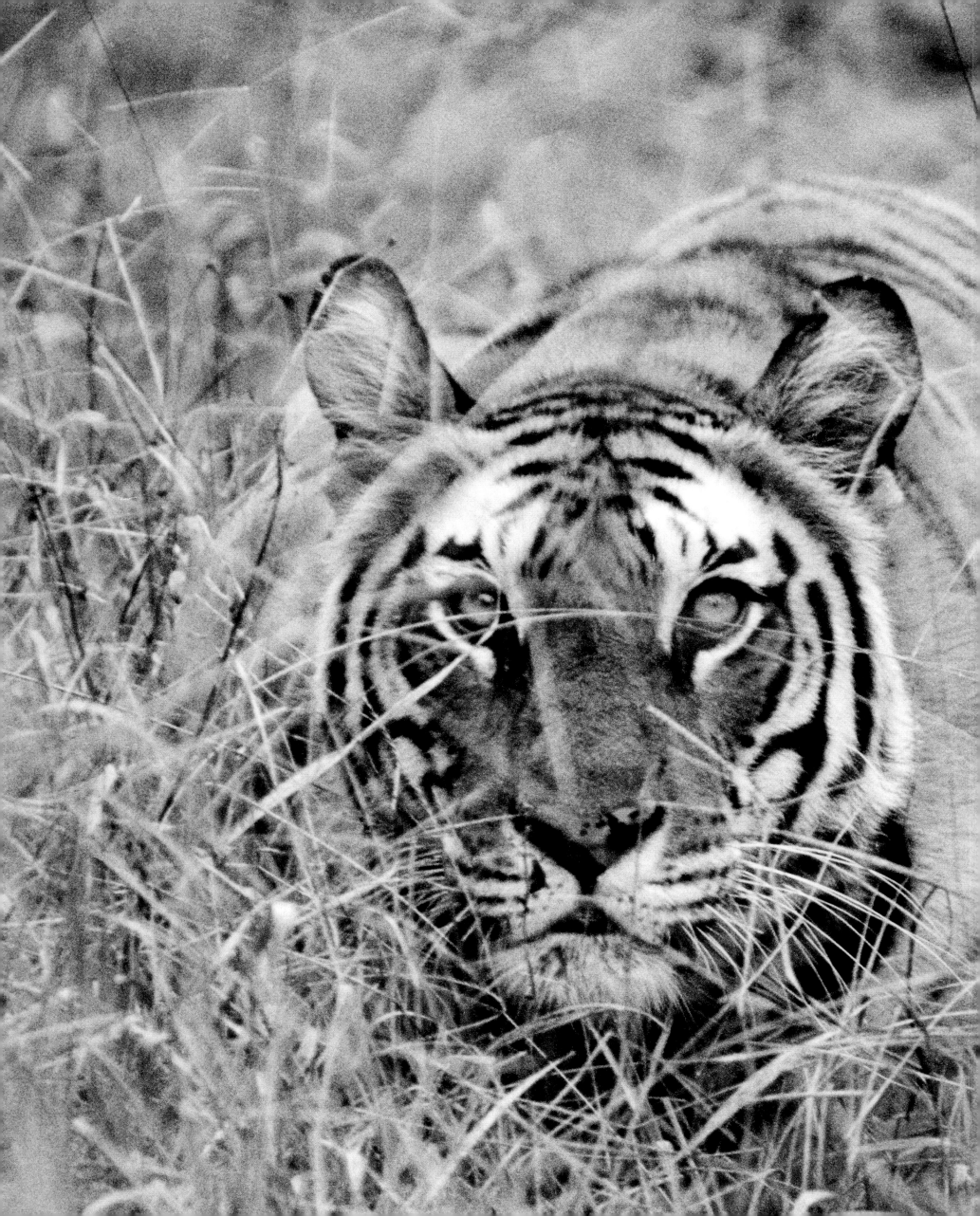

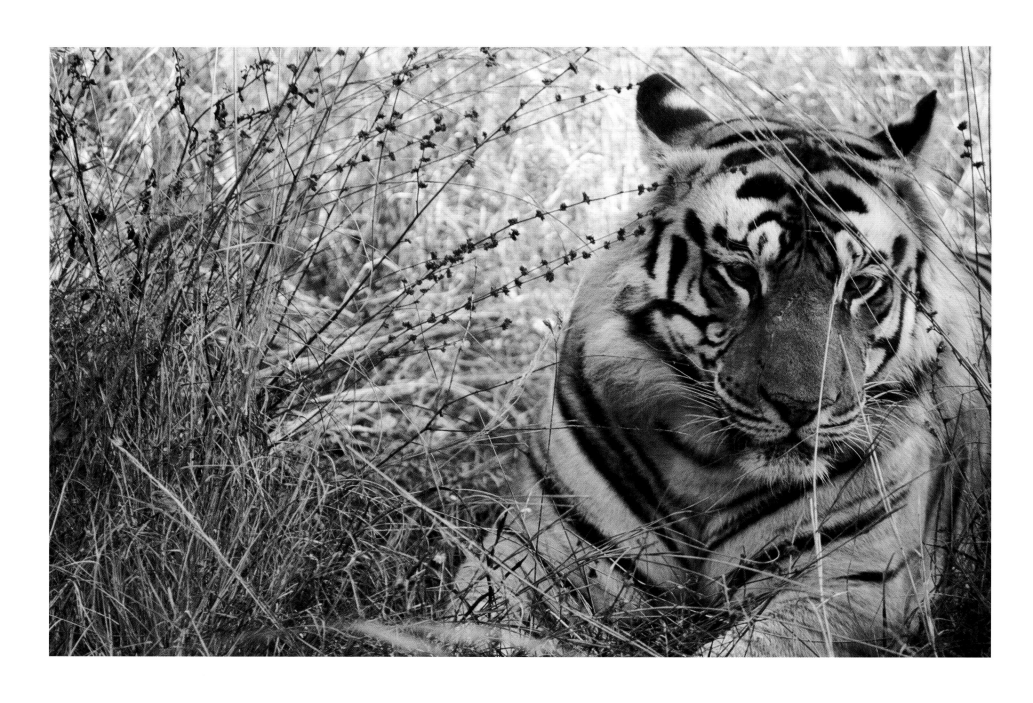

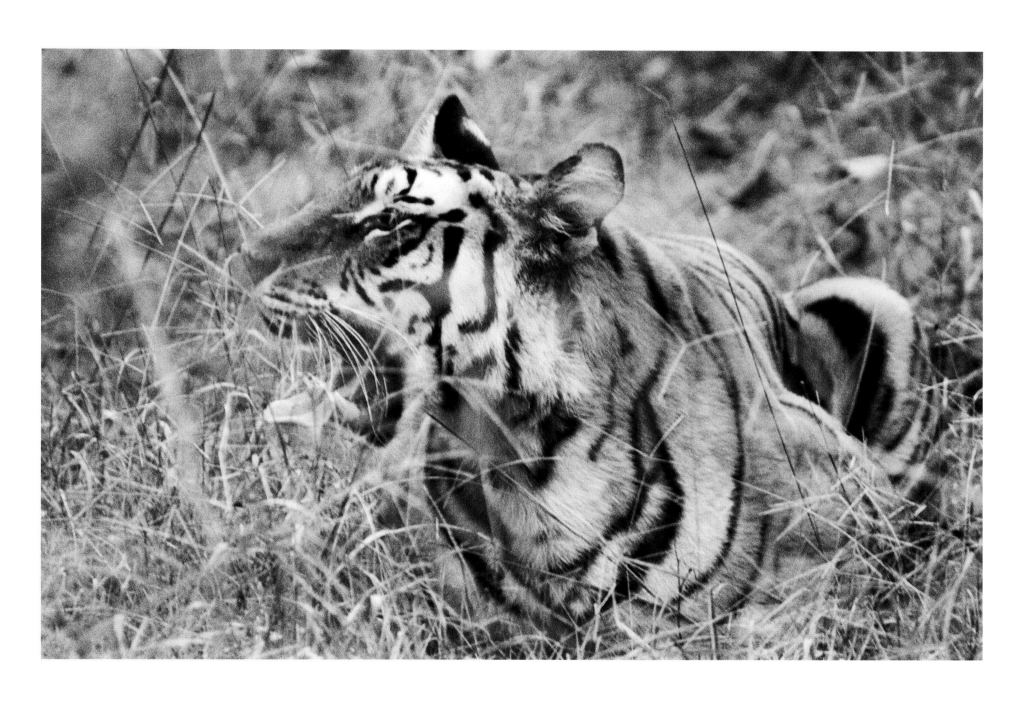

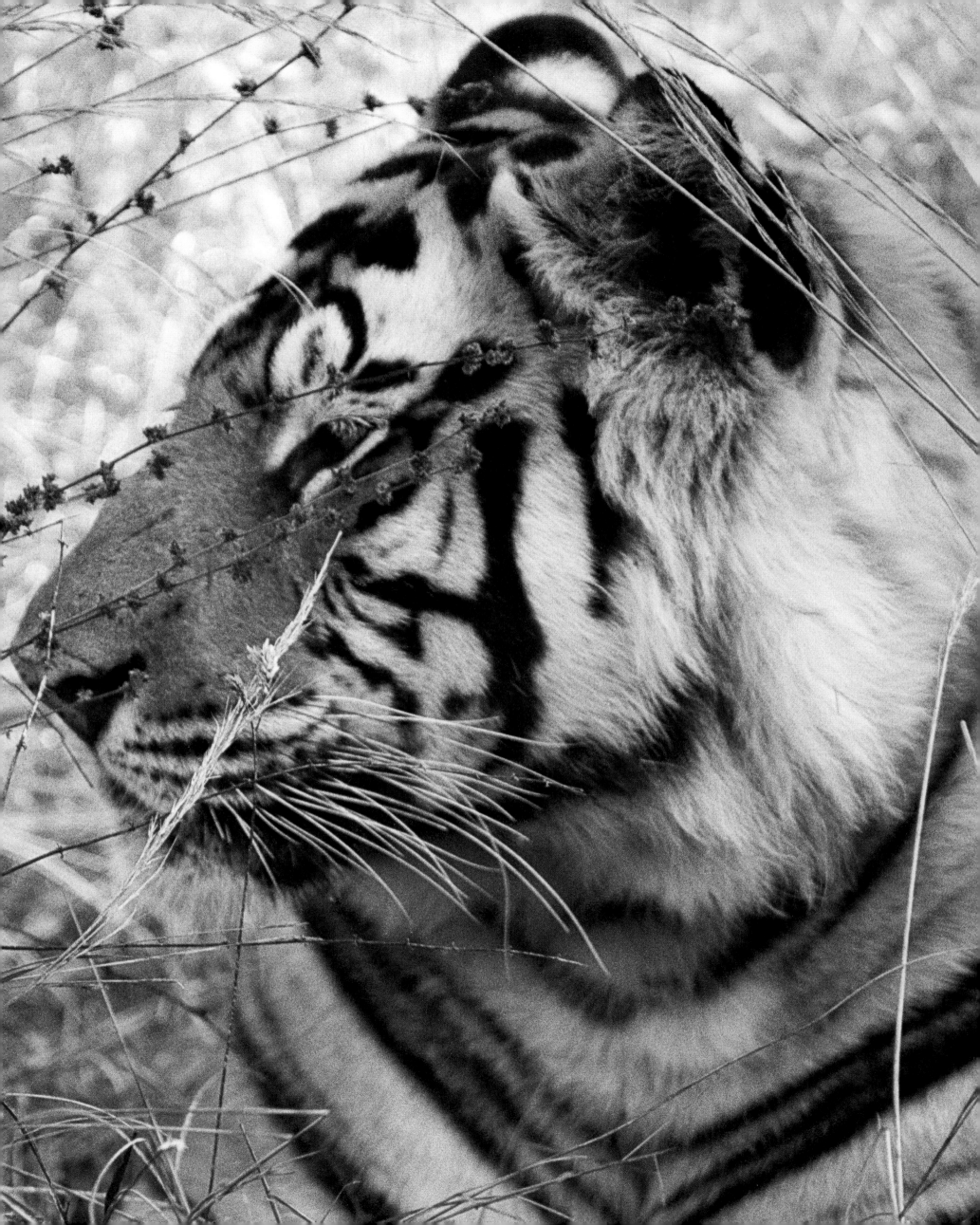

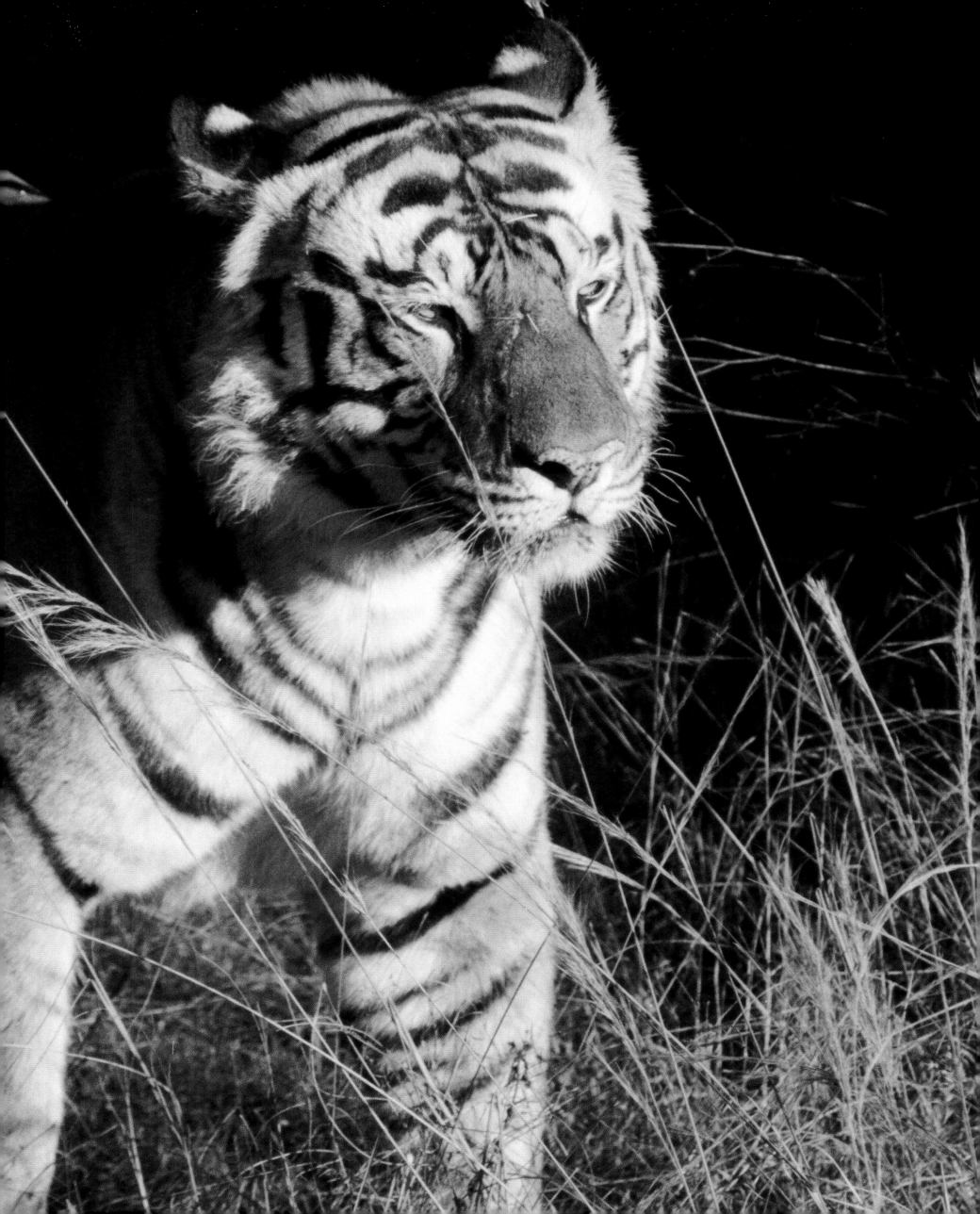

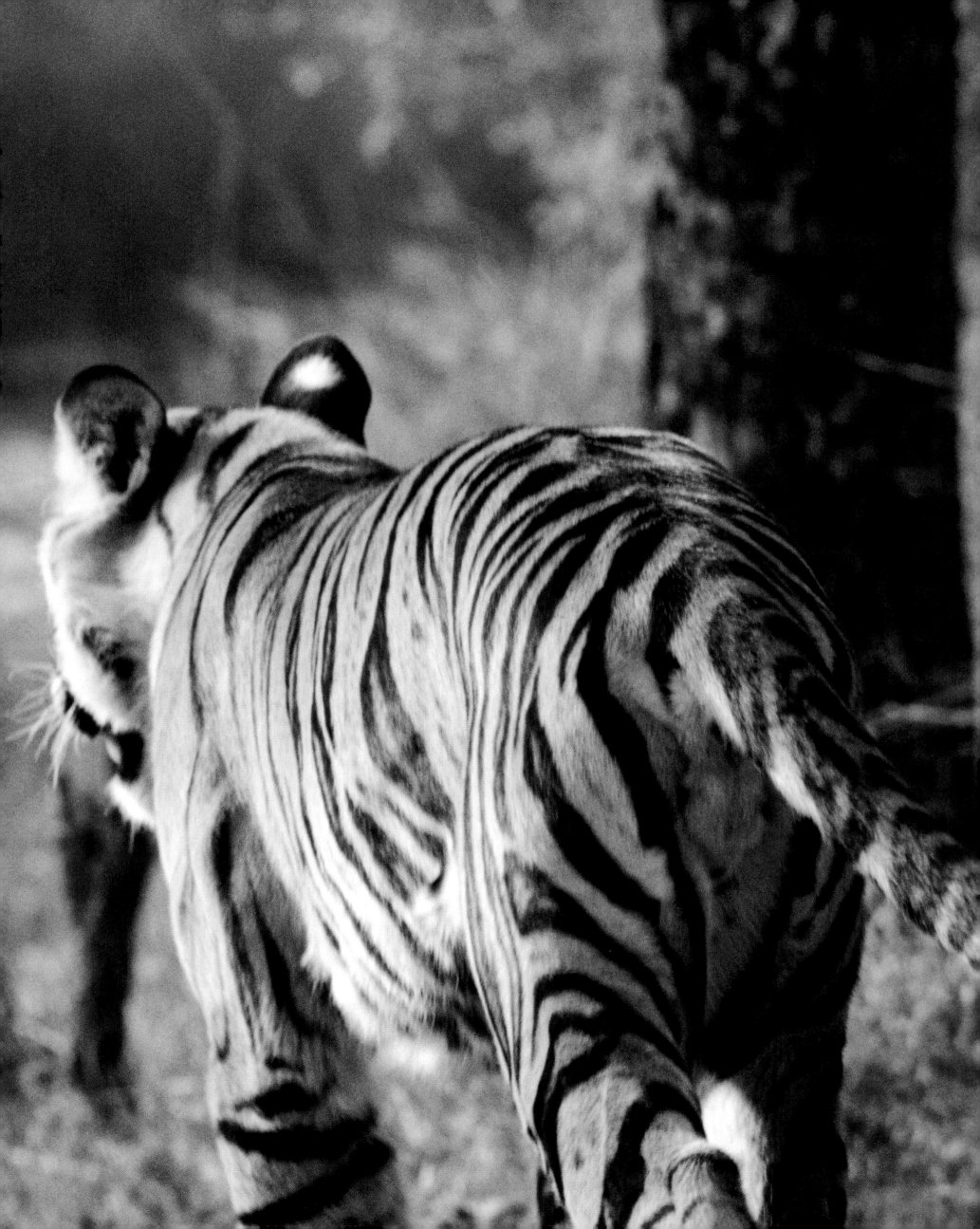

TIGERS

Sy Montgomery

Look into the face of a tiger. At a zoo, in a circus, or from the back of an elephant in the wild, there are several things you may notice. The tiger may look past you. It may look through you. At the zoo, it may be waiting for its dinner. At the circus, it will have its mind on the act. When Westerners see a tiger in the wild, it is usually 'laying up' beside a kill. (Trackers on elephants go out in the early morning to look for tigers, who aren't likely to abandon their meal, and then pick up their clients from the tourist camp and bring them to the resting tiger.) Sitting by its kill, the tiger is magnificent, breathtaking in its colouring, size and power. But it is not very interested in you.

Not usually, that is. But every once in a while, a tiger will look right at you, head up, ears alert, pupils huge, as into the eyes of a lover. A tiger looked in this manner into the face of a friend of mine. She was at an American zoo. The tiger, bored, had ignored everyone else who had visited its exhibit. But then my friend arrived, and the tiger's attention sprung to life like a flame. She was in a wheelchair; she would have been easy prey.

To look into those devouring eyes teaches you something essential about the tiger: it is a predator par excellence. The tiger can become invisible behind a single blade of grass. It can fly at its prey, leaping more than 30 feet in a single bound. An experienced tiger can kill its prey instantly with one bite, fitting its teeth between the bones of the neck like a key in a lock.

But to look into the face of a tiger also teaches us something important about ourselves: that we are made of meat. Humans like to forget this. We even like to forget that we eat the flesh of other animals. We eat a pig, a jolly, intelligent, comfort-loving creature that is as smart as a dog, but we call it pork. We eat an infant cow, the soul of innocence, but we call it veal. We certainly don't like to think of our own flesh as meat. In our arrogance, we imagine ourselves to be the rulers of the earth, that the world is our oyster. We certainly don't consider ourselves to be food for another being.

But the tiger remembers. Even though wild tigers seldom kill people, they know what we are. We are all – chital deer and boar, frog and fish, hero astronaut and street beggar – made of the same stuff. We would taste just fine to a tiger. It could so easily stalk us and ambush us, kill us with a single bite, and gnaw the flesh from our bones.

Surely this is why, wherever the tiger is found, it elicits a reverence and wonder accorded to no other being. In Sumatra, holy men commune with tigers to speak with dead heroes. The Mendriq people of Malaysia consider the tiger to be the connection between the thunderstorm and the underworld. The people of the Sundarbans, the area of mangrove forest along the Bay of Bengal straddling the border between India and Bangladesh, say that the tiger is the original owner of all the riches of the forest, and it must still be propitiated before the people fish, harvest

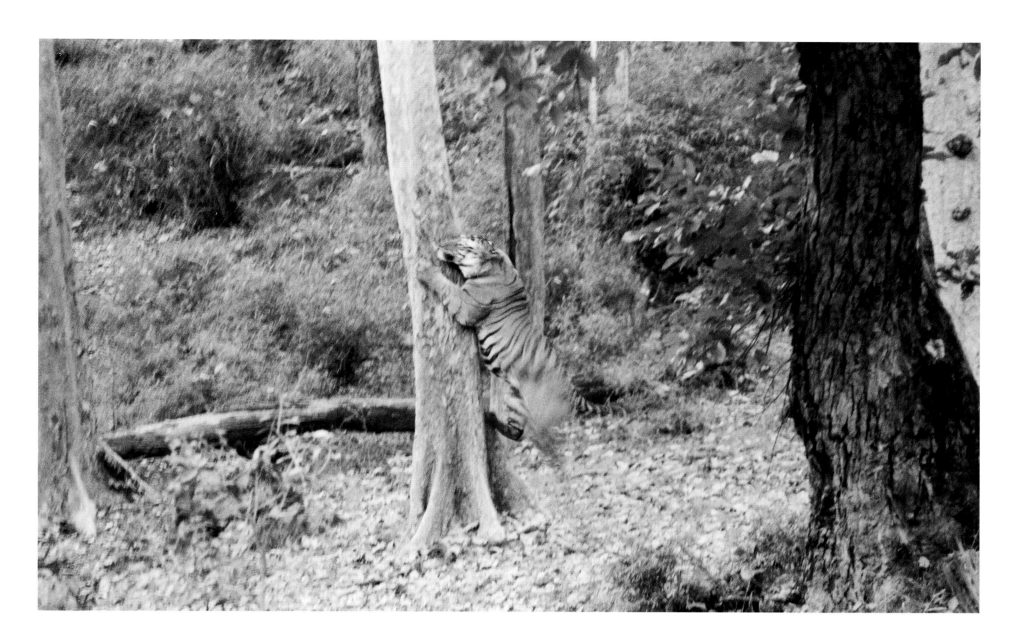

timber or collect wild honey. To disrespect the tiger, these people know, is to invite terrible consequences.

In our hubris, in our greed, we are now breeding, consuming and polluting at such a rate that scientists estimate that our human activities obliterate a dozen species each day. We have already eradicated four of the eight original subspecies of tiger. We are seeing the consequence of our actions: we are losing the refreshment of clean water, the fertility of the soil, the dazzling abundance of the many lives on this planet, of which our own human lives are but one kind.

In the gaze of the tiger may rest our salvation. If we can remember that we are but meat, perhaps we can remember how to hold our planet and its creatures in reverence once more.

POLAR BEARS

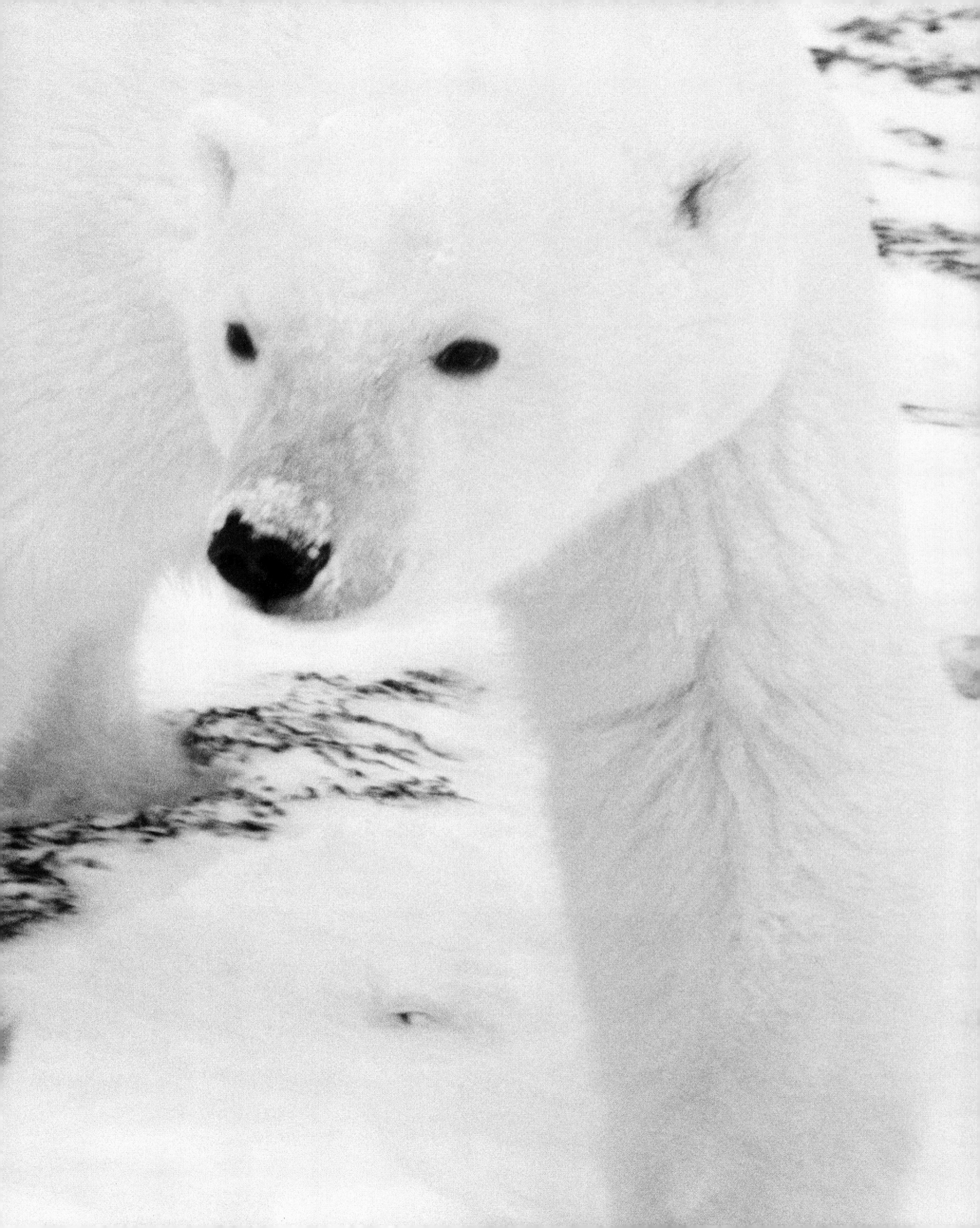

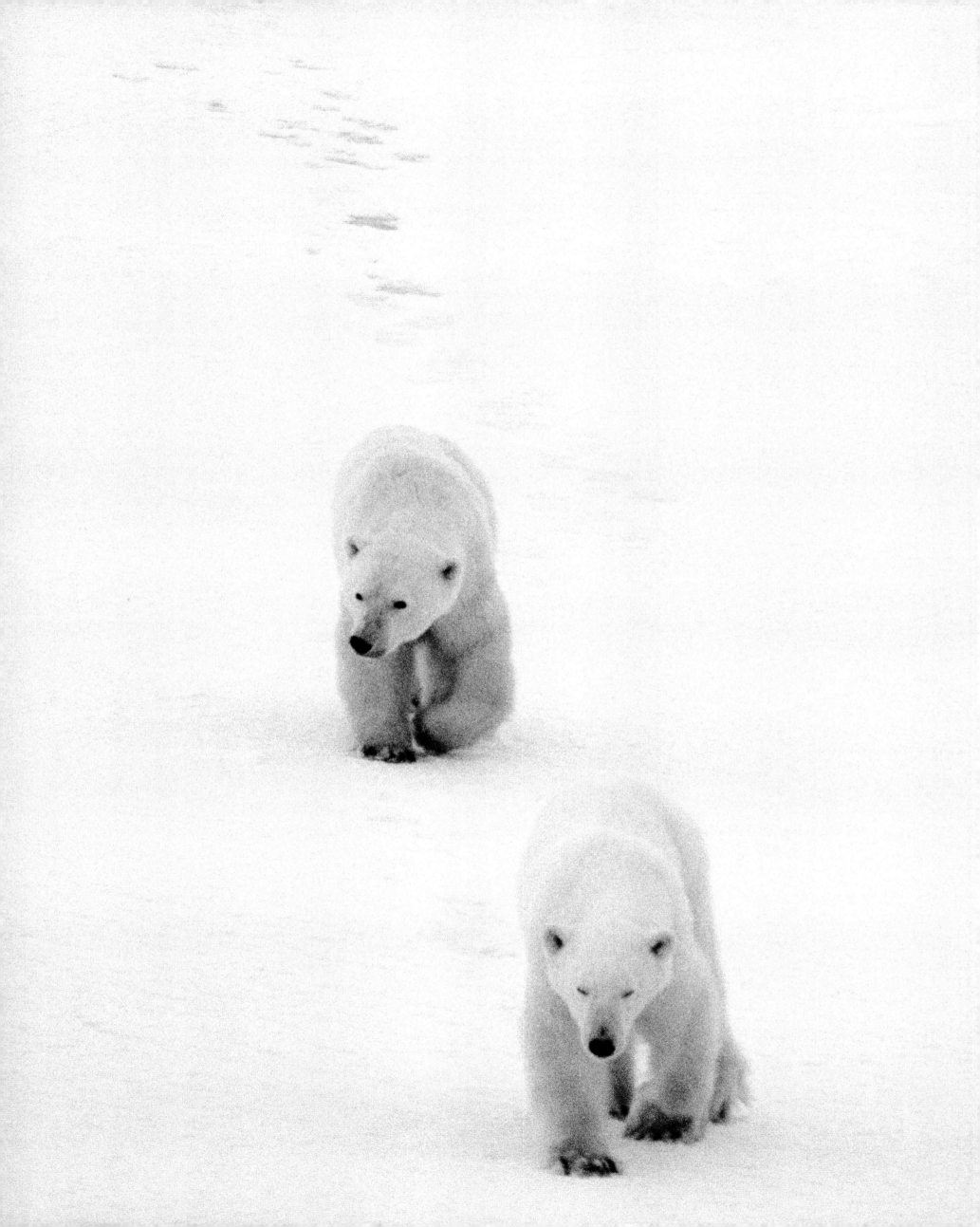

> Man is the product of a very unusual epoch in earth's history, a time when the claws of a vast dragon, the glacial ice, groped fumbling towards him across a third of the world's land surface and blew upon him the breath of an enormous winter.

LOREN EISELEY,
'THE ANGRY WINTER',
IN *THE UNEXPECTED UNIVERSE*, 1969

Marie and I saw our first ice bear, the greatest predator on earth, on Hudson Bay, north-east Canada, in November 2004. That seems like prehistoric times now: climate change was not yet on everyone's mind, and we did not know the extent to which the ice was melting and the polar bear was threatened. During our visit to the area we were told stories by a Polish man who had escaped the terrors of the Nazi regime and had settled in Churchill, on the shore of Hudson Bay in the province of Manitoba. He had been happy to get away from the worst evils of humanity during the Second World War, and he could only smile at the close encounters he'd had with polar bears on the streets of his adopted home. Circling his car repeatedly in order to avoid a curious bear seemed to him a small price to pay for the haven he had found.

Safe in our tundra buggies, the massive tyres of which kept the vehicle high off the ground, we were mesmerized by Arctic fox that came to visit every night to investigate the smells that emanated from our buggies. Polar bears would also amble by in their daily quest for food; in a spectacle that drew from mythic times, these spectral white denizens of the snows and ice would appear in utter silence out of the black 'nothingness' of night like otherworldly sentinels.

Once, under the spellbinding theatre of the northern lights' filigree webs of electric-green, a bear walked under the iron grille that formed our outside deck. It had been attracted by our dinner and at one point, as it stared up at us strange beings who walked on two legs, its face came within a few inches of mine. To see at such close quarters its tongue, its inquisitive eyes, was surely to encounter a fellow being. As Jean Malaurie recorded in *The Last Kings of Thule* (1956), his account of the life of northern Greenland's Inuit people, ' "After all, he's the one closest to us!" Kutsikitsoq said. (The bear is so closely identified with man that, according to Inurterssuaq, when one had killed a bear one was to observe a period of mourning as for humans – three days for a male, five for a female.)'

The bear under the deck of our buggy seemed pleading, and inviting, but no one would want to come face to face with such potential ferocity and untamed explosive power. Our visitor was at once superbly adorable and a monster of sheer beauty. No one needs to be told how powerful a polar bear is; many of the bears we saw seemed much smaller than the monsters of legend (because of the reduction in sea ice, from which polar bears search for seals, their favourite prey, many bears are not as strong or healthy as previous generations were), but nevertheless they can weigh more than half a ton. The polar bear haunts our imagination, but we do not know how it will fare in a generation's time, after the depredations of oil drilling and melting sea ice and glaciers. Still today, some may consider it to be as malefic as the great white shark, but it is man's depravity and greed, not the bear, that threaten the top of the world.

All the wonders of modern civilization are palsied in the presence of the eternal ice and snow.

THE TIMES,
21 NOVEMBER 1849

Bears have always been the northern hemisphere's premier totem. If we are left with only mechanical and animated totems to play with, surely something will collapse in the soul of the human animal, never to arise again.

The Inuit people, unlike many trophy hunters today, have always understood the importance of each animal's *inua*, or soul; their mythology and shamanic practices tell of the days when animals could 'transform' into humans. All animals had to be respected, especially the polar bear. When it was hunted and killed it was honoured. Lack of respect could result in hunger. These days, it is spiritual hunger that is visited upon modern man, who for $40,000 (£25,500) can hire an Inuit guide to enable him to shoot a polar bear to display as a rug. We have overturned the Inuit understanding of the cosmos; we are melting the snows and have desecrated the great marauder of the north. What are we doing? As recorded by John Bennett and Susan Rowley in their book *Uqalurait: An Oral History of Nunavut* (2004), one Inuit told them that 'in order to survive on the land, you have to protect it. The land is so important for us to survive and live on; that's why we treat it as part of ourselves.'

In July 2008 we arrived in Norway's remote Svalbard archipelago in a brilliant daze of light and snow. Lost in the freezing ocean some 400 miles from the mainland, midway to the North Pole, Svalbard is removed from the mayhem of the rest of Europe. This reclusive station, seemingly reserved for those who live on the edge of the known world, feels like a mythic place; it feels like Thule, the mysterious lands of the far north first written of by the Greek explorer Pytheas in the fourth century BC. The polar bear survives here; some 2000–3000 still roam the vastness in the ferocious winds and the atrocious cold spells, ruling over the hyperborean extremes that once crushed sailing ships looking for a passage from Europe to Asia.

But already 2000 years ago, in his play of the Greek myth of Medea, the Roman philosopher and dramatist Seneca foresaw the time 'when the Ocean will unloose the bands of things, when the immeasurable earth will lie open, when seafarers will discover new countries and Thule will no longer be the extreme point among the lands.' One could be tempted to believe that he had predicted the breaking up of the ice and the discovery of the fabled Northwest Passage over North America, the name of which was until recently synonymous with legends of lost lands at the ends of the earth. In our mind's eye, the polar bear, this supreme solitary denizen, symbolized our double as a migrant of fantastic strength and determination. It was a four-footed predator, yes, but also a ghost affirming the loneliness of infinities that haunted our journey on this planet. Its very gait expresses the solitude of immensity. Its piercing black eyes search the expanses for solace, for prey, for fellowship, for

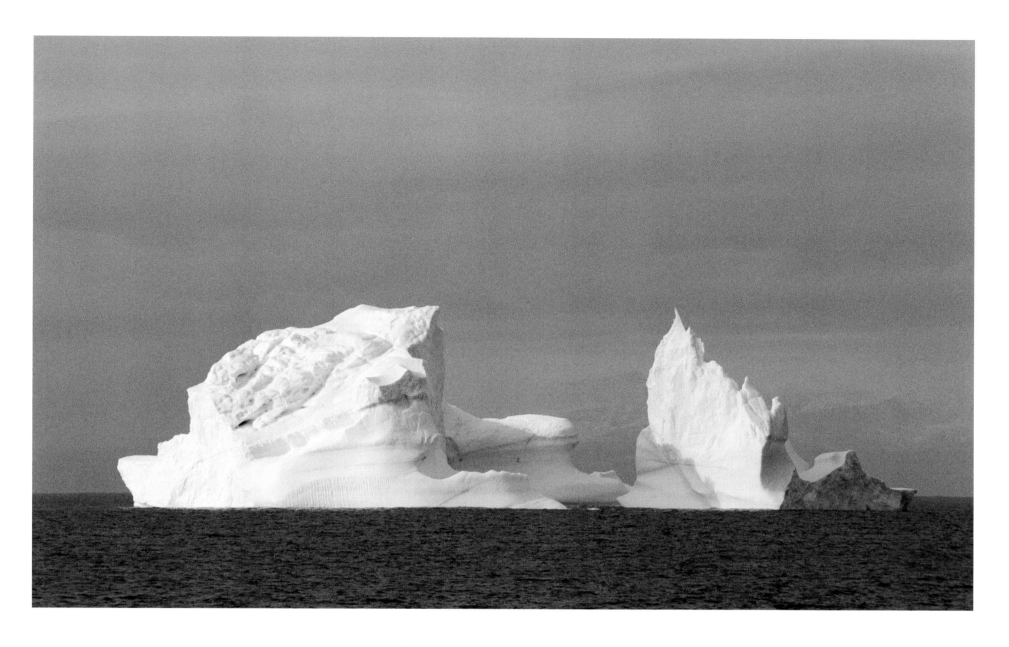

familiar landmarks in the barrens of windswept and, to us humans, inhospitable magnificence.

It had snowed generously the previous winter, and now the fabled ice pack moved in gigantic frozen Rorschach-test patterns, recombining in endlessly variable arrangements. During our journey we were fortunate enough to see eleven polar bears scrambling amid the ice floes, seemingly immune to the cold. On our ship, our guide, Robin, a South African who had settled in Norway, regaled us with tales of the days, years back, when he would venture out in the great snowy desert on his own with his huskies. He showed us slides of a young bear, maybe one year old, that had befriended his dogs, remarkable shots of bonding between two species that millions of years ago shared an ancestor. But despite the apparent intimacy between the dogs and the young bear, we knew only too well that this great being stalked prey with unrelenting stamina and power.

From the safety of our ship, we saw polar bears roaming the ice pack and felt the privilege of watching these awesome wayfarers moving tirelessly, like uncanny and enduring spirits. As one male gambolled towards us across the ice sheets, we felt its expectant and gallant efforts to make some kind of contact with the alien vessel. At one point we witnessed it jumping over open water, its body reflected on the surface of the sea. It pursued our ship, while far away on the other side of the strait a mother polar bear watched anxiously over her cub, in case the male came too close. They were the rulers of an empire of snow and ice and yet also the victims of this rapidly changing environment.

It was here, at the top of the world, that Robin told us of the rare white lions of South Africa. At first the story sounded like a fable, but among these lands of crystal and mystery the lions seemed the perfect counterpart to the bears. Slowly a link was established between two distant worlds and two seemingly disparate predators at opposite poles of existence. Kittiwakes and their haunting arias accompanied us on ten remarkable days on board, while ice crashed against the hull of our expedition ship, reminding us of the precariousness of human existence. The summer ice was prolific. Our ship even had to turn back when we could not navigate through the Hinlopenstretet. Each strait full of cracking miniature continents, and the spell of birds trailing our ship, summoned the words of Loren Eiseley in his 1960s essay 'The Star Thrower': 'Has the wintry bleakness in the troubled heart of humanity, at least equally retreated? That aspect of man referred to when the Eskimo, adorned with amulets to ward off evil, reiterated "Most of all we fear the secret doings of the heedless ones among ourselves."'[1]

We returned to Spitsbergen, the largest of the archipelago's islands and the only one to be permanently inhabited, to wait for the plane that would transport us back to mainland Europe. In the icy alien world lit by the

blazing midnight sun, walrus, minke whales, caribou, Arctic fox and seabirds had enchanted us; we had visited the periphery of the great land of Thule, and our son, Lysander, who was then aged three, had seen his first ice bears. Looming snow-clad mountains and strange cloud formations created hallucinations of a world without duplicity and war. From the ship we had seen entire countries of ice that had been dragged underwater, as if in warning to those who approached the mysteries of the north too closely. We saw a rare fog bow, a rainbow arching over the water through the mist-laden atmosphere, and its double exquisitely reflected in an ice-free patch of ocean. We were transfixed by this Thule, and wondered what would happen to its spirit, and ultimately the human soul, if the ice at the top of the world were to vanish. The fog bow was like a vision of a world beyond our reckoning, a portal to another dimension. Even the wind danced tangibly on one's fingers, as if touched by the magic of belugas and narwhals, the fantastic 'mermaids' that swim below the pack ice beyond the grasp of mere mortals. Far away in Canada, the Inuit, who never made the journey to these shores, have the word *sila*, meaning 'breath', 'wind' or 'weather', but it can also signify 'mind', 'wisdom' and a host of other concepts and relationships that technological society can probably no longer fathom.

On Spitsbergen, in the settlement of Longyearbyen, we met a schoolteacher who was watching over children playing outdoors, surrounded by peaks that formed an otherworldly playground. The mountains all around created a seemingly perfect refuge, yet beyond the town's immediate borders lay the realm of the polar bear. People here are urged to take guns with them if they walk off into the back country. We were told how one day, a friend of the schoolteacher decided to walk to the top of the hill closest to town, and did not take a gun. Perhaps the young woman simply forgot, or perhaps she thought she would not need it; she had gone on this walk many times before and had never needed to protect herself. But this time, as she reached the top, along came a bear. Surprised to see her, it charged at her, swiped at her and took her head off. A gun might have scared it off; the young woman could have fired at her would-be foe and had a chance to defend herself. Instead she was mutilated. Such are the encounters one faces with the world's largest predator.

When I asked the teacher if she thought that she and the island would be better off without bears, she replied, 'No, the bears were here first, we are second.' I sense that most of the inhabitants of Svalbard feel the same. One has to respect the world in all its aspects and one has to honour the bear, 'the other', because it is a large part of our very history as migrants, as marauders. Without the polar bear, without its frozen realm around the North Pole, a significant part of existence and its magic would fade into a vanished world.

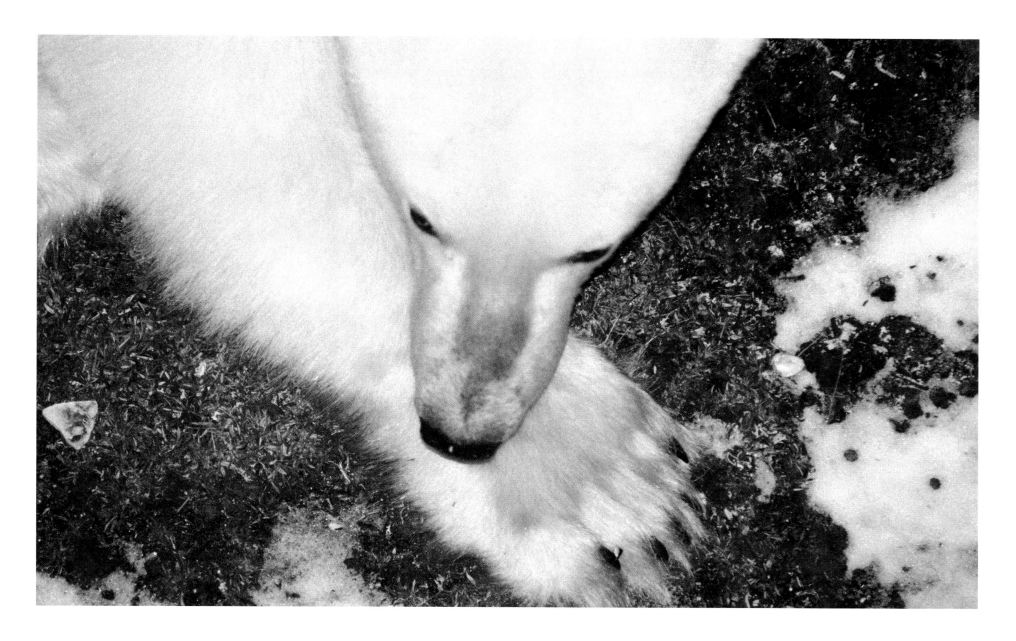

We made another trip to the Arctic in the late summer of 2009, around the area of Baffin Island, off the north-east coast of Canada facing Greenland. We beheld the great icebergs between the two, and were transfixed by countless floating palaces glistening as if they were phantasmagoric constructions on an alien planet. The sublime icescapes at the top of the world echoed a saying of the first people of the New World, as recorded by Knud Rasmussen from an elder almost a century ago: 'Wisdom can be found only far from man, out in the great loneliness.'[2]

Here the great imponderables surfaced like gigantic ships of ice, and we wondered, as the frozen millennia fell into the sea in a warming environment, how long these great monuments would sail across the vastness. Between the fractures and fissures of the great geological maelstrom of the north lay a spirit no longer cherished by modern man, who wishes no longer to wander among the ice but to break it, to challenge the weather and to rule the elements – a decision that may, in the years ahead, prove to be fatal.

While we were on Baffin Island we had the rare privilege of spending time with the artist and elder Kananginak Pootoogook, whose lithographs are known throughout Canada and around the world. We showed him a picture of the fog bow we had seen in the European Arctic. The fog bow is an apparition one sees only rarely, as if it were a lifeline to another dimension not usually afforded to ordinary mortals. Kananginak looked at the Christmas card we had made of the image, and told us that in the old days, the elders would occasionally see this, along with a pole underneath it supporting the fog bow. It was the bow that upheld the world! In an instant we were given an image of what modern man had long ago forgotten. An entire cosmology underpinned the reverence for the ice and the telluric realities that modern humanity had lost, undermining the earth. This image furnished us with a symbol and a prayer that, if we so chose, could grant us insight and salvation. Ice-core studies may be giving scientists knowledge of climate conditions in our planet's past, but here, at the top of the world, stretches an ineffable cosmos we barely understand.

We returned to the Canadian Arctic in 2012, on a Russian expedition ship that took us on a 2500-mile trip around Greenland and northern Canada. We saw icebergs, as we had seen three years previously, but this year virtually the entire surface of Greenland had thawed; a winter trip through the Northwest Passage, as well as the Northeast Passage running along the Arctic coast of Russia, had been accomplished for the first time. A glacier twice the size of Manhattan had broken off the west coast of Greenland. We saw, rising out of the depths, our first bowhead whale, the population of which was ravaged by whaling before a

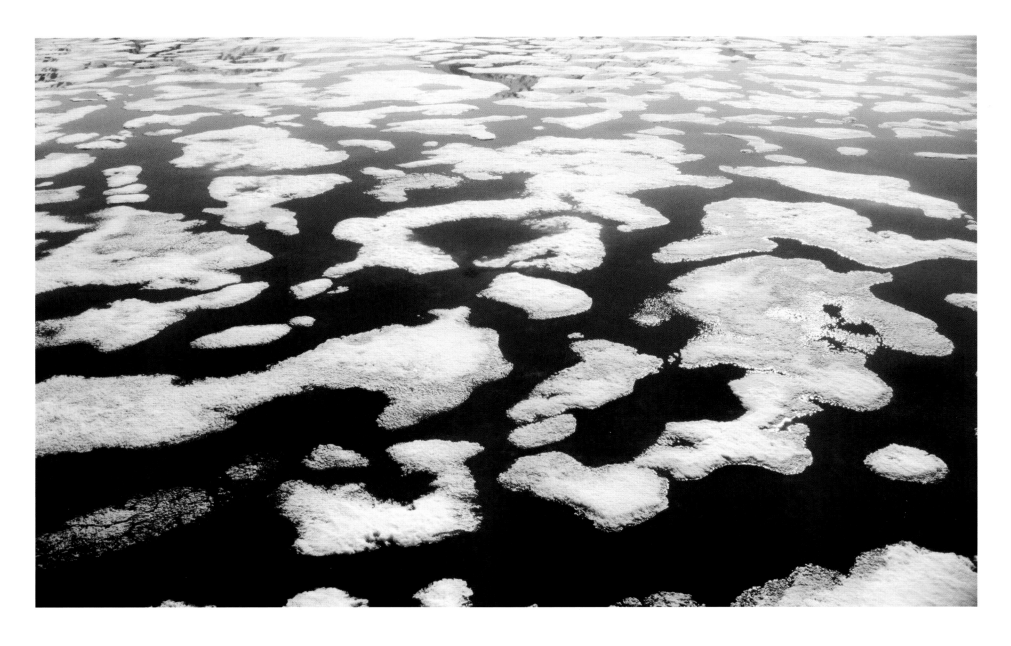

moratorium in 1966. We saw the spectral halos of icebergs on the distant horizon, Fata Morgana mirages of a parallel universe shimmering over the Davis Strait.

Then, a week later, where beluga whales were feeding in shallow waters off Prince of Wales Island, we saw some fifteen polar bears skirting the edge of the water, some of them eating from beluga carcasses. At this feast for the monarchs of the north, there were both single males and mothers with cubs. Our ship came within 100 feet of them as they watched us intently. We were held spellbound by the sheer marvel of the predatory colossus of the north. One watched us from the water, standing on its hind legs; some smelled us from the shoreline; others gambolled over the ridges, disappearing into the back of beyond. We were floating on what felt like the edge of the known world; what lay beyond only the Inuit shamans truly understood. They who entered trances and altered states, in which they followed the polar bear across the ice packs, are no more.

The Inuit call white people 'the people who change nature'. It is time for our civilization to beware of its grandiose schemes of conquest and progress. We cannot afford to undermine what remains of the earth. The polar bear, with its remarkable ability to live without food for months, is perhaps the greatest mammalian survivor on the planet. We may discover that there are kingdoms of ice in outer space; but I am almost certain that polar bears exist only on this earth. And what they signify in their overwhelming powers of endurance, we cannot hope to match. If they should be swept away and lost in the heat of our wayward civilization, we will follow in short order.

With that last sighting of polar bears, we bid goodbye to a world seemingly beyond the frontiers of this planet. For ten days we had seen no cars, no industry and none of the mayhem that passes for civilization in the modern world. I had read of those who had braved the Northwest Passage for glory, explorers who had suffered terrible ordeals as their ships were crushed and swallowed by the ice in the northern latitudes. On their voyages they were met by seals, whales and birds, but it is probably with the polar bear, the sovereign of white infinities, that their spirits spoke most. I feel that the bears are guardians of secrets that transcend the flesh. It is little wonder that Mary Shelley opened her novel *Frankenstein* (1818) aboard an Arctic ship; what haunted the mind of the West in the early nineteenth century continues to haunt us today. But now our Frankenstein, the creator of monsters, is the global civilization that continues to challenge the Fates, to threaten the future of the ice and the survival of the polar bear. A century ago the *Titanic* was sunk by an iceberg that had probably broken off from Greenland's west coast. Today, it is the loss of the ice that may overturn our planetary civilization as we know it.

The Pole is the roof of the world, the birthplace of our climate condition, and the Earth is not eternal. Men of science, like men of state, have a duty imposed by ethics. The Earth is living: it can and will avenge itself: already there are portents. The Earth has no time left for man's ignorance, arrogance, sophistry and madness.

JEAN MALAURIE,
THE LAST KINGS OF THULE, 1956

Notes
1. Loren Eiseley, 'The Star Thrower', in *The Unexpected Universe*, New York (Harcourt Brace & World) 1969.
2. Knud Rasmussen, *Observations on the Intellectual Culture of the Caribou Eskimos* [1930], New York (AMS Press) 1976.

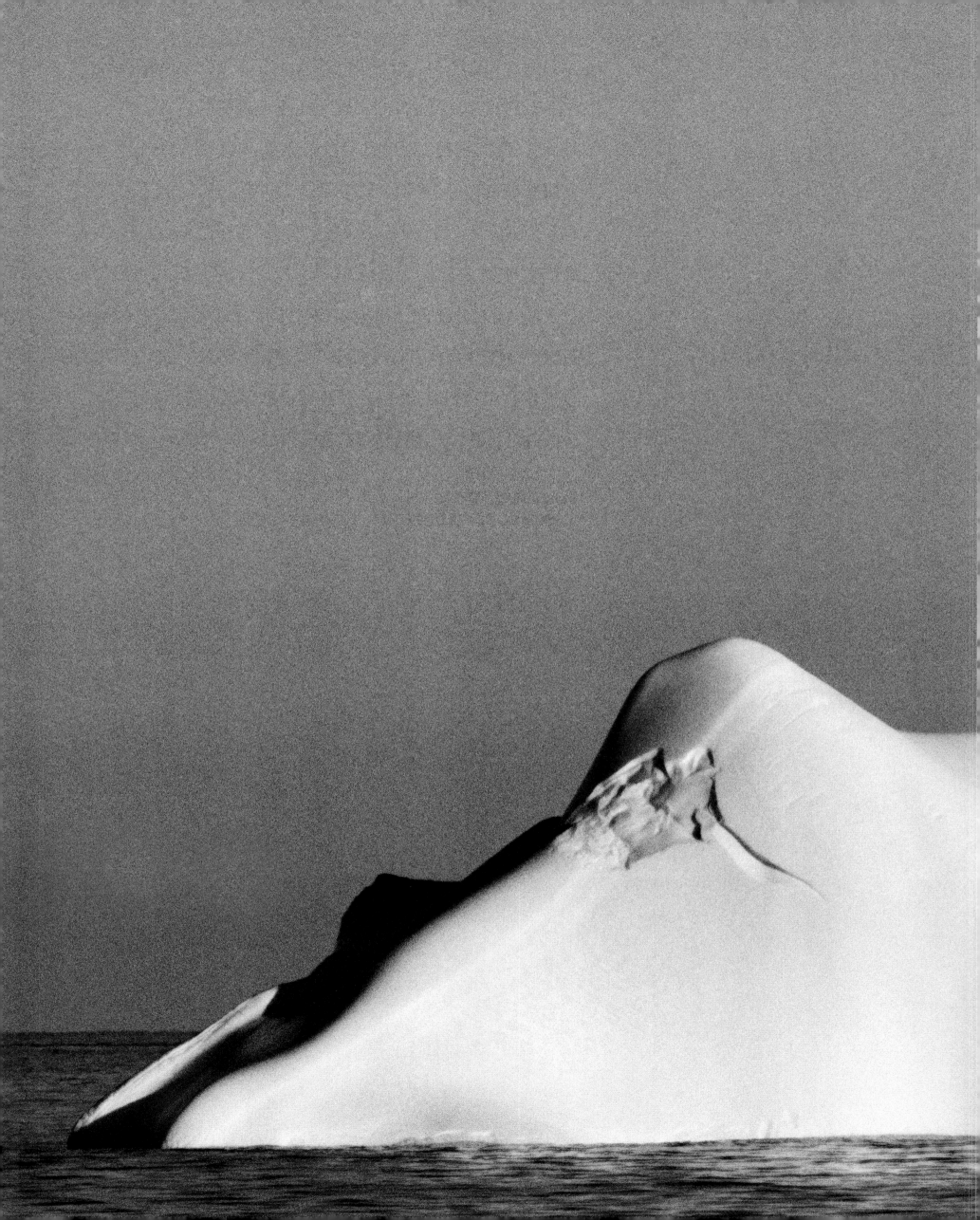

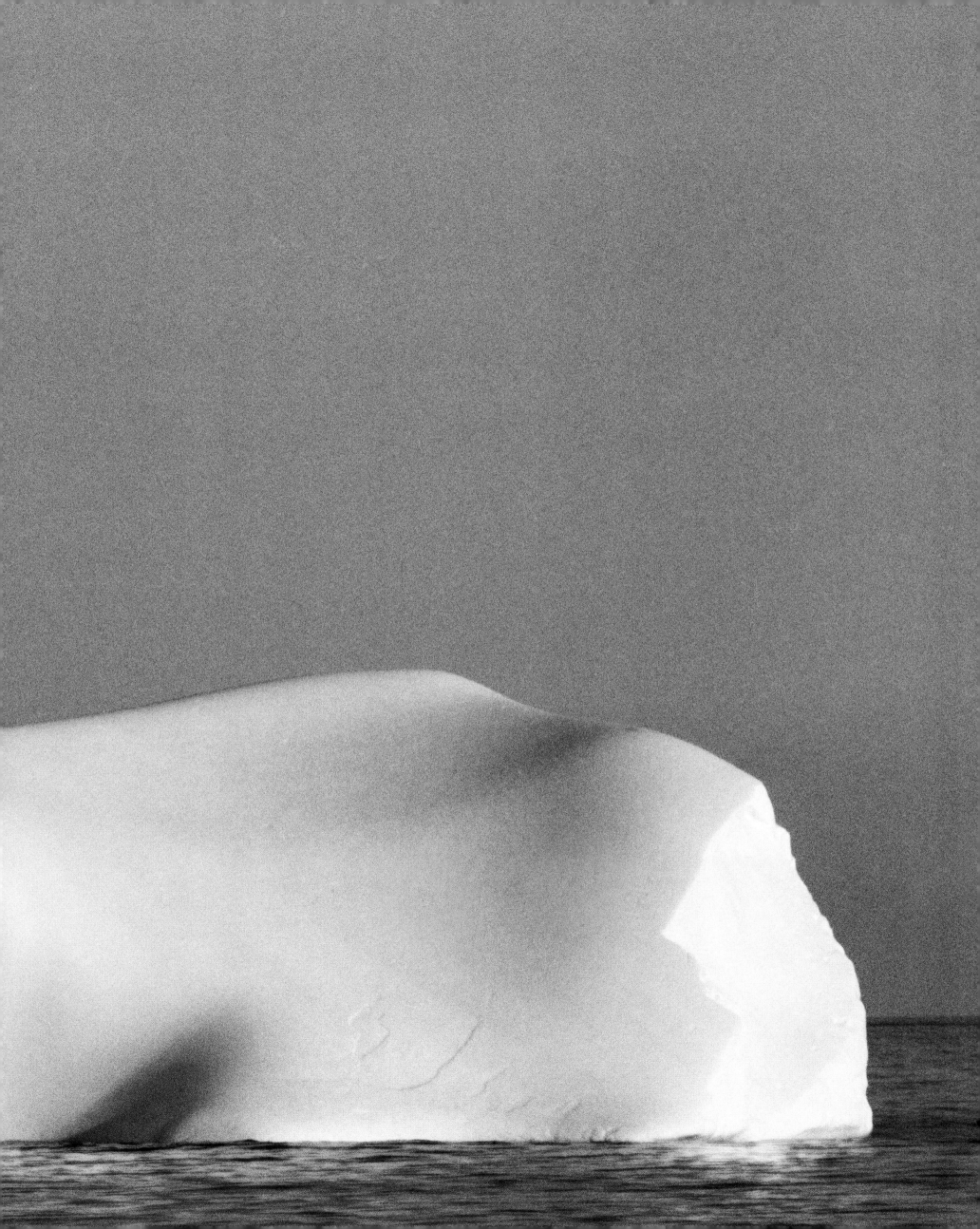

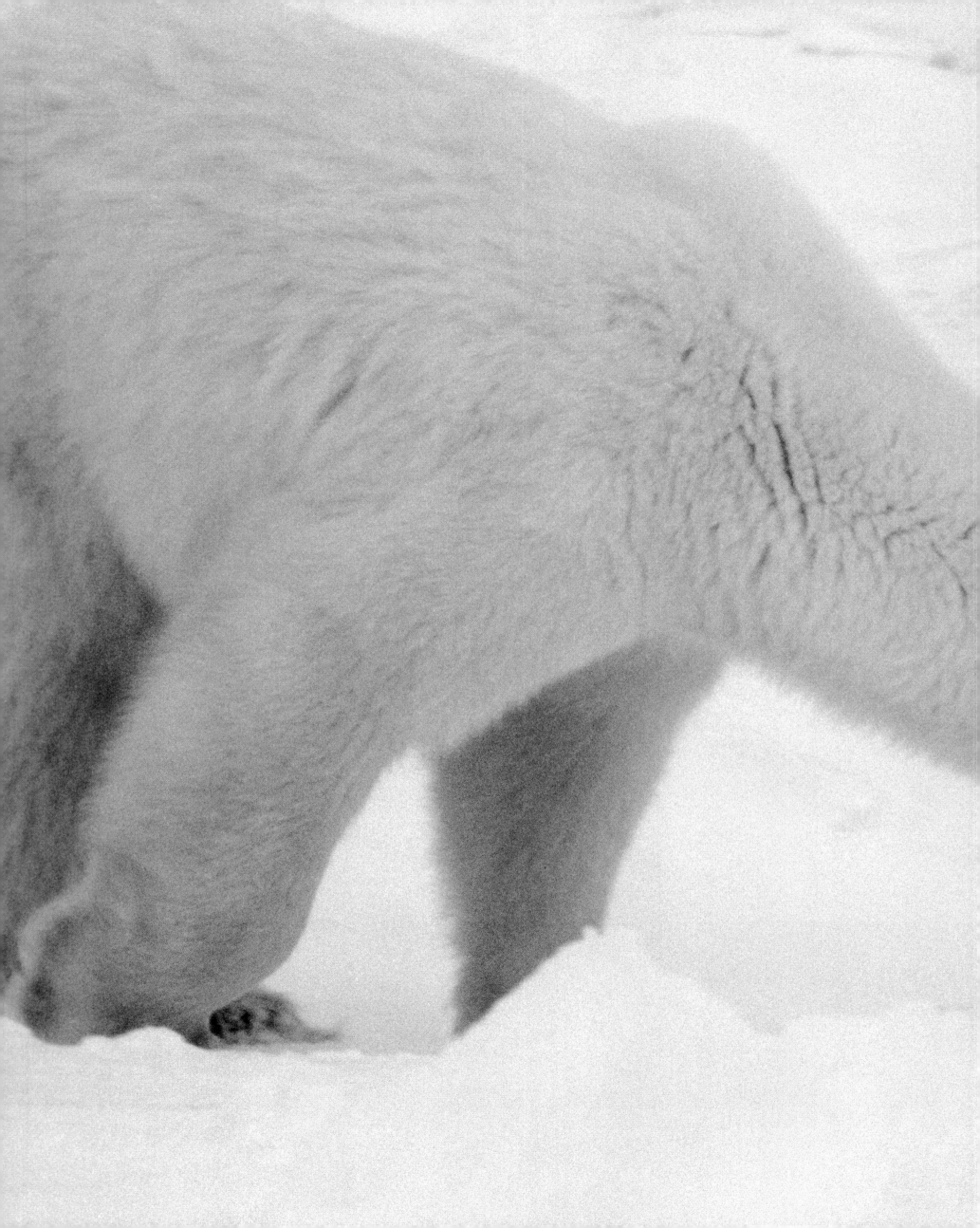

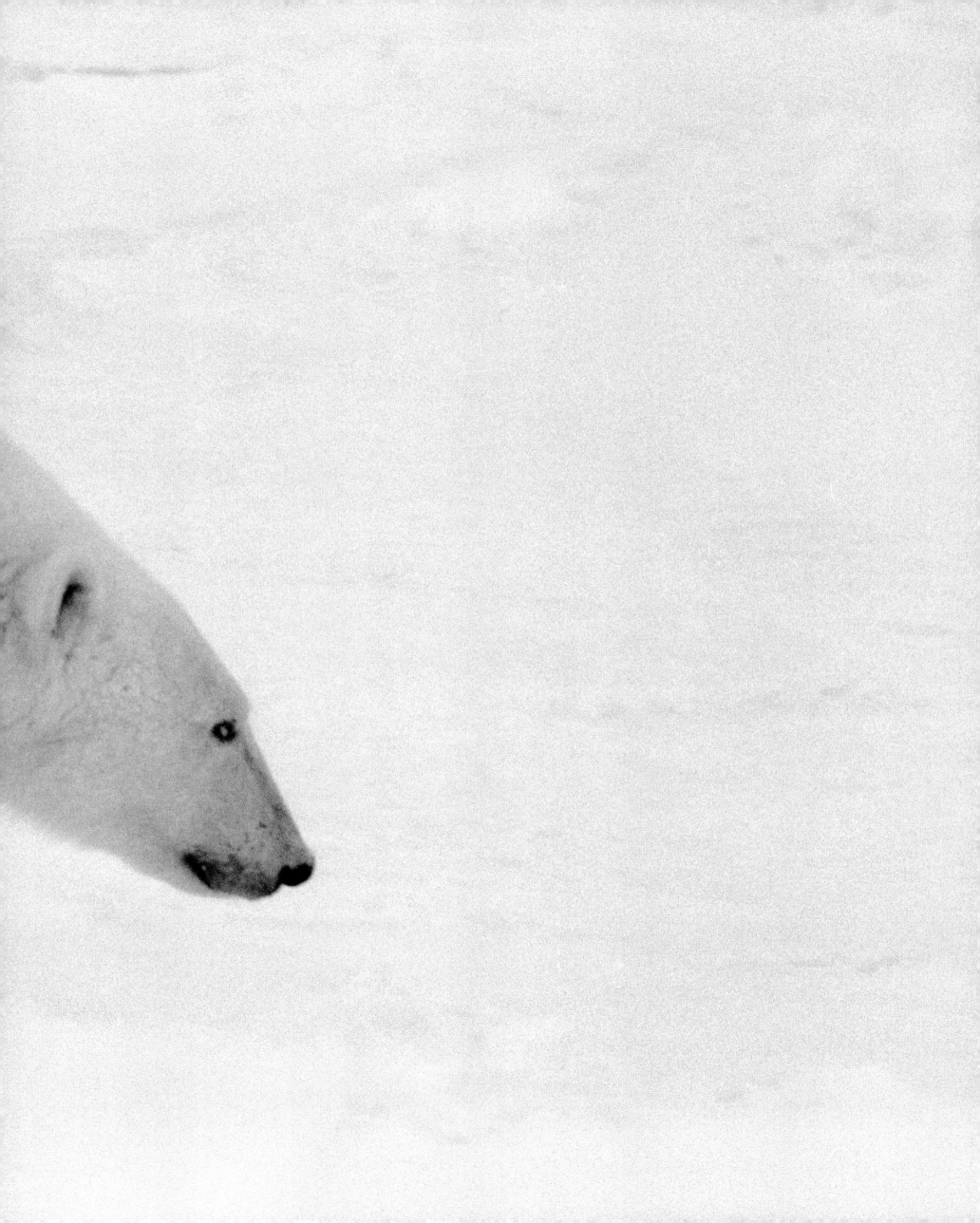

115

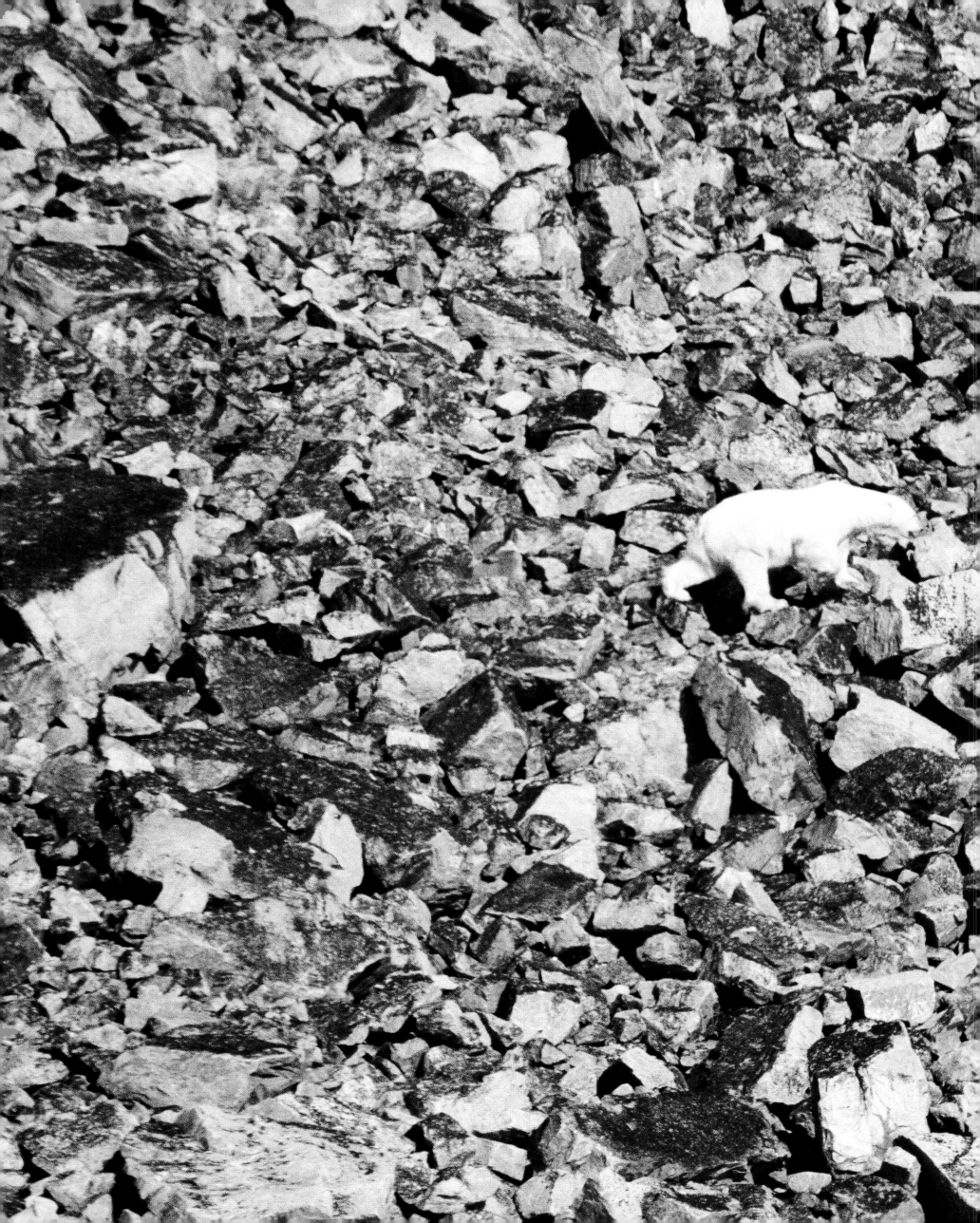

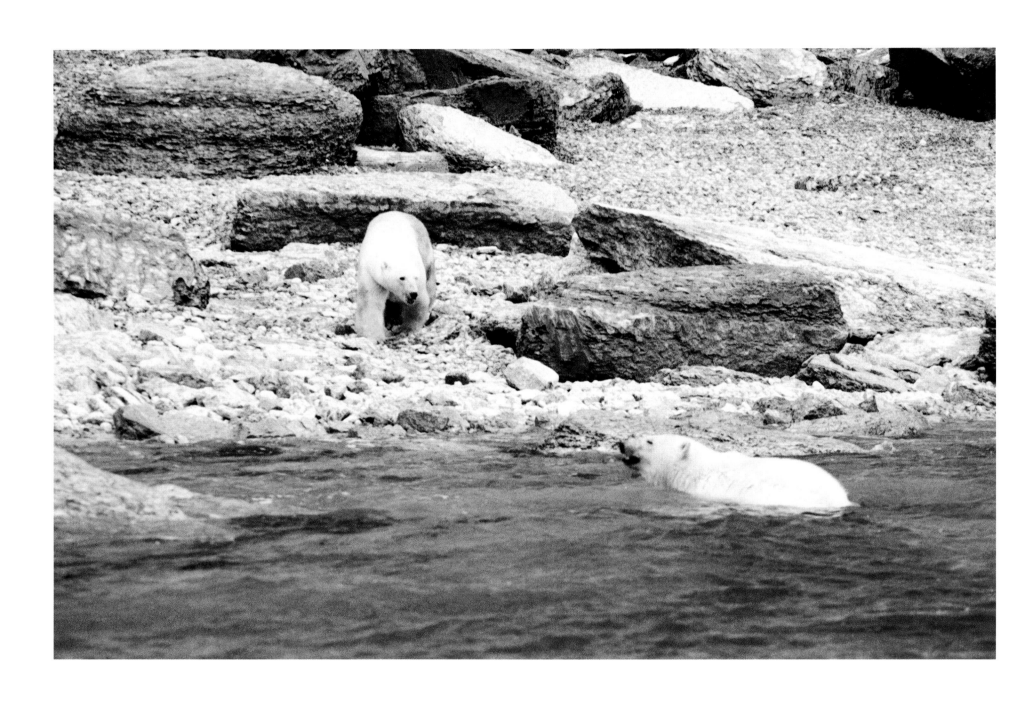

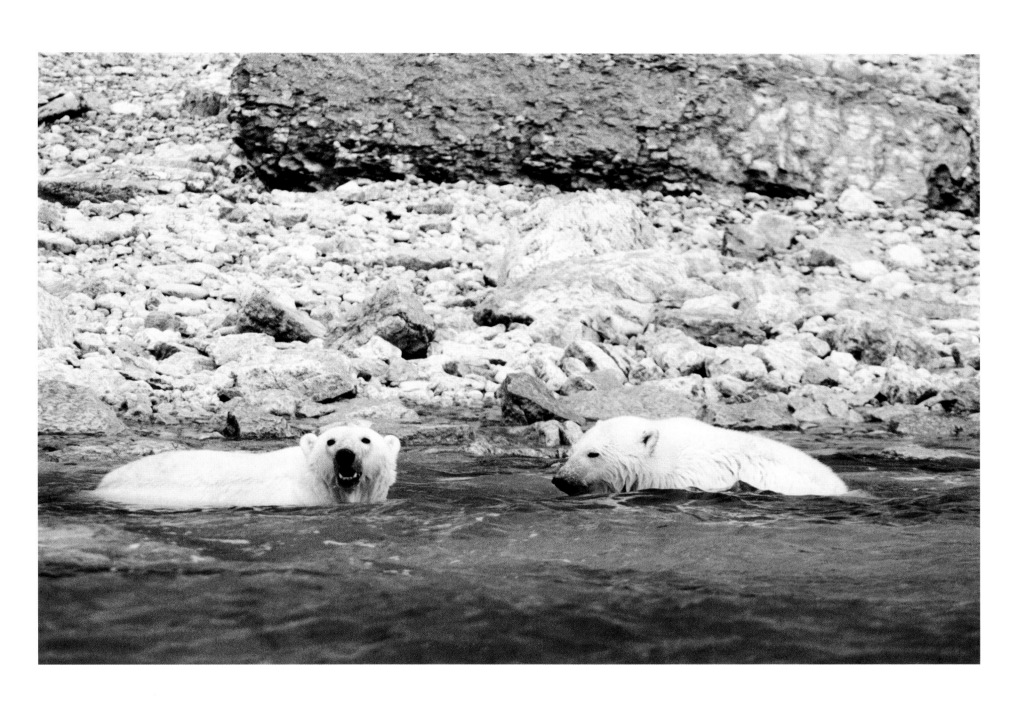

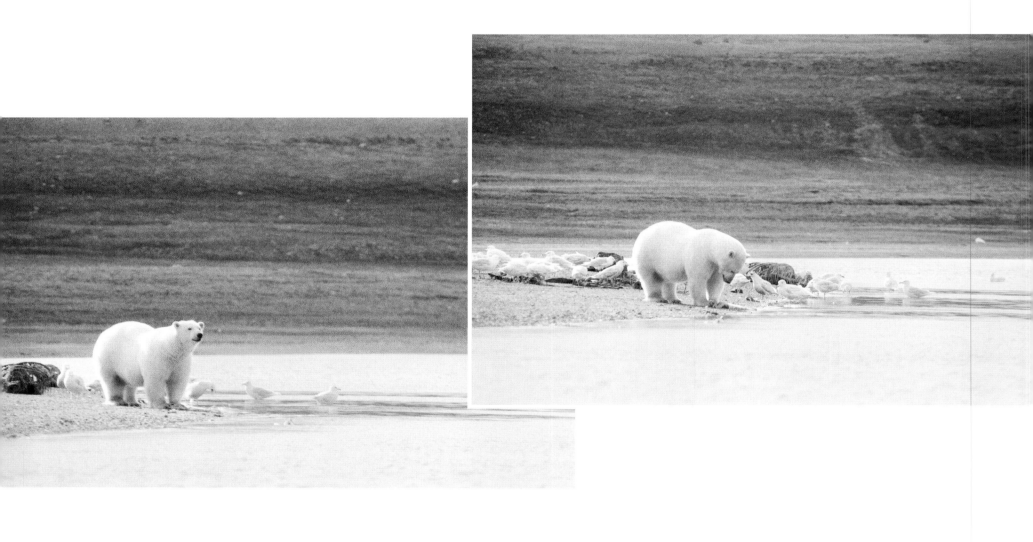

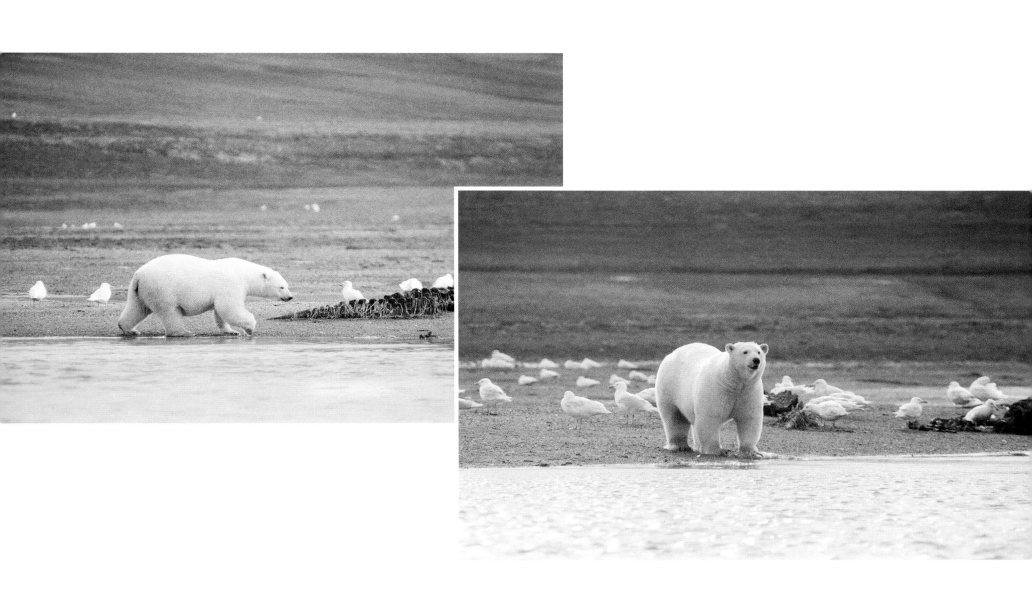

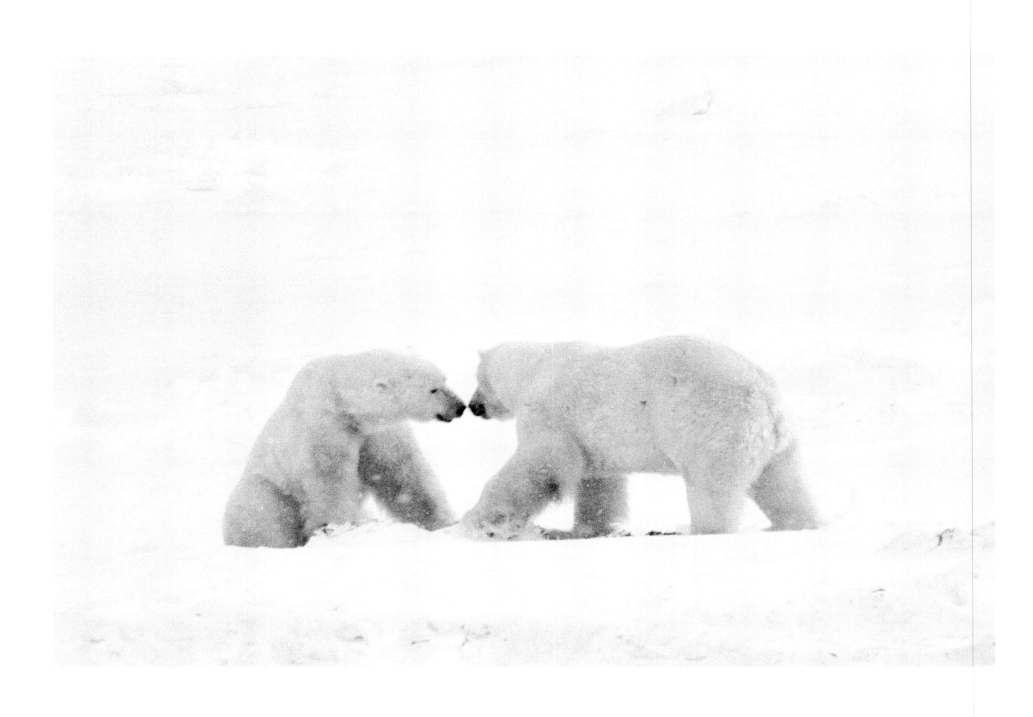

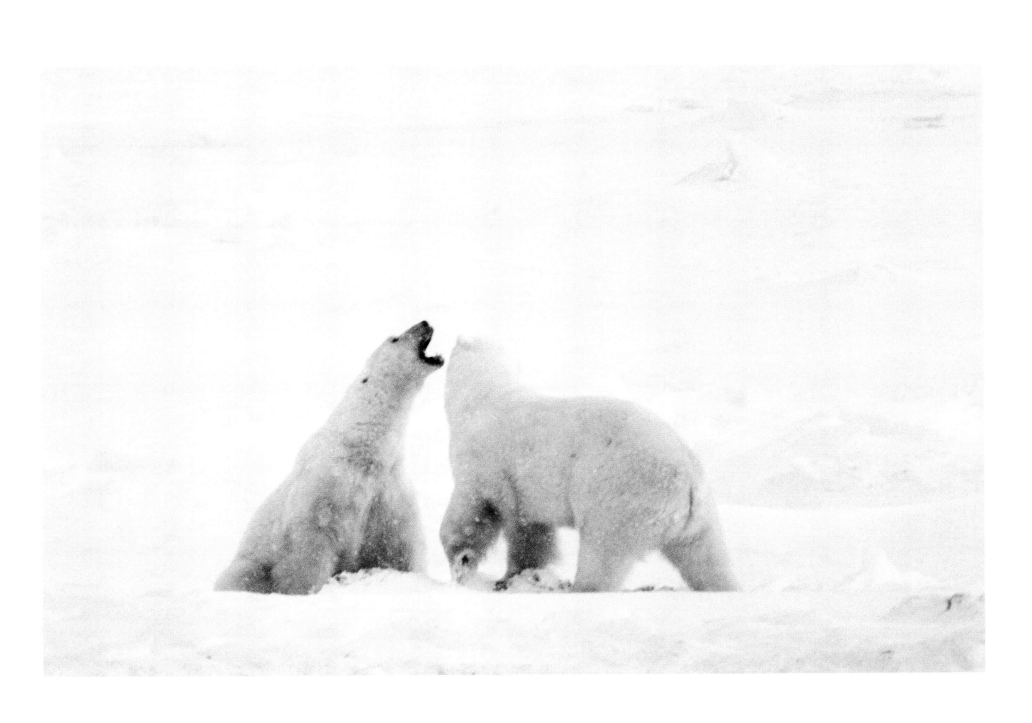

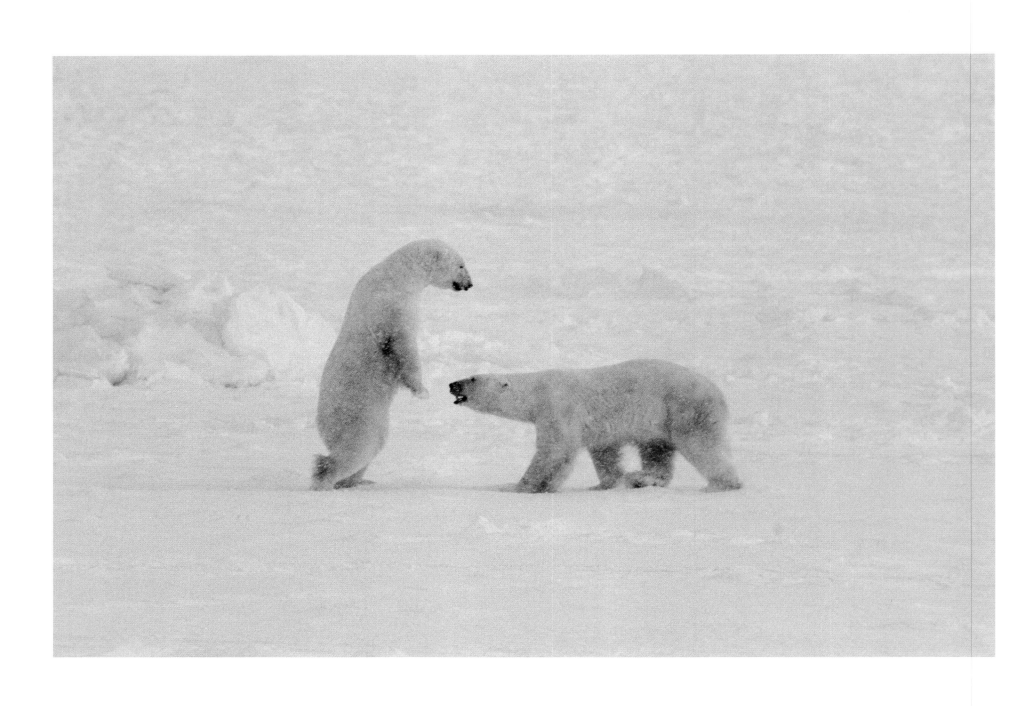

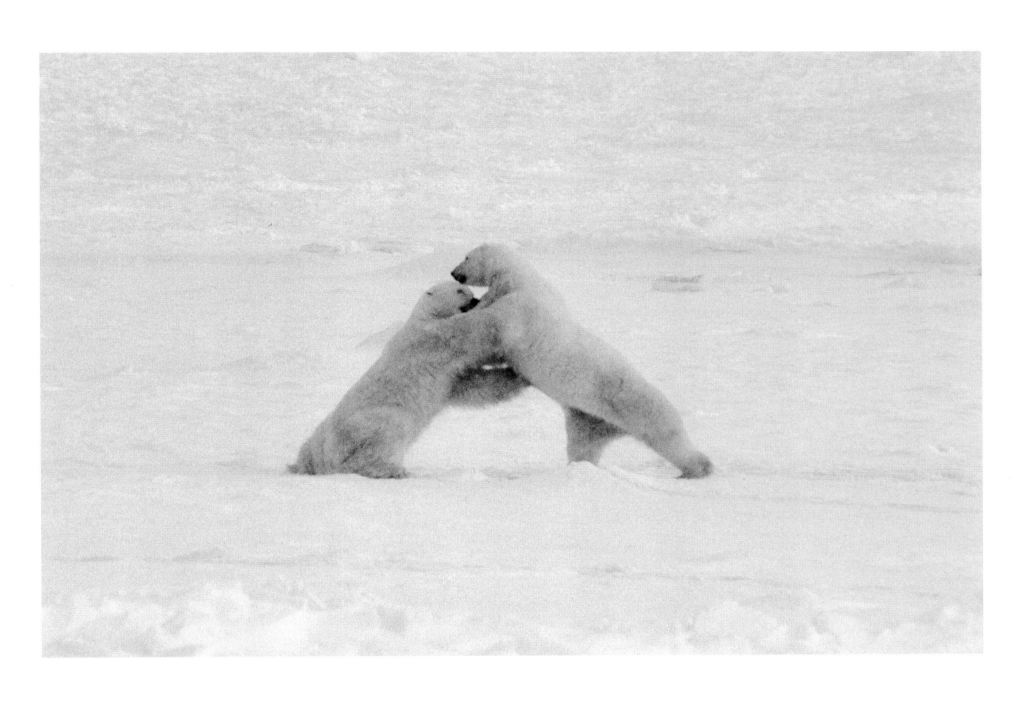

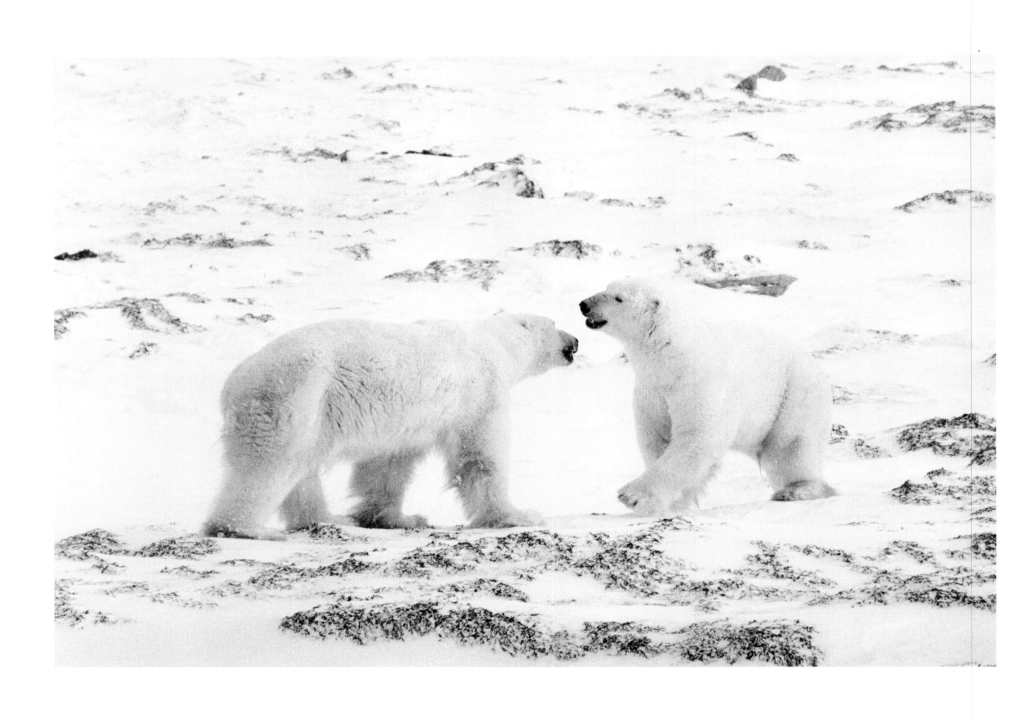

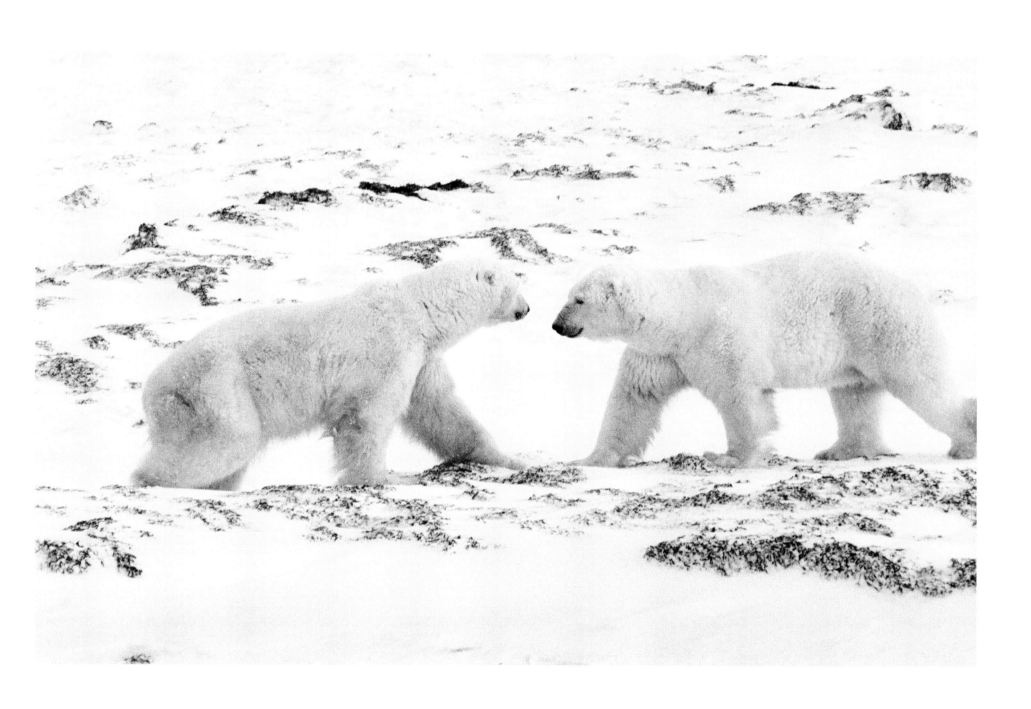

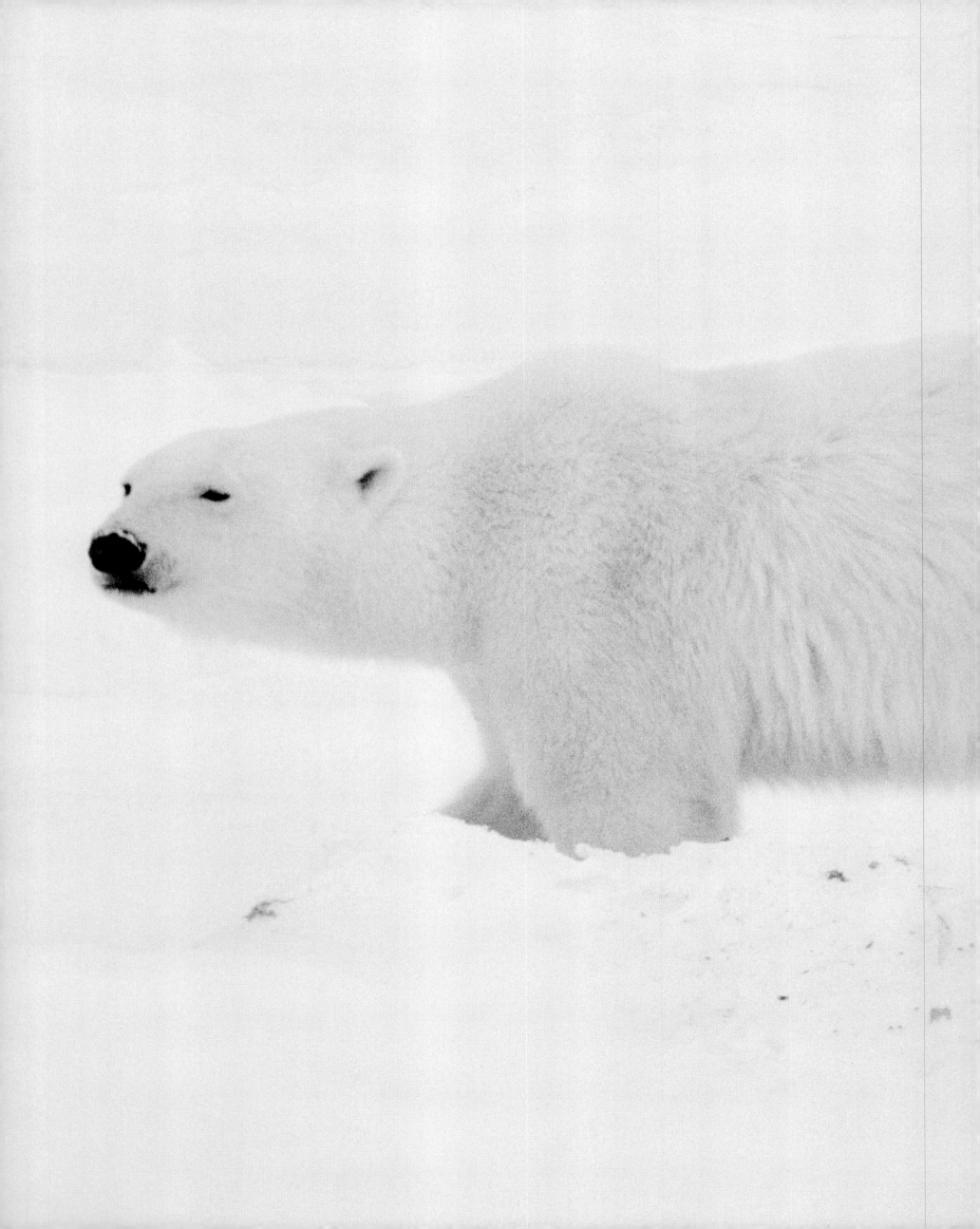

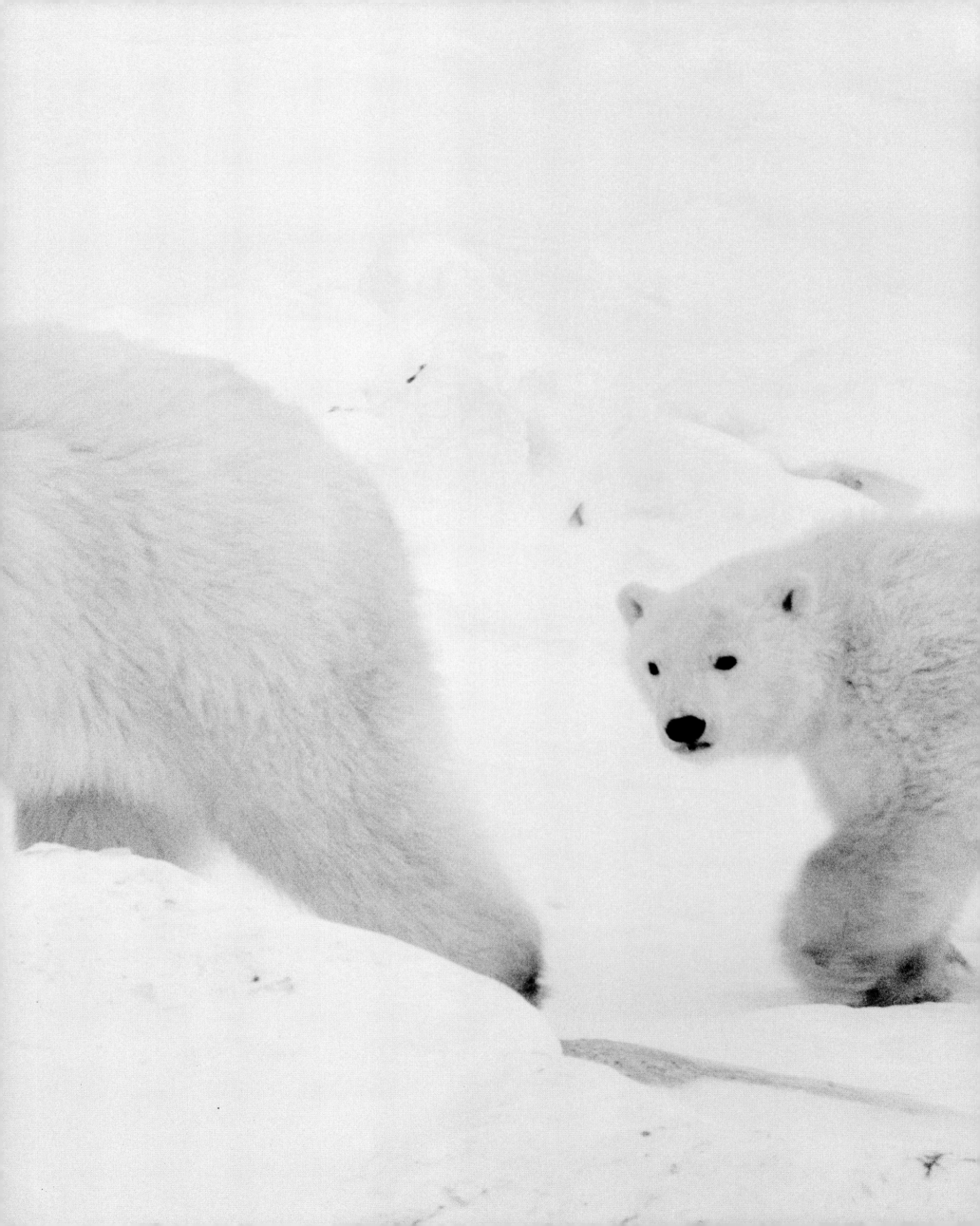

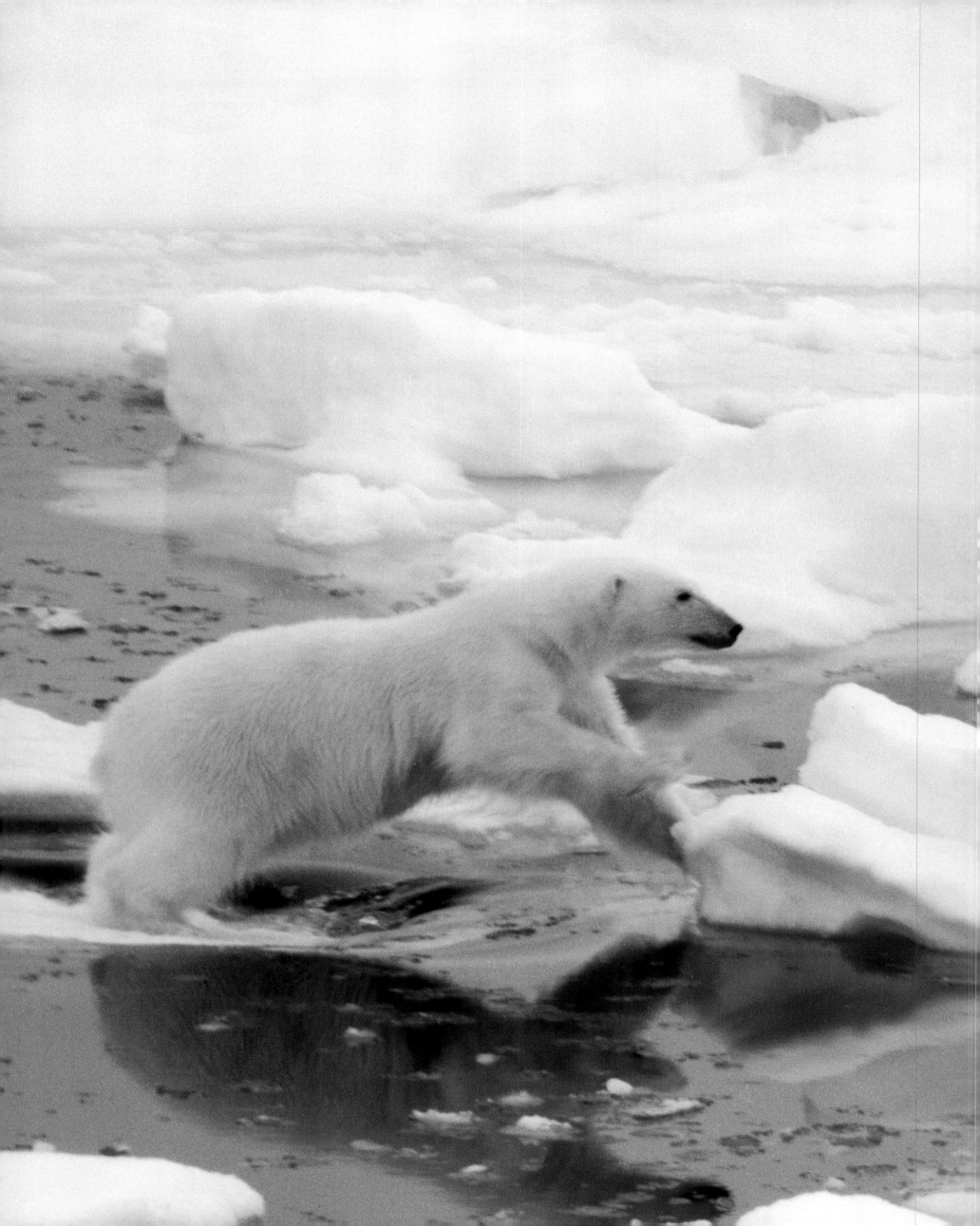

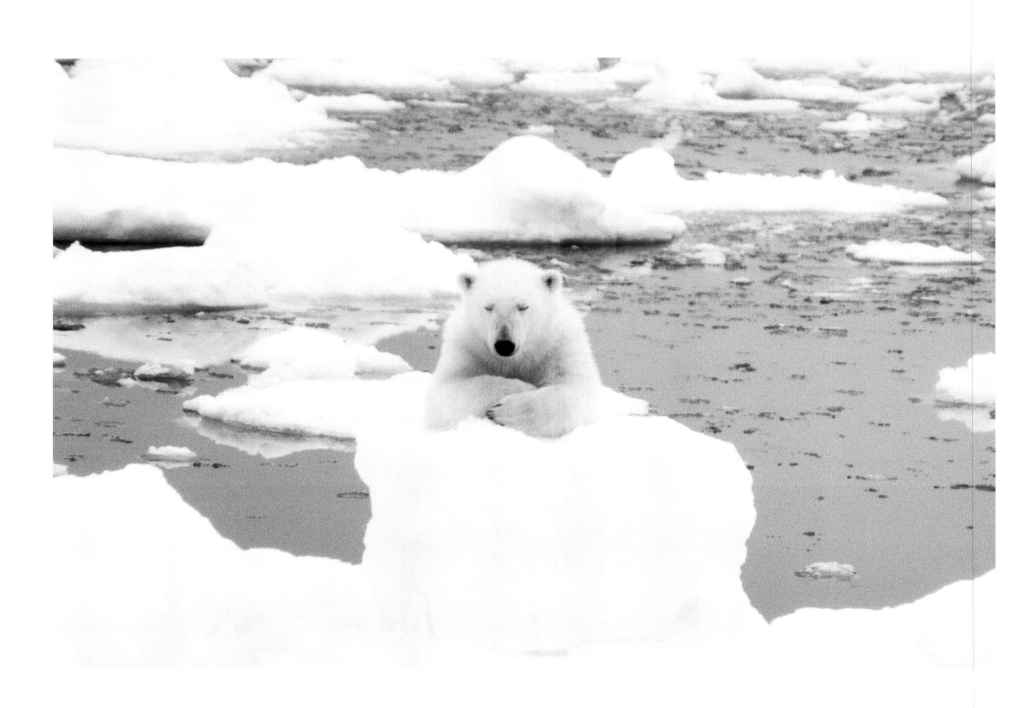

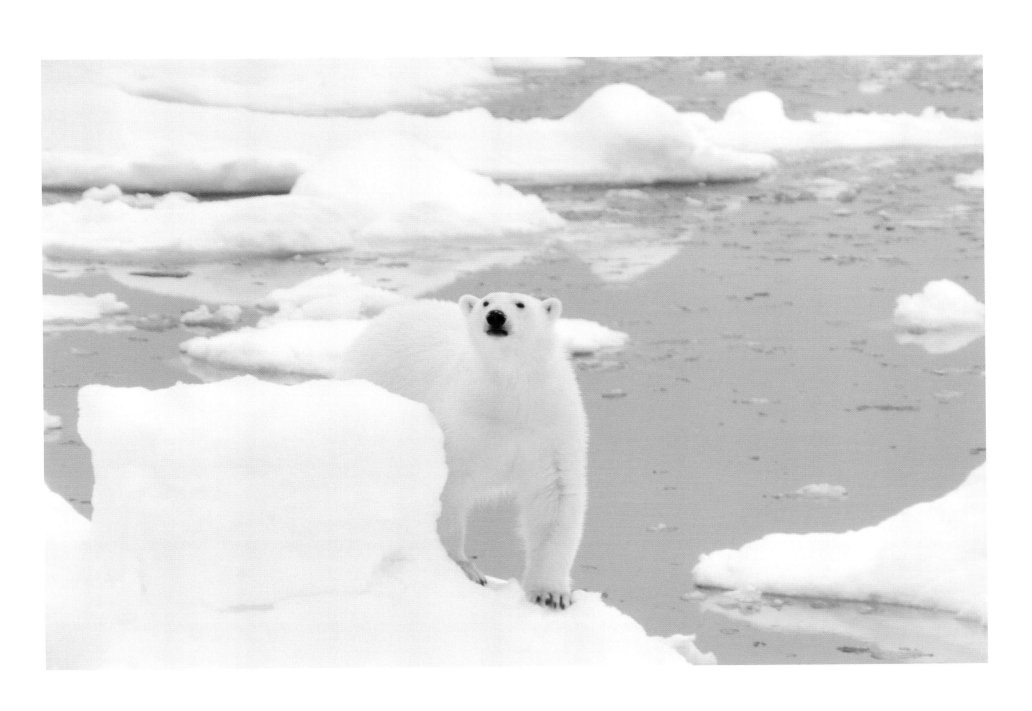

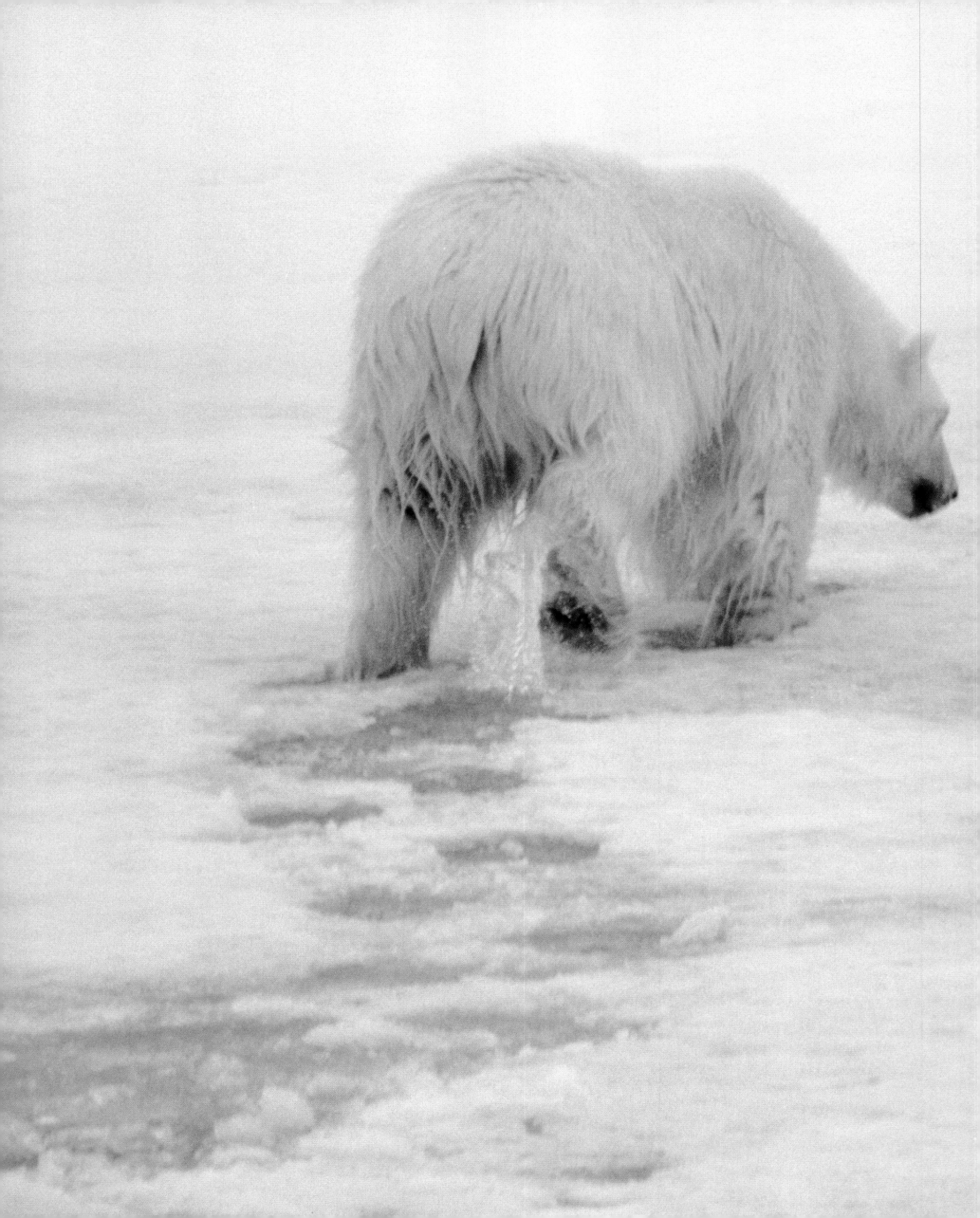

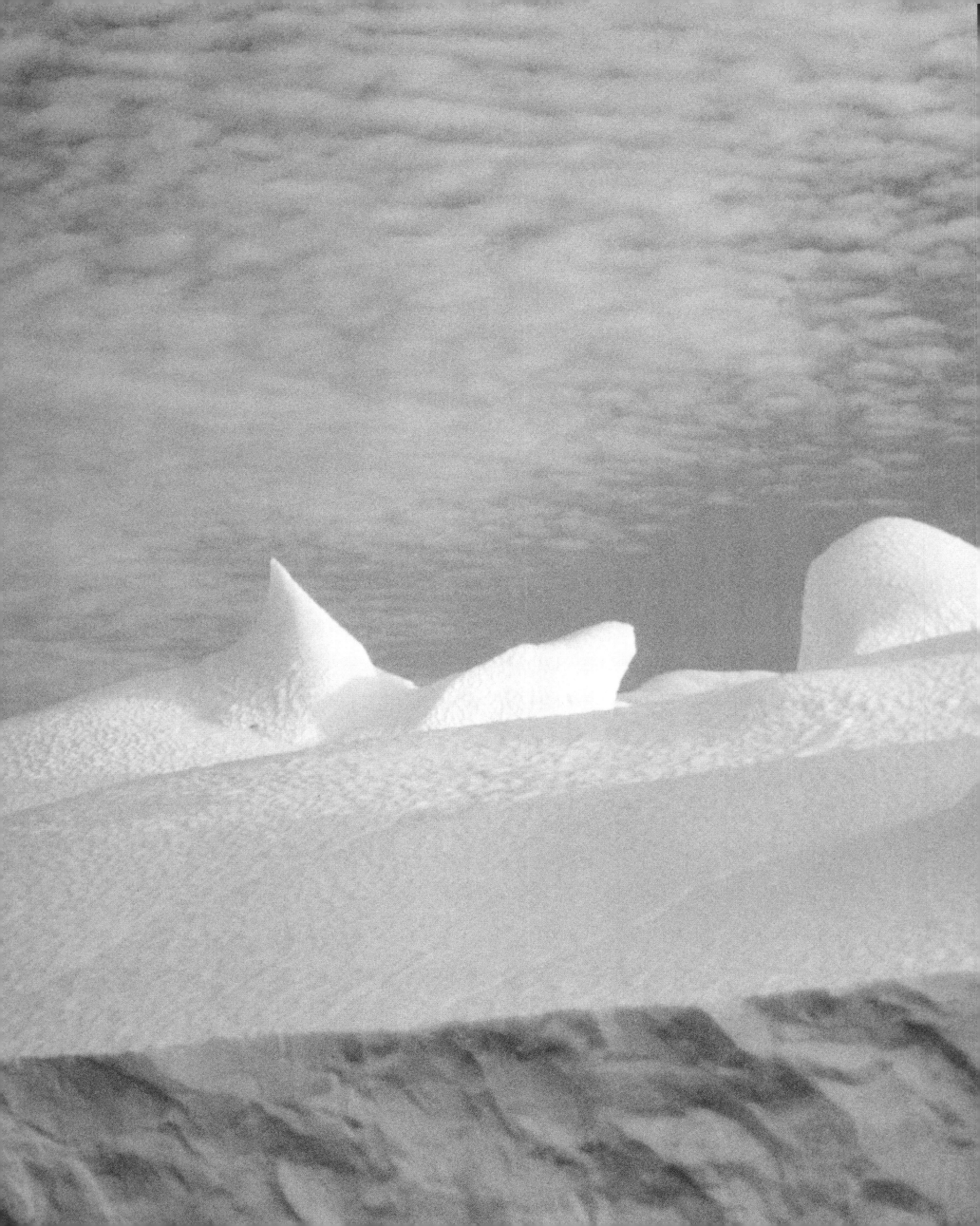

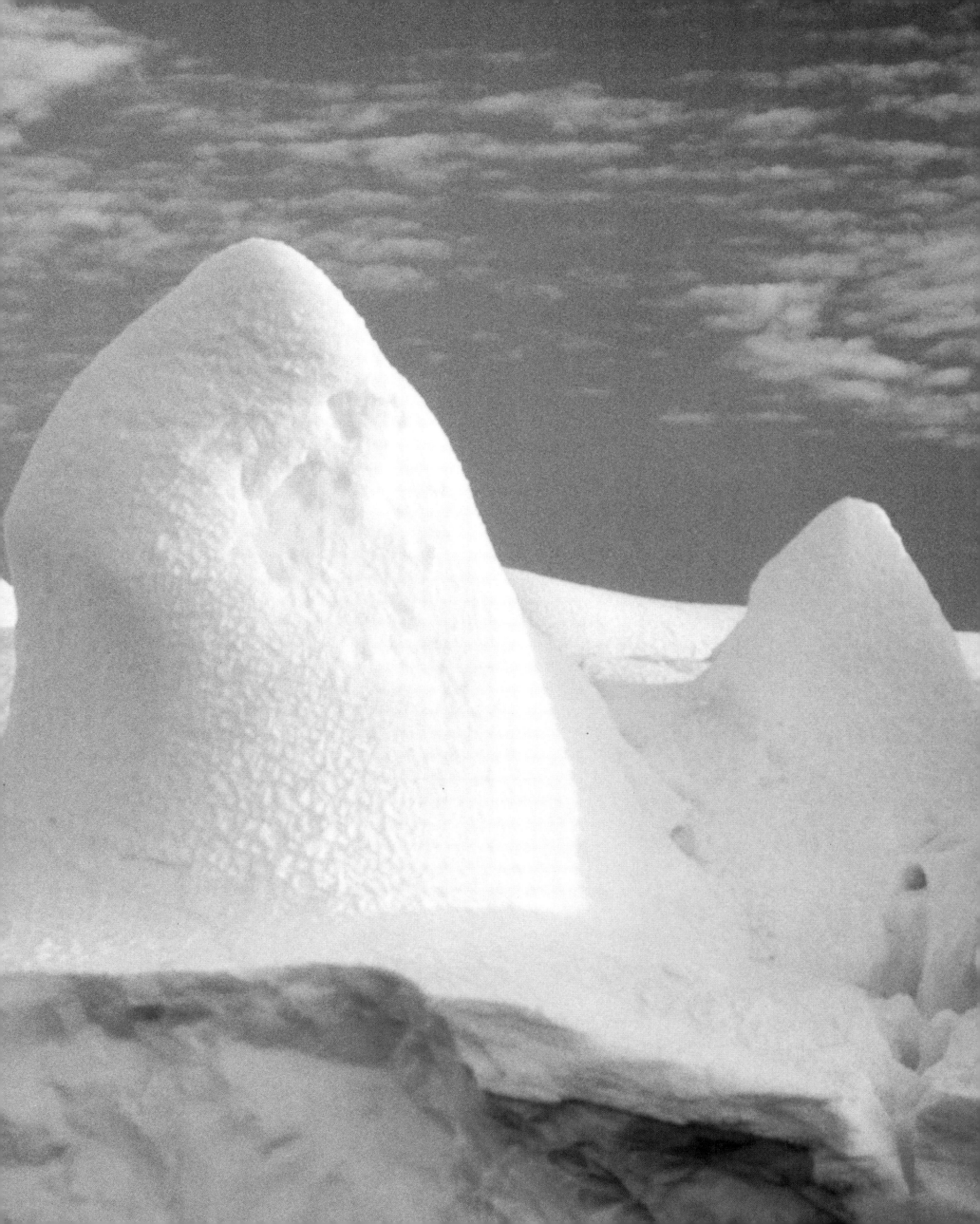

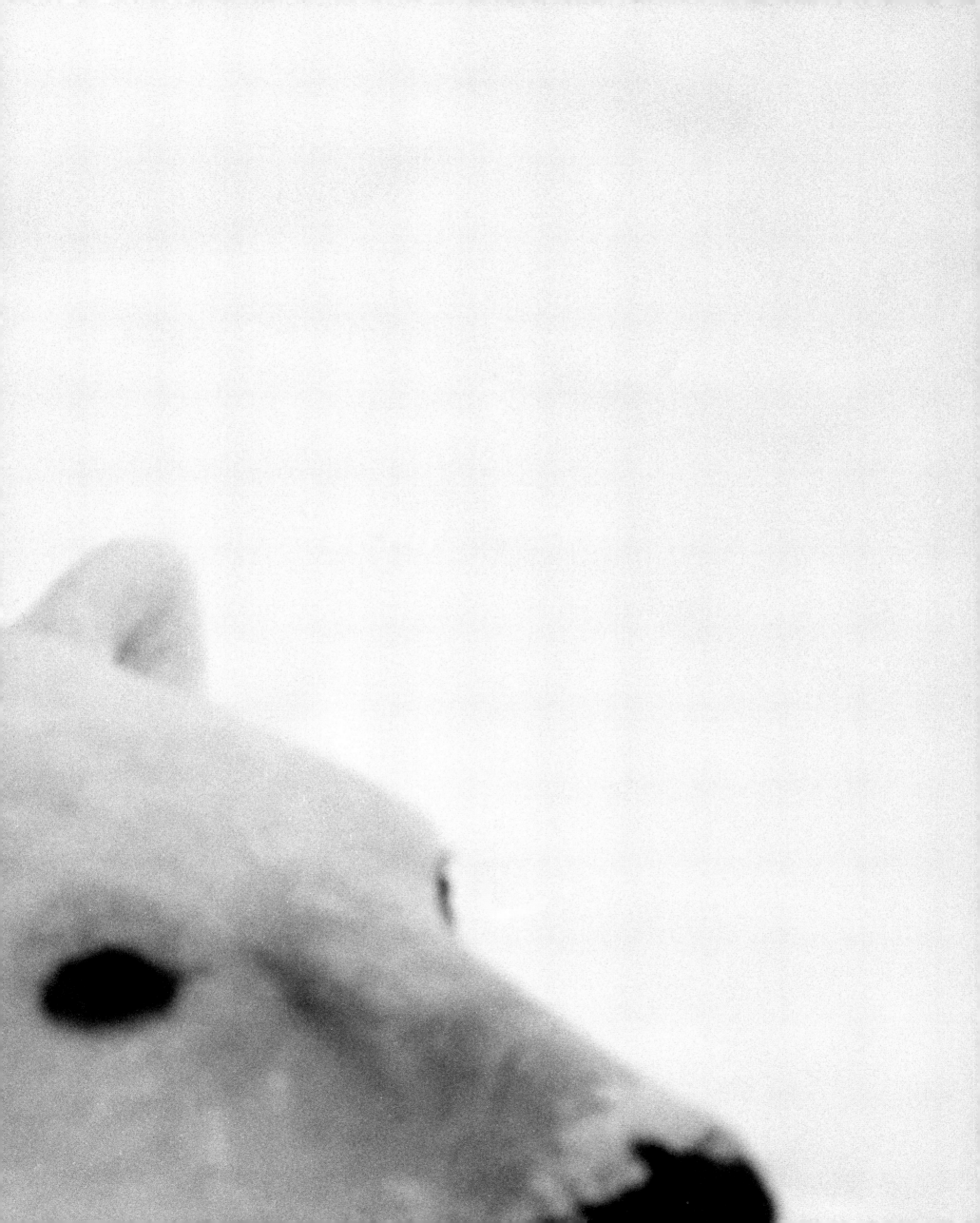

POLAR BEARS John Houston

I don't know if I will ever be considered an elder. Faced with the challenge of doing justice to this book – to the spirit of the polar bear, no less – I wish I were one now. Elders speak when they have something of value to contribute, not simply to hear the sound of their own voices. I wish I were an *Inuit* elder. When I was a child, elders taught me that the only information worth repeating is that which can be gathered through personal experience, or from the observations of those one knows and trusts. Elders seem to be among the few remaining initiates in the ancient laws that helped all beings, human and non-human, properly to walk this earth together.

Esteemed Inuit elder Mariano Aupilardjuk, who grew up in the time of shamanism, told me that respect for the non-human was instilled in him from childhood:

> *We were absolutely forbidden to disrespect animals, so we avoided it at all costs. There were many strict rules to be followed, and they were different for each animal. In my experience, polar bears were surrounded by the most rules. I learned this as a child, by seeing it with my own eyes. 'Polar bears have souls. They are very wise.' That's what I was told. It's one of the first things I learned.*

Within living memory, the Arctic home that the Inuit share with the polar bear has undergone drastic change. 'Our environment has suddenly become a stranger to us', elders are now saying. Many of them agree that climate change was prophesied. Jose Angutingunirk suspects that the animals are being made sick by the earth:

> *I don't really know the reasons for the gradual change, but I've heard from my grandfather that the earth and the sky can be changed by people. So I've heard. Now the animals with fur, if it turned out they had been burned, that would cause our sky and our earth to change. That's how I heard my grandfather tell it, and this is how I feel. The birds, polar bears, caribou, seal, all those with hair: he said they must not be burned, as this can cause damage to the land and the sky. This has been heard since who knows when.*

I recorded this curious prophesy and didn't think much more about 'the burning', until one day months later when I was interviewing the Inuit environmental activist Sheila Watt-Cloutier. She explained that it is not humans who are top of the Arctic food chain, but the polar bear. Through biomagnification, persistent organic pollutants (POPs) are concentrated from phytoplankton to shrimp, then to fish, to seals and finally to polar bears, and the bears end up with a burning dose. Pollution from the smokestacks of the world's industries, which operate day and night, has indeed caused our sky and our earth to change. Could we be witnessing the realization of the Inuit prophesy?

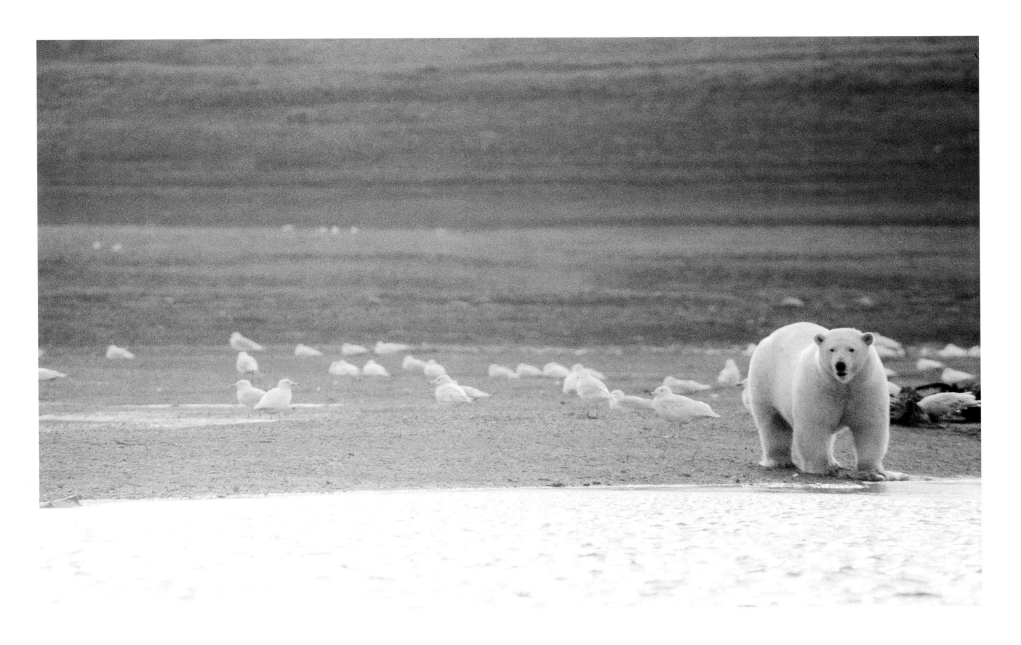

Lately several industrialized nations have been clamouring for the polar bear to be saved; some of these countries are among those poisoning the polar bears and melting the floating ice that is their habitat. Governments are seeking to save polar bears through sanctions, to stop them from being hunted. Many important decisions are being made on the polar bears' behalf, but who among the decision-makers *knows* the polar bear? Arguably, those who know polar bears best are the Inuit, a people that have hunted them sustainably for millennia. Both polar bear and Inuit – two great Arctic survivors – are feeling the stresses of the incursions of Western civilization.

Not long ago my friend Lamech Kadloo, an Inuit actor who also hunts to feed his family, and a resident of Pond Inlet, Baffin Island, received a notice from the health centre, as did other local hunters. They were advised that polar-bear meat was regarded as polluted, and that they and their families should stop eating it. After carefully considering this warning, Lamech felt he had to speak out, and he wrote back:

Yes, I have something to say about the foods we eat. Since the beginning, our meat has been our survival. Today, we don't depend completely on meats, but they have the power to restore us – the animals we catch on the land. About the foods you can buy at the store – we can never rely on them completely. They are too expensive, so we will continue to live from our animals. Some time ago we were told that polar bear meat, which we traditionally ate raw or frozen, had to be over-cooked until it fell off the bone, for fear of the parasites it might contain. But now I hear the government advising us not to eat it at all because of toxins. It was not like this for our ancestors. Thanks be to the polar bears, who have kept us alive – right up to today. It is not for you to tell us not to eat them; rather it is for you to stop poisoning them. They were the daily bread of our forebears, also our descendants will always get life from the animals. These are the things I wanted most to say.

Nowadays the polar bear is also regarded by Inuit hunters as a source of cash – a commodity that has been rare since Greenpeace and Brigitte Bardot turned fashion against the seal hunt in the 1970s. Today, if a senior hunter is lucky enough to be asked to guide a polar-bear sport hunt, the proceeds will constitute most of his annual income.

Another old friend of mine, the late Peter 'Tatiggat' Arnatsiaq of Igloolik Island, once recounted a hunting story that has stayed with me. He had hitched up his dog team to take out a sport hunter who was keen to bag the ultimate trophy. Tatiggat tracked a bear, and his dogs got the hunter within shooting distance, but the man couldn't see the white bear against the snow. Tatiggat got him considerably closer, but again, peering out at all the snow and ice, the hunter complained that he simply could not

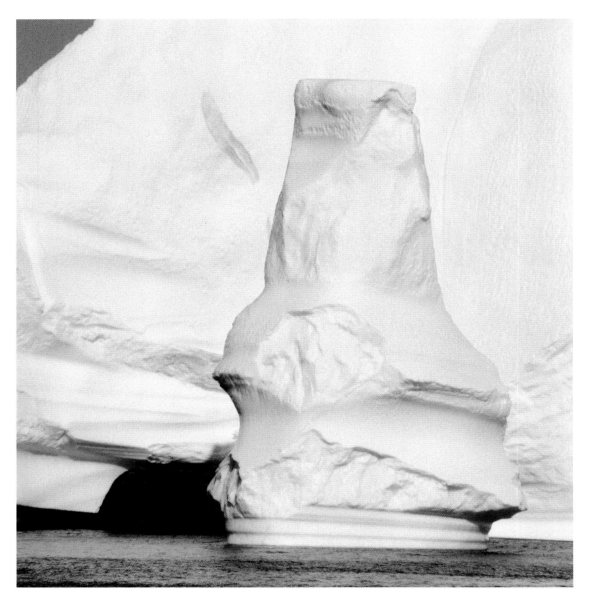

see the bear. In the end, my friend took his dogs so close that he feared for their safety, allowing the hunter finally to make the kill and to compile photographic proof for his office wall.

The polar bear is one of the planet's great beings; I doubt many would disagree with this statement. But nobody seems to agree on *how* bears should be treated. Maybe our problem is that, like that sport hunter, very few of us can fully and clearly 'see' the polar bear. Those who live to the south of the polar bear's lands are caught up in the ideal of this charismatic predator, emblematic of the vanishing wild.

For the Inuit, the bears' power is very real, and the outcome of a meeting with a polar bear is never certain. One winter in the 1970s, while I was living in Pangnirtung, Baffin Island, a wild-sounding story whirled around the community, involving a senior member of the family group who were my hosts. Joanasie Kakee had been out with his nephew one night, checking a seal net they had set in a tidal crack in the sea ice. They were happy about the seal they had caught and were getting ready to take it home to their family, when the nephew heard an unusual sound. He looked over to his uncle and saw him standing there – headless! Frightened as the nephew was, he took a closer look, and it turned out that Joanasie's head was inside the mouth of a polar bear, which was practically invisible against the snow in the dark. Whether the

nephew wrestled his uncle free or the bear preferred to dine on seal is not clear, but the hunters were able to escape. Joanasie recounted this story as we sipped tea, surrounded by the Kakee family in a warm wooden house. Impressed by his matter-of-fact delivery, I suggested that he must have been terrified during the worst of it. 'No', he replied in his lilting Inuktitut. 'Our family always lived where the bears live. Sometimes they ate us, sometimes we ate them ... We're polar bear people.' I looked around the room at the powerful, ancient faces as Joanasie's words burned into my memory.

The shamanic connection between Inuit and polar bear was so strong that even after a century of Christian missionary work one can still catch glimpses of it. During that winter in Pangnirtung, I once observed a hunter returning in the half-light, hauling the entire skinned carcass of a polar bear. Nothing prepares you for that sight. There lies a fallen giant, and it would be disrespectful to think of that great being as anything but our superior.

The shamans still enforced the many taboos surrounding the polar bear when elder Mariano Aupilardjuk was a young man, and he remembers those rituals:

> *After a bear is hunted and killed, it is brought back to the igloos, our traditional dwellings. Its head is placed on the inner wall, in accordance with Inuit belief. When it's hanging up, if the bear is female, a woman's things are laid out before it for it to look at. And if the bear is male, a man's things will be hung up for it to look at. [People] want to keep the [bear's] soul occupied with those things, for fear it will seek revenge on a person. I used to see this practised, though not too many times. To avoid people being attacked by animals' souls, animals were treated with extreme care. It was forbidden to disrespect them, or to allow them to suffer a slow death. If at all possible, kill them swiftly ... So it is.*

Of all animal helping spirits in the Inuit world, the polar bear was considered to be the most powerful. One did not choose one's helping spirit, but the most worthy apprentice might be picked by Nanurluk, the enormous white spirit bear. First, he or she needed to have a hunger to 'see'. One of the old ways was to find a pole of driftwood, attach a raven's feather to the top of it, then offer this to an *angakkuq* (a shaman) while saying the word *Takujumagama*, '(I am here because) I want to see'. The shaman might send the apprentice off dressed in old animal-skin clothing with many holes, to build a snowhouse with many cracks in it. Isolated in that unheated igloo for one full moon, hungry and shivering, the apprentice waited to be visited by the animal spirits. If Nanurluk found the apprentice worthy, he devoured his or her flesh, leaving only the skeleton. The apprentice was then reborn into the old body but filled with a new light – a new vision. From that lonely place emerged a shaman,

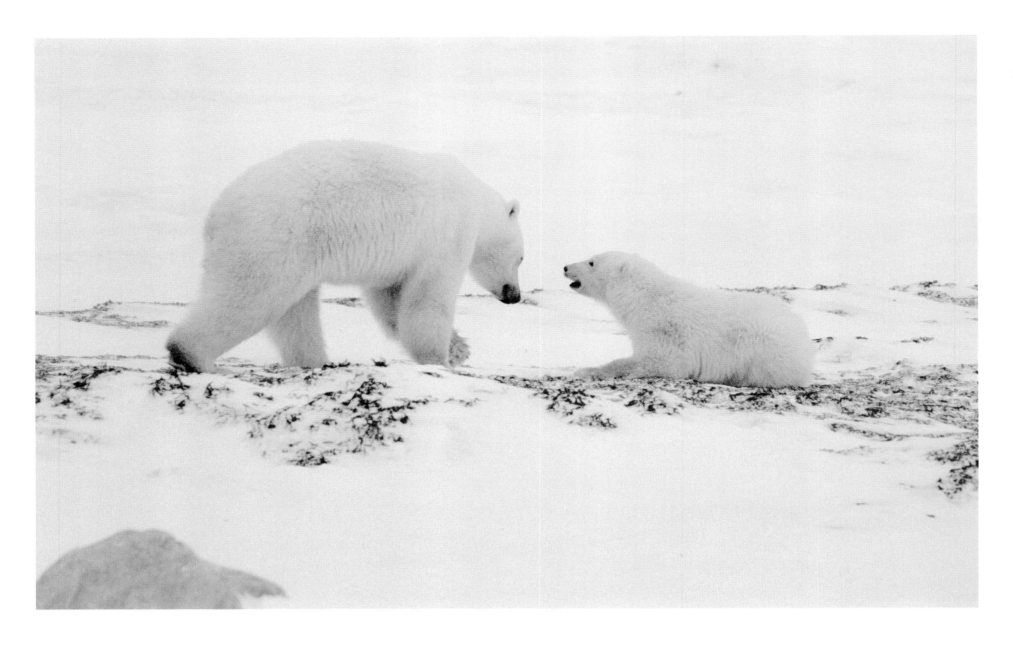

with the polar bear as spirit helper. Now no longer fully human but part of both the world of man and the world of animals, the shaman served the people by interpreting the narrow path that had to be followed to avoid offending the spirits of the sea and air. The Danish ethnologist Knud Rasmussen, the father of Eskimology, observed in 1931 that shamans are 'people possessed of special gifts that can bring them in communication with the spirits of the earth, the air and the sea. By means of preternatural beings they can see "the things that are hidden", and they can help their fellow men who have got into danger, either on account of sickness … or if … they have become possessed by an evil spirit.'[1]

Shamans were equipped to help us walk properly in the world, preserving a balance between human and animal. Why can they not come to our assistance today, before we wipe polar bears off the face of the earth and then follow their paw prints to our own extinction? Christian missionaries set out to destroy the ancient Inuit system of beliefs and ideas, and they did their work so well that today only a few elders remain who can teach us about the spirit of the polar bear. This world of knowledge is at risk of dying with them. My godfather, the late Kananginak Pootoogook, artist and hunter, liked to accompany me occasionally as the honoured elder on the Arctic ecotours I guide, and he noted that the passengers were eager to disembark the explorer vessel in rigid inflatable boats to scout for polar bears. One day he mentioned to me that he had a few thoughts to share with everyone, if I could find a suitable time. We juggled the scheduled events and that afternoon I was happy to translate for the hundred or so passengers who came to listen. In considered, quietly spoken words, my godfather advised us that there was more to the *nanuq*, the polar bear, than we could see through our cameras. There was a whole world of traditional Inuit wisdom on the subject, but, understanding our hurry to see more bears, he had selected just two items from that body of knowledge: 'First, when a polar bear is staring at you and doing something that looks like yawning, that bear is not sleepy. It's a sign that the bear wants to eat you and is preparing to attack.' Suddenly, nobody in the audience was yawning. 'And also, if you are not sure how to behave around polar bears, just remember, they are more intelligent than you are. They are your superiors. Keeping these things in mind will help you to stay safe in their lands.'

This system of beliefs and ideas is now referred to as Inuit Qaujimajatuqangit, Inuit traditional knowledge. Imagine a great library, a university of thoughts that have not been written down, the entrance gate hidden. An uncredited professor of this university, elder Mariano Aupilardjuk, makes a heartfelt plea:

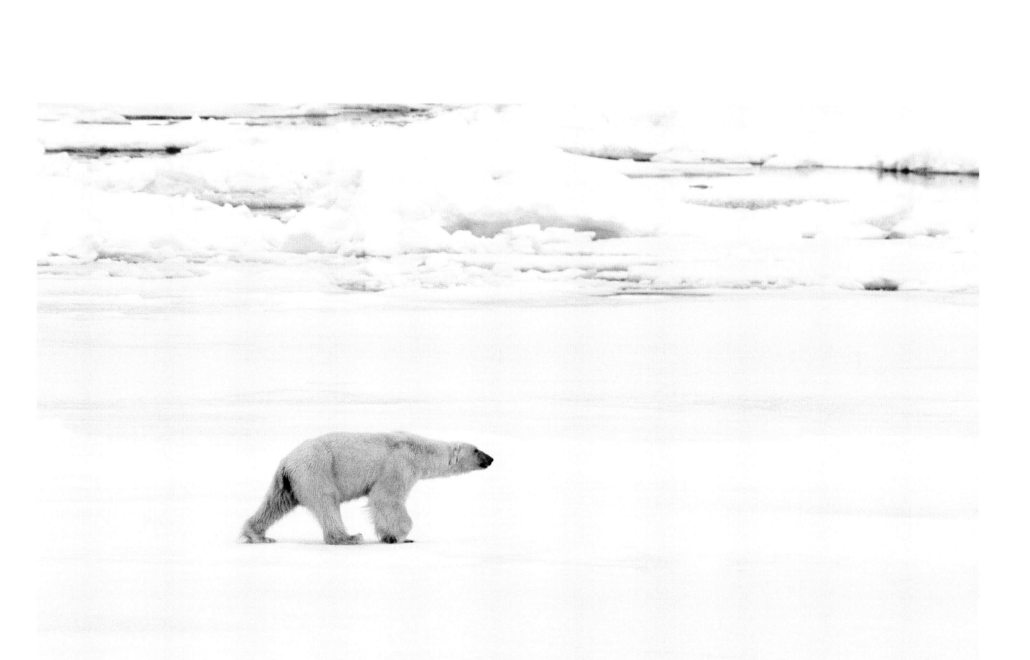

> Midway between ourselves and the colossal events in the sky, the great beings become interlocutors, whose lives sift the forces of the wind, and water and fire, seeming to say that all such phenomena ultimately are purposeful and ongoing expressions of a meaningful world.
>
> PAUL SHEPARD,
> THE OTHERS: HOW ANIMALS MADE US HUMAN, 1996

The Inuit system of laws and principles is vast. If it's not too difficult, in the future, for those studying ... I'm not sure what subject ... please, let them know it exists. Let even some of it be understood. Because in the future the land will need protection, the sky and sea will require care, and we would all then accept the responsibility. There it is; that's my every wish.

Hear the soft-spoken Inuit elders as they patiently try to help us 'see' the polar bear. I think they are doing this in the hope that one day we'll grow up to be mature adults, stop fighting among ourselves, acknowledge the truth of the ancient prophesy that 'the earth and the sky can be changed by people', and together accept responsibility for looking after our planet. Stop 'burning' the polar bears. They are Very Important Persons and worthy of our utmost respect. Look into their souls and you will be changed.

In the 1920s, Orpingalik, a Netsilik Inuit oral poet, shared with Rasmussen 'My Breath', a drumsong he had composed while recovering from a long illness.[2] I think it fitting that the last words of respect to the spirit of the polar bear be said by this Inuit elder, hunter and shaman:

Beasts of the hunt! Big game!
Oft the fleeing quarry I chased!
Let me live it again and remember,
Forgetting my weakness.
Unaya. Unaya.[3]

Let me recall the great white polar bear,
High up its back body,
Snout in the snow, it came!
He really believed
He alone was a male
And ran towards me.
Unaya. Unaya.

It threw me down again and again,
Then breathless departed and lay down to rest,
Hid by a mound on a floe.
Heedless it was, and unknowing
That I was to be its fate.
Deluding itself that he alone was a male,
And unthinking, that I too was a man!
Unaya. Unaya.

Notes
1. Knud Rasmussen, *The Netsilik Eskimos: Social Life and Spiritual Culture* [1931], New York (AMS Press) 1976.
2. nunatsiaqonline.ca/stories/article/98789_taissumani_may6 (accessed 4 February 2013).
3. *Unaya* is an expletive in the Netsilik language, rather like the 'yeah yeah yeah' in songs by the Beatles.

PRELIMINARY PAGES AND PROLOGUE

Pages 4–5: A lion in the Maasai Mara, Kenya, 2002. Because of lack of prey in the Mara ecosystem, lions could disappear from the Mara within a generation.

Pages 8–9: A tiger in Bandhavgarh National Park, India, 2009. A hundred years ago, tigers abounded in India; in 2008, a report estimated that there were fewer than 1500 in the country.

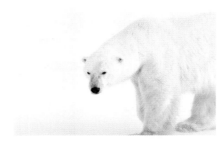

Pages 10–11: A polar bear on Hudson Bay, Canada, 2004. The sea ice has been breaking up weeks earlier than previously: around the end of June as opposed to mid-July a few years ago.

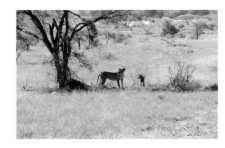

Page 15: The lioness known as Kamunyak, 'the blessed one' in the language of the Samburu people of north-central Kenya, in 2002 with the last of several baby oryx antelopes she 'adopted' in Samburu National Reserve; see page 30.

Page 17: A tiger sharpening its claws by scaling a tree, Bandhavgarh National Park, 2009. Despite the enormous challenges faced by the tiger, it is not necessarily doomed; it is at home in all habitat types, and in temperatures ranging from 47°C in the shade (as in Rajasthan) to below 0°C, as in the foothills of the Himalayas.

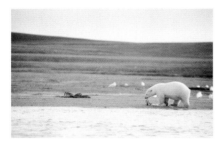

Page 18: A polar bear on Somerset Island, northern Canada, feeds on the carcass of a beluga whale, 2012. We were amazed to find so many belugas in the shallows, and dozens of bears – single males and mothers with cubs – ambling about looking for food.

Page 19: An iceberg in the Davis Strait near Greenland, 2009. Nineteenth-century explorers saw the Arctic as a virgin world to conquer, a place where 'civilization' could transform the native Inuit into 'better' humans.

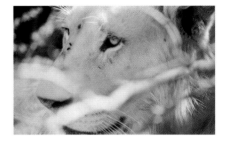

Page 21: A young male white lion peers out from the bush at the Timbavati nature reserve, South Africa, 2010.

LIONS

Pages 22–23: A male lion and his female partner share a rare moment of quiet gazing; Tarangire National Park, Tanzania, 2007.

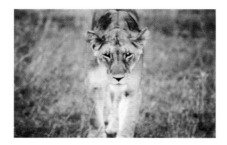

Page 24: A lioness stalking prey near the Telek river in the Maasai Mara, 2002.

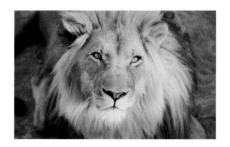

Page 26: The clear, focused gaze of a desert lion in the Kunene region of Namibia, 1999.

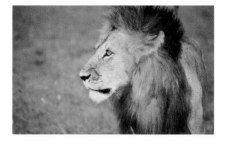

Page 27: A lion near the Telek river in the Maasai Mara, 2002.

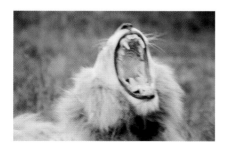

Page 28: A male white lion in the Timbavati nature reserve, 2010. White lions (which in fact vary from blond to near-white) are found in the wild only in South Africa, where their population is estimated at 400.

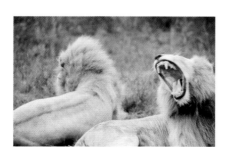

Page 29: White lions, Timbavati, 2010. White lions are regarded as sacred by the local native people, but are sought after by trophy hunters. Many white lions today are bred specifically for the hunt.

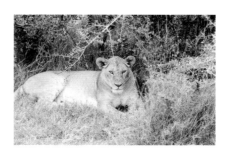

Page 30: Maasai Mara, 2002. A lioness rests by a thorn tree, then (in the following three images) meanders through the grass.

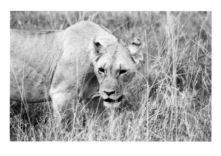

Page 30 (see left).

152

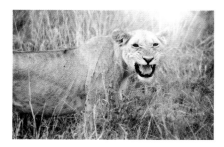
Page 31 (see opposite, bottom row, second from right).

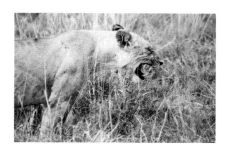
Page 31 (see opposite, bottom row, second from right).

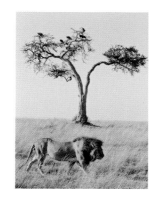
Page 33: A lion walks past a tree laden with vultures in the Maasai Mara, 2002. We followed its movements until it reached a watering hole, where it had a drink.

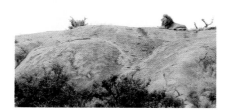
Page 35: A male lion rests on a rocky koppie (small hill) in the central Serengeti, 2012.

Pages 36–37: Timbavati, 2010. A lion hurries past us as he follows the call of a female.

Pages 38–39 (see left).

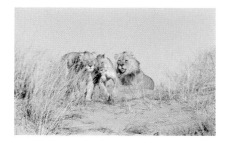
Page 40: In 2010, in the Kalahari savannah of southern Africa, we attempted for a week to see lions, with no success. Finally, a few hours before sunset on our last day, we noticed a male's golden mane against the red sand. Then, one at a time, appeared four females, the harem of this male.

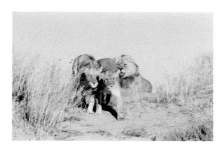
Page 40 (see left).

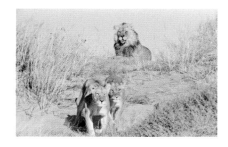
Page 41 (see row above, second from right).

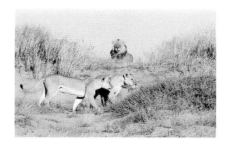
Page 41 (see row above, second from right).

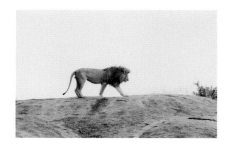
Page 42: A lion in the Serengeti, 2012, walking across a rocky koppie to drink at a watering hole.

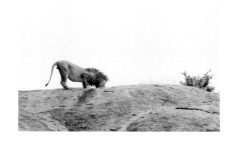
Page 43 (see left).

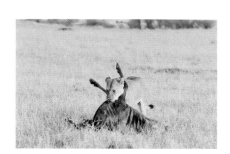
Page 44: A lioness with her kill, a wildebeest, in the Maasai Mara, 2002. She is then joined for a meal by others from her pride (pages 46–47).

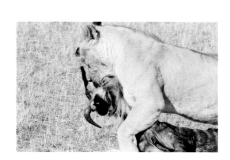
Page 44 (see left).

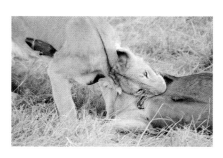
Page 45 (see far left).

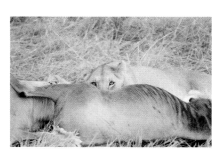
Pages 46–47 (see far left).

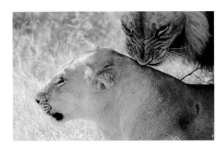
Pages 48–49: A lioness with her mate in the Okavango Delta, Botswana, 2010.

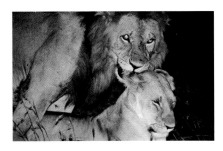
Page 50: Lions mating at dusk in the Maasai Mara, 2002. Mating can take place every fifteen minutes, often over several days.

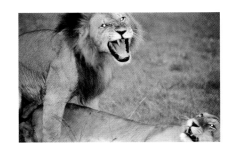
Page 51 (see left).

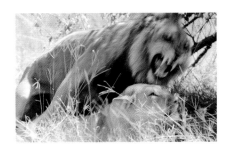
Pages 52–53: Lions mating in the Okavango Delta, 2010.

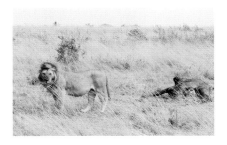
Page 54: A lion with its kill, a buffalo, in the Maasai Mara, 2002.

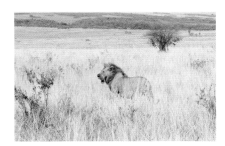
Page 55: Maasai Mara, 2002.

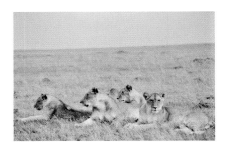
Pages 56–57: A pride of lionesses keep a lookout while resting; Maasai Mara, 2002.

Pages 58–59: These elephants in the Serengeti, 2012, were made a little nervous by several lionesses sitting above them in the acacia tree. Some of the elephants shook the tree in an effort to dislodge the cats.

Page 60: A white lioness eating, Timbavati, 2010. White lions are not albino; their pale hair colour is caused by a recessive gene.

Page 61 (see left).

Page 63: Sparse vegetation growing on an outcrop near the Chyulu Hills, southern Kenya, 2002.

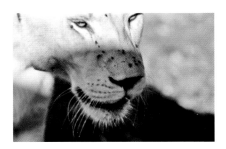
Page 64: A white lioness in Timbavati, 2010.

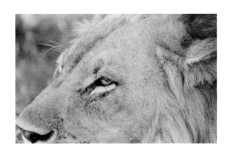
Page 65: A male lion near our camp in the Maasai Mara, 2004.

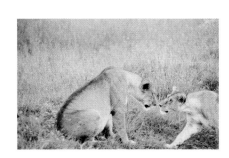
Page 66: Two lionesses greet each other in the Serengeti, 2012.

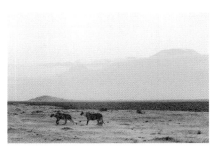
Page 67: Amboseli National Park, Kenya, 2007. Two lionesses patrol the plains at dusk, with Mount Kilimanjaro, across the border in Tanzania, in the background.

TIGERS

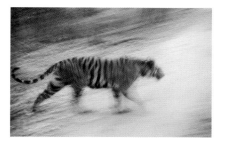

Pages 68–69: A tiger crosses our path early in the morning in Bandhavgarh National Park, 2009. All the photographs of tigers in this book were taken at Bandhavgarh.

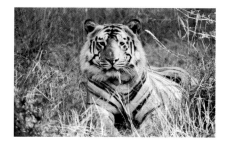

Page 70: A superb male eyes us from 20 feet away.

Page 73: A tiger appears from afar as it roams through the forest.

Page 75: Well camouflaged by its markings, the tiger is absorbed by the forest. When tigers hunt, they are successful in catching their prey (usually sambar, chital or boar) in only one in ten attempts.

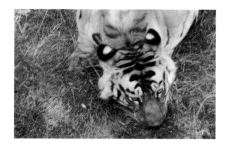

Page 77: From the back of an elephant we had a overhead view of this tiger. A tiger's forehead markings often resemble the Chinese character for the word 'king'.

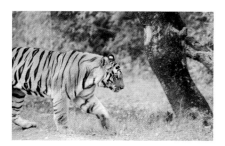

Page 78: A young tiger on the lookout.

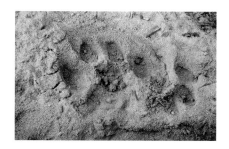

Page 79: A tiger paw print in the sand. Such prints are often used in estimating population numbers.

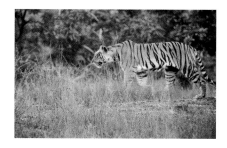

Pages 80–81: Tigers' markings are unique to each individual animal, as fingerprints are to each human.

Pages 82–83: A tiger flashes past us at speed.

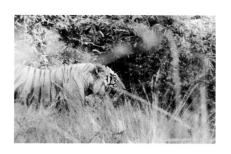

Page 84: A tiger on the prowl.

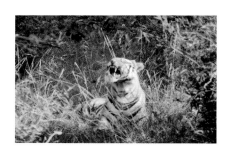

Page 85: Growling in the grass.

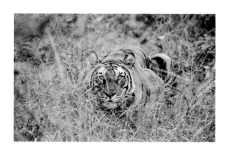

Pages 86–87.

Pages 88–89: At first glance, the tiger's stripes appear to be extensions of the grass.

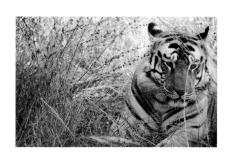

Page 90.

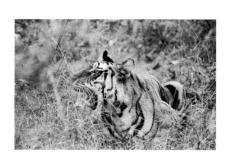

Page 91.

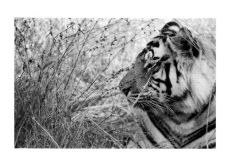

Pages 92–93: An oversized house cat in profile.

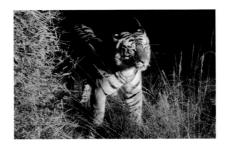

Pages 94–95: A tiger photographed from the back of an elephant.

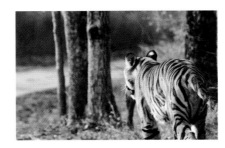

Pages 96–97: A tiger on the prowl.

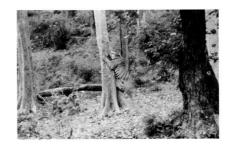

Page 99: It was an exhilarating moment for us when a tiger climbed up a tree.

POLAR BEARS

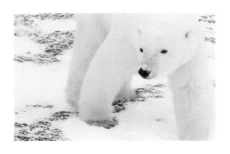

Pages 100–101 and 102 (right): Bears in the vicinity of Churchill, on the shores of Hudson Bay (just south of the Arctic Circle), 2004. The word 'Arctic' comes from the Greek Arktos, meaning 'bear', and refers to the constellation Ursa Major (the Great Bear), which hovers over the Arctic region.

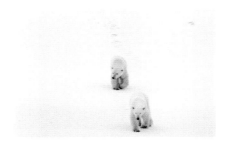

Page 102 (see left). The Inuit remind us that each being, each animal, has a soul – a concept that our technological society has forgotten.

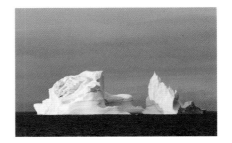

Page 105: Towering icebergs in Disko Bay, western Greenland, 2009.

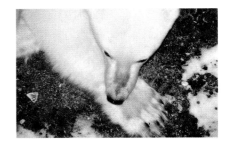

Page 107: Hudson Bay, 2004.

Page 108: A melting ice pack off Svalbard, halfway between Norway and the North Pole, July 2008. It appears worryingly possible that there may be an ice-free summer at the top of the world in the not-so-distant future.

Pages 110–11: An iceberg in Disko Bay, 2009.

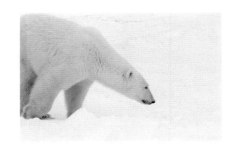

Pages 112–13: Near Churchill, 2004.

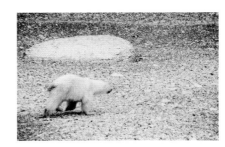

Page 114: In the late summer of 2009, from the sea we followed a few very thin polar bears along the shoreline and imposing cliffs of Akpatok Island, northern Quebec. Away from the ice and snow of their usual winter habitat, the bears are more easily visible.

Page 115 (see row above, far right).

Pages 116–17 (see row above, far right).

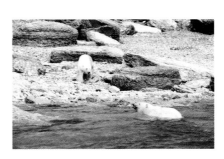

Page 118: Akpatok Island, 2009. Polar bears are very much at ease in the water. They have been known to swim more than 60 miles from shore.

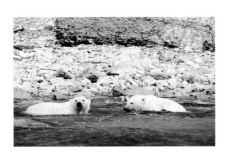

Page 119 (see left).

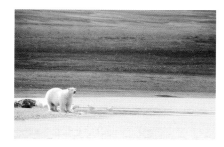

Page 120: A healthy male polar bear attracted to the carcasses of beluga whales near Lancaster Sound, in the far north-east of Canada, 2012. The area has the world's greatest concentration of polar bears.

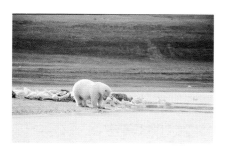

Page 120 (see left).

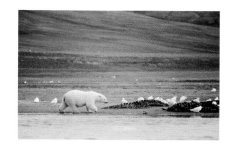

Page 121 (see far left).

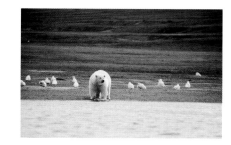

Page 121 (see far left).

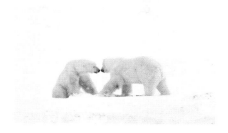

Page 122: Two males greet each other near Churchill, 2004, as the ice was starting to freeze on Hudson Bay.

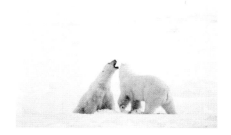

Page 123 (see left).

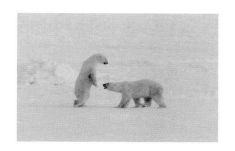

Page 124: Two male polar bears enjoy a spot of wrestling near Churchill, 2004.

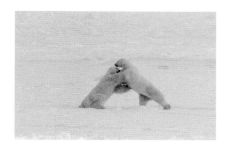

Page 125 (see left).

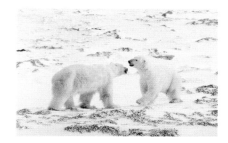

Page 126: Near Churchill, 2004. Adult males can weigh 800–1700 lb, two to three times the weight of a female, and can measure up to 10 feet in length.

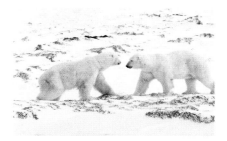

Page 127: Near Churchill, 2004.

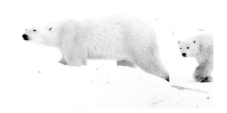

Pages 128–29: A mother with her cub near Churchill, 2004.

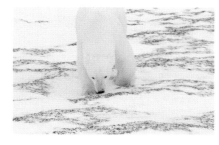

Pages 130–31: A wandering male near Churchill, 2004.

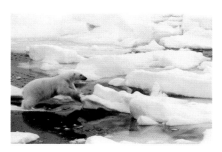

Pages 132–33: A male polar bear leaps between ice floes in Svalbard, 2008.

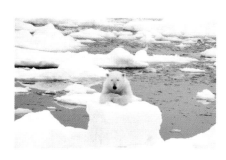

Page 134: Svalbard, 2008. The endearing, almost friendly poses polar bears can strike belie the fact that they are the strongest predator on earth. Their sense of smell, too, is astounding.

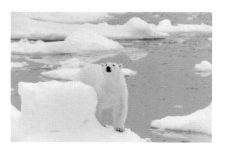

Page 135 (see left).

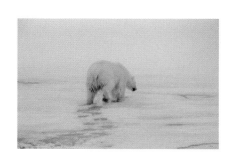

Pages 136–37: A male sloshes about in the soft ice, Svalbard, 2008.

Page 138: A fog bow in the ocean off Svalbard, 2008. It appeared suddenly, like a vision, a window into another world.

Page 139: Mist and an eerily smooth ocean off Svalbard, 2008. For a brief period at the end of summer each year, only isolated pieces of ice, such as these, remain.

Pages 140–41: An iceberg in Disko Bay, 2012.

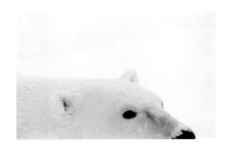
Pages 142–43: Near Churchill, 2004.

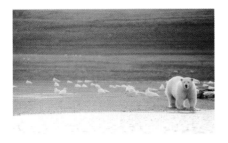
Page 145: A well-fed male looks us over in Lancaster Sound, 2012.

Page 146: An iceberg in Disko Bay, 2009.

Page 147: The optical illusion known as a Fata Morgana mirage, created by rays of light bending in the earth's atmosphere, distorts this view of icebergs in Disko Bay, 2012.

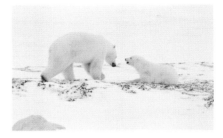
Page 148: A mother with her cub forages for much-needed nutritious seaweed near Churchill, 2004.

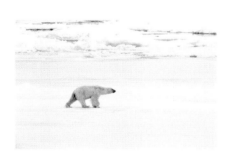
Page 149: Svalbard, 2008.

Page 151: Strange cloud formations appear in the Arctic; Svalbard, 2008.

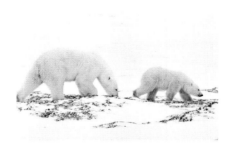
Page 160 (see row above, far right).

ACKNOWLEDGEMENTS

Our deepest thanks go to Koni for his remarkable lion story; Moses, whose Maasai understanding of the land humbles us; Satao Elorai for providing the views of Kilimanjaro and a true home away from home; Ol Kanjau and Mike Rainey for introducing us to the complexities of the Maasai and Samburu worlds; Ol Donyo Wuas and Richard Bonham for their work with the Maasailand Preservation Trust; our guide Rodgers Mariki, whose humour graced us throughout our visit to the Serengeti; Gee and all at &Beyond for sharing the life force of Botswana's Okavango Delta, one of the world's supreme wildlife sanctuaries; Linda Tucker and Jason for their love for the white lions of Timbavati; Rakita, Fred and James of Rekero, who helped Lysander to take his first steps on the plains of the Mara and who helped him to see his first lions there, in the place where mankind was born; and Belinda and Isak, and the first peoples of the Kalahari, for introducing us to gemsbok and the ancient reality of the sands. We send a special thanks to Raza and African Mecca, for being a voice of honesty and integrity in the safari world at a time of great changes in Africa. We also send enormous thanks to Elizabeth Marshall Thomas, whose insight into the timeless ways of the first peoples and the lion serves the heart of Africa in us all.

We also give our thanks to Shailin Ramji and his gracious wife, Rhea, for their hospitality at Bandhavgarh; Joseph, whose expertise is a model to all guides searching for the ineffable still lurking in the forests of India and Asia; Kattupan, the great mahout; and Sy Montgomery for her incomparable love of the wild and her journey that shed so much light on the tiger's mind and the mangroves of the Sundarbans.

We feel immense gratitude to Cathy Lawton for her heart, grace and understanding, and for helping us to appreciate the Arctic, one of the most sublime landscapes on earth. We also thank One Ocean Expeditions, whose care and expertise are unparalleled, for their hospitality at the top of the world; Dennis Mense, whose humour and knowledge of the sea inspired us to appreciate the Arctic's fragile wonders; John Houston, whose honouring of the elders and knowledge of the Inuit language are a gift to us all; Kananginak Pootoogook, whose smile and harbouring of the spirit of the ancestors we will never forget; and Robin Buzza, whose adventures in Svalbard with his huskies and the polar bears continue to inspire us.

Our further thanks go to Dorothy Lichtenstein, an incomparable spirit whose love of our planet underscores the understanding that art must serve the greater journey of life, for her support; Vivian Day, whose journey led her to Kenya so many years ago and who has been an unfailing ally in giving voice to Africa; Carol Rodgers in London; Nicole and Cody for their unwavering professionalism and friendship, and for understanding that an entire universe exists beyond what the eye beholds, and that the art of photography must serve the greater art of life; all those at Merrell who helped with this 'manifesto'. Thank you for giving us the opportunity to share our vision for those who do not have a voice.

We send heartfelt thanks to the following foundations working to save what is left of the wild: the African People & Wildlife Fund; the African Wildlife Foundation; Born Free; Conservation International; Lion Guardians; Panthera; Save Our Tigers; Save Tigers Now; Wildlife Conservation Society; and the World Wildlife Fund. And finally, we thank all the heroes in conservation all over the world. They know that 'the others' form an essential part of our being and that saving life today is the battle of our time, so that we never have to tell the children, 'This is where the wild things were'.

First published 2013 by Merrell Publishers, London and New York

Merrell Publishers Limited
81 Southwark Street
London SE1 0HX

merrellpublishers.com

Text copyright © 2013 Cyril Christo, except: pages 62–66 © 2013 Elizabeth Marshall Thomas; pages 98–99 © 2013 Sy Montgomery; pages 144–150 © 2013 John Houston
Photographs copyright © 2013 Cyril Christo and Marie Wilkinson
Design and layout copyright © 2013 Merrell Publishers Limited

Text extract on page 13 from *The Roots of Heaven* by Romain Gary, translated by Jonathan Griffin, published by Michael Joseph.

Text extract on page 76 from *Thinking Animals* by Paul Shepard, published by Viking Press.

Text extract on page 103 from 'The Angry Winter', in *The Unexpected Universe* by Loren Eiseley, published by Harcourt Brace & World.

Text extract on page 109 from *The Last Kings of Thule: A Year Among the Polar Eskimos of Greenland* by Jean Malaurie, translated by Gwendolen Freeman, published by G. Allen & Unwin.

Text extract on page 150 from *The Others: How Animals Made Us Human* by Paul Shepard. Copyright © 1996 Paul Shepard. Reprinted by permission of Island Press.

The publisher has made every effort to trace and contact copyright holders of the text extracts reproduced in this book; it shall be happy to correct in subsequent editions any errors or omissions that are brought to its attention.

All rights reserved. No part of this publication may be reproduced, stored in a retrieval system or transmitted, in any form or by any means, electronic, mechanical, photocopying, recording or otherwise, without the prior written permission of the publisher.

British Library Cataloguing-in-Publication data. A catalogue record for this book is available from the British Library.

ISBN 978-1-8589-4610-8

Produced by Merrell Publishers Limited
Designed by Nicola Bailey
Project-managed by Marion Moisy

Printed and bound in China

Jacket, front:
A tiger passing at speed, Bandhavgarh National Park, India.

Jacket, back (top to bottom):
see pages 38–39, 86–87, 100–101.

Tigers, panthers, jaguars, lions etc. Why is it that these things have stirred me so much? Can it be because I have gone outside the everyday thoughts that are my world; away from the street that is my entire universe? How necessary it is to give oneself a shake from time to time; to stick one's head out of doors and try to read from the book of life that has nothing in common with cities and the works of man.

EUGENE DELACROIX,
JOURNAL, 1893

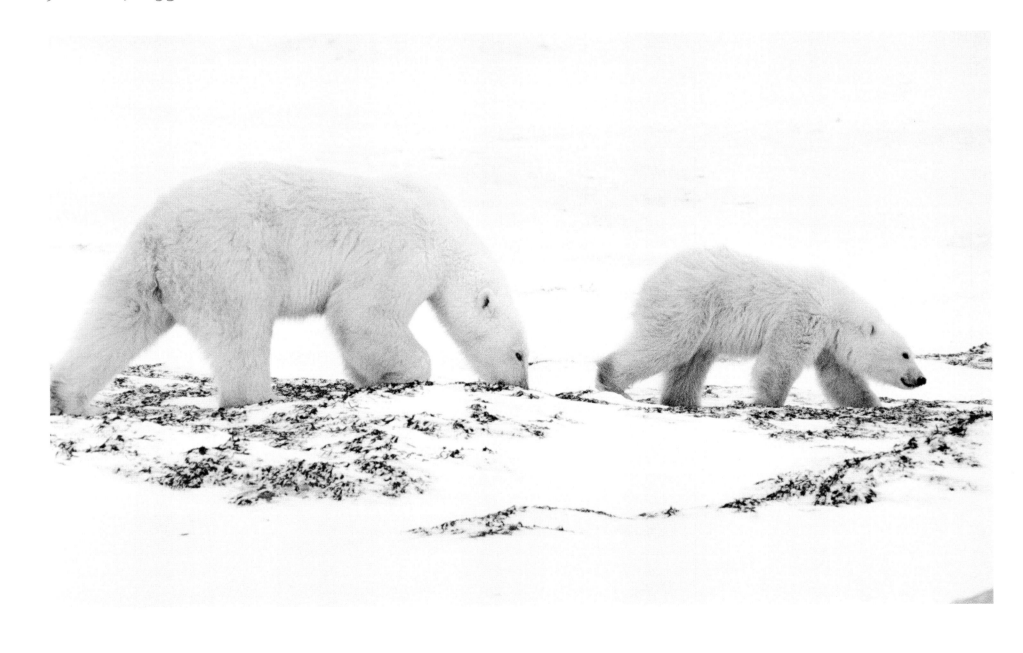